Earth Color

EMMA BURLEIGH

LIMINAL 11

First published in 2022 by Liminal 11

Editorial Director: Darren Shill
Art Director: Kay Medaglia
Editor: Eleanor Treemer
Cover Design: Tori Jones and Emma Burleigh
Designers: Tori Jones and Allie Oldfield

Printed in China

ISBN 978-1-912634-48-4
10 9 8 7 6 5 4 3 2 1

www.liminal11.com

Contents

Introduction

Welcome.

Responding to nature through art takes me beyond the usual machinations of my chattering mind and opens the door to my more perceptive, feeling heart. This course aims to help you tune in to your instinctive and intuitive nature, and in doing so, open up a channel of communication and empathy with the natural world. Cultivating a sensitive way of relating to plants, animals, and the elements through art-making enables us to truly know that we are not separate from this world. We can feel, in our bones, that we are made from and are an intrinsic part of nature. We can understand the interdependence between the heart of the earth and our own hearts.

I hope this book encourages you to enjoy a rich connection with the wild, by which I mean both the wild planet all around you and the — perhaps as-yet unexplored — wild parts of yourself. If you yearn for more freedom of expression, and to know the untamed places within and around yourself more deeply, I made this book for you.

This book is also for you if you long to share your love for our beautiful, natural world, and you keenly sense the need to repair our collectively damaged relationship with nature. Nature nurtures us, and so this course is intended for anyone who wants to calm a troubled mind or soothe a hurting heart. It's for anyone who feels lost, numbed, or laid low by stress. If you're lost in the woods, this is a trail that will lead you home to soulfulness, meaning and joy.

Through this course I hope to support you, and those you share this work with, to cultivate a deep, appreciative relationship with our other-than-human companions, to love and be loved by nature, and to draw closer to your own true, soulful, wild self.

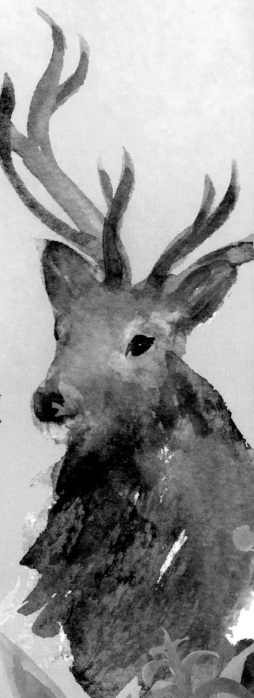

Nature Connectedness and the Pathway of Beauty

Many of us are concerned, even despairing, about the destruction that humanity is wreaking upon the planet. Reconnecting with nature is an urgent priority for us as a species. And as we become more connected with nature, there is a measurable improvement — not just for the environment, but for our own minds.

Nature Connectedness is the psychological construct associated with pro-nature behaviors and wellbeing — and it has become an important field of study. Over several years of research into the types of activities that seed Nature Connectedness, researchers at the University of Derby in Britain identified five "pathways" that led participants to develop higher levels of active care for our environment and experience sustained increases in their personal happiness and health.[1] These five pathways to Nature Connectedness are:

Senses — Tuning in to nature through the senses.

Emotion — Connecting with the emotions evoked by being in nature.

Beauty — Noticing and appreciating nature's beauty.

Meaning — Considering your life's meaning now you understand yourself in relation to nature.

Compassion — Caring for nature and taking action to protect it.

During the course we will ramble along all five of these paths. Oftentimes the paths will intersect, merge, and take us down delightful new byways and glades. In essence, however, this book is all about the pathway of beauty. It speaks to the poet and mystic inside you: your inner artist, who may have been a little — or a lot — neglected. The course aims to sharpen your awareness of all aspects of your inner nature — everything that makes you human, and everything that makes you animal and alive — but we will move softly along the beautiful pathway of "quietly being," of contemplation and appreciation, and of gentle, restorative art-making to get there.

Through making art in connection with the natural world, we can awaken the lover of beauty, the sensitive one inside each of us. Rumi, the 13th century Persian poet, said: "There are a thousand ways to kneel and kiss the earth." In this book, I offer you some artistic ways of "kneeling and kissing." Through these small but not insignificant gestures, I believe each of us can help to repair our individual and collective relationship to the web of life in which we are held.

How you can use this book

This course encourages you to take a walk every day, or nearly every day. It could be a short walk of just ten minutes; however, if mobility is tricky for you then feel free to use whatever medium allows you to access the outside world. This experience could even be more of a sit-down than a walk, perhaps on a sunny park bench. Of course, you're welcome to take an all-day hike if you have the time and the energy, but just a leisurely amble around your garden or a stroll to the old tree at the end of your road will do.

The goal is to experience nature in whatever way works best for you. If you're not able to leave the house for any reason, you can still connect to nature through this book, through your window, through images on screen or paper, and most important of all, through your imagination.

If possible, use this book as I've suggested and do one exercise every day — or nearly every day — for eight weeks. They say it takes around 30 days to form a habit. If you can make a little foray into the natural world each day for the first four weeks, you may find you build up an excellent new routine. Studies show that connecting with nature — assuming your basic needs have been met — is four times more effective in providing a sense of having a "worthwhile life" than any improvement in your socio-economic status. [2] Better still, there's good evidence that making art in response to nature will amplify the benefits to your wellbeing. [3]

That said, it's absolutely okay to take longer than eight weeks to complete this course. It's also fine to dip in and out. Perhaps it's only possible for you to do one drawing per week, or one a month. If so, feel free to take a year, or as many years as you want, to work through the book. Interestingly, the amount of time you spend in nature has been found to be much less important than the quality of connection you cultivate once you are there. [4]

What you will get out of the course

The emphasis is on process, not production. Think of your works of art as appreciations, poems, or even prayers that you are creating from nature and offering back to nature. They do not need to be masterpieces; they do not need to be Instagrammable; they do not even need you to like and approve of them. Of course, I encourage you to share the results of your efforts, if you want to, when they please you, but consider the purpose of this course to be about deepening the relationship between yourself and our living, breathing planet.

The artworks you produce will simply be one of many possible expressions of this deepening friendship between yourself and the more-than-human world. This is a friendship with radical healing potential. Forest bathing guide M. Amos Clifford reminds us that, while "humans are not separate from nature and have no free pass to escape the effects of the traumas we inflict upon it," the cure is in the connection. "Healing of people and forests happens together, or not at all. The medicine that brings healing is in the relationship."

Sitting in nature and making a painting may not sound very important, but those of us who take time to draw closer to the earth are adding one more precious drop to a crucial medicine pot!

How the course is structured

This course is set out in a particular order: in Week 1, I invite you to ground yourself through a series of mindful art activities designed to connect you to the living world through your five senses. Over the subsequent weeks, I go on to guide you through the essential elements and energies of nature, which, for structure, I've loosely aligned to the ancient Hindu and Yogic system of chakras.

We begin at the beginning with the earth, which is associated with the root chakra and the foundations of our life. Week by week, we will continue moving upwards through the various forces of nature, ending with notions of soul, sky, and cosmos (connecting to the crown chakra) in Week 8. However, if you prefer to approach the course non-chronologically, selecting particular exercises in any order simply because they resonate with you in the moment, I have no strong objection. Trust your instincts on this.

What you need:

Essential:

- Drawing and painting materials — select a few from the list below
- A sketchbook or journal with thick enough paper for you to paint and sketch on (e.g. over 130gsm)
- Clothes (for walking) that you don't mind getting muddy
- A bag for gathering some delicate objects
- A camera (your phone camera will be fine)

Nice to have:

- A thermos of tea or coffee
- A mat to sit and lie on
- A flask of water to drink and a snack to munch
- A good raincoat and some waterproof trousers if you live in inclement weather, or a sun hat / sun protection if it's hot

Art materials to choose from

Listed below are all the items I suggest you use in this course. If you don't want to buy them all, you can adapt the exercises to the mediums you already have.

Paints:

Essential — a watercolor set, plus a few brushes in a range of sizes and shapes, and a cup or jar for washing brushes.

Other things it would be great to have — a dip pen, pots of ink (black and perhaps a few other colors), a set of Inktense Blocks, a set of gouache paints and/or a tub of white gouache (good for covering mistakes or mixing with watercolor to make a more opaque paint).

Drawing Materials:

Choose a few items from this list — ordinary HB pencils (or a pack of drawing pencils in the HB to 9B range), black charcoal, colored pencils, oil pastels, soft pastels, a water-resistant black or brown fineliner pen, a set of colored fineliner pens, a ballpoint pen, a white gel pen, and an ordinary wax candle or wax resist stick.

Paper:

As well as a high-quality sketchbook, I recommend that you purchase some watercolor paper for when we paint "wet in wet" style. There are a lot of options when it comes to watercolor paper, which can be quite overwhelming. For our purposes, any will do, but the best value and most useful is a general multi-use watercolor paper. This will weigh around 200 to 300gsm and be labelled "Not" or "Cold Press." Collect some unusual types of scrap paper too — brown parcel paper, interesting envelopes you've received in the post, tissue and gift wrap paper, and newspaper.

Other:

A small bag of clay (this can usually be found in art and craft stores. It needn't be "air drying": select the most natural, pure clay you can find without man-made polymers.)

Code of Care

In this course, we will interact with nature in ways that are explorative but not invasive, curious but not disruptive. We're looking to develop an intimacy with nature that causes no harm. I've drawn up a few guidelines to ensure we enter wild places with both care and respect:

- If you are choosing to make art outdoors, please do not leave behind any materials that you did not source directly from the landscape.

- Try not to wander away from human made paths, because at breeding times you could disturb ground nests or cause the animals who live there some unnecessary panic.

- Occasionally, I'll invite you to pick a leaf or flower from a plant. Pick only one or two, and only pick from plants which are clearly in abundance. Be careful not to pick anything rare, protected or poisonous. If in doubt, don't pick it!

- Never pull up a whole plant! In many countries it's illegal to do this with wild plants, and for good reason.

- To avoid disturbing the landscape, it might be best to gather only what has fallen on the ground. If you take things home to draw or paint, try to return them back to the earth when you're done.

- Be mindful where you tread and take care not to trample on newly growing buds in the ground.

Let's begin…

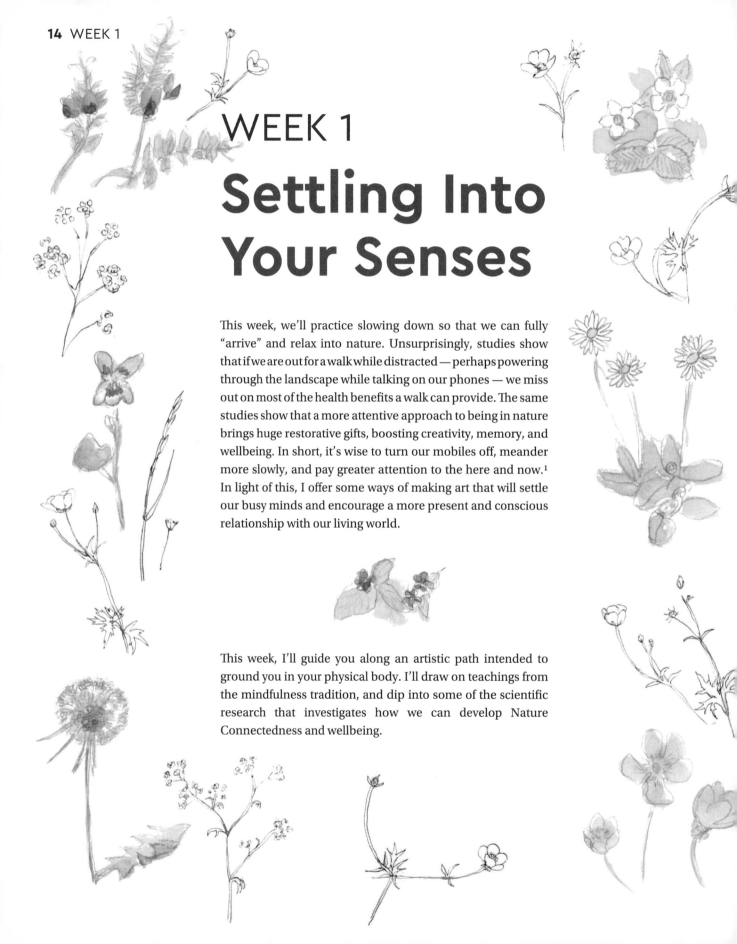

WEEK 1
Settling Into Your Senses

This week, we'll practice slowing down so that we can fully "arrive" and relax into nature. Unsurprisingly, studies show that if we are out for a walk while distracted — perhaps powering through the landscape while talking on our phones — we miss out on most of the health benefits a walk can provide. The same studies show that a more attentive approach to being in nature brings huge restorative gifts, boosting creativity, memory, and wellbeing. In short, it's wise to turn our mobiles off, meander more slowly, and pay greater attention to the here and now.[1] In light of this, I offer some ways of making art that will settle our busy minds and encourage a more present and conscious relationship with our living world.

This week, I'll guide you along an artistic path intended to ground you in your physical body. I'll draw on teachings from the mindfulness tradition, and dip into some of the scientific research that investigates how we can develop Nature Connectedness and wellbeing.

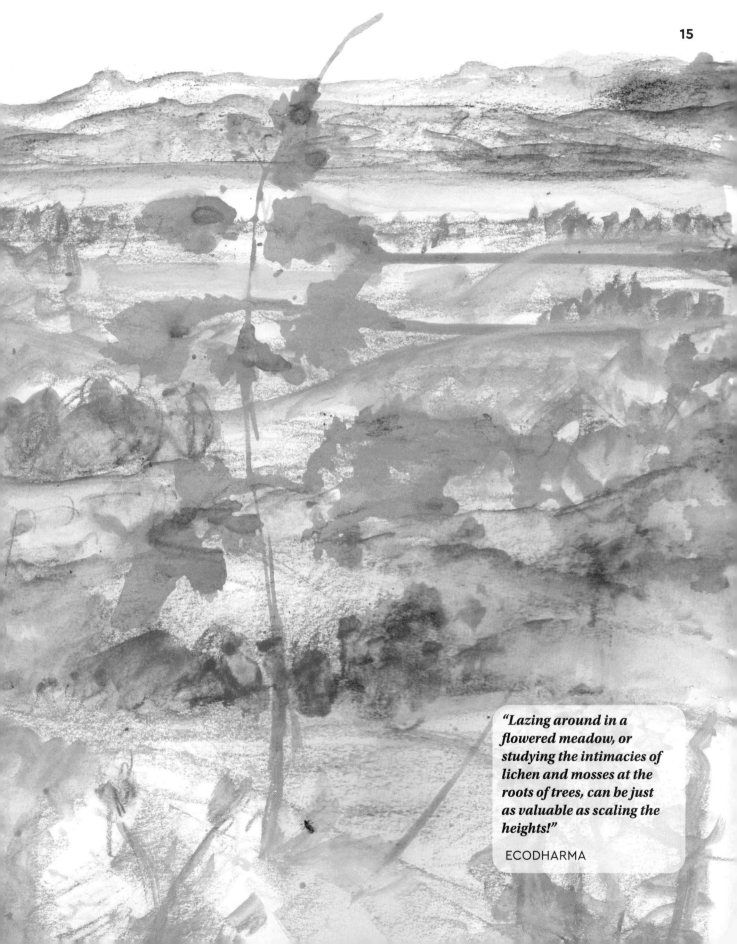

"*Lazing around in a flowered meadow, or studying the intimacies of lichen and mosses at the roots of trees, can be just as valuable as scaling the heights!*"

ECODHARMA

Day 1
Be

Today, take a slow, leisurely walk (or otherwise connect with nature if walking is difficult for you) and just notice what you notice. Bring a sketchbook and a pen or pencil along with you, and if the weather is not too unsuitable, take a flask of hot tea or a cool drink, a snack, and a picnic blanket to sit down on.

The aim is not to cover a lot of ground but to amble gently, taking time to notice all the details: the texture of a tree, the tiny things underfoot.

I urge you to stay still long enough to hear the sounds that surround you — the rustles amongst the leaves and the ripples on the water — and to move slowly enough to sense the breeze on your skin and the scents in the air.

Note what you experience as you go along by naming it calmly in your mind, then letting it pass on by. Your inner commentary might go something like "cool breeze on my cheek... honking call of a goose... soft swish of footsteps on mud." There's no need to go looking for anything special; just let the experiences come to you however they happen to.

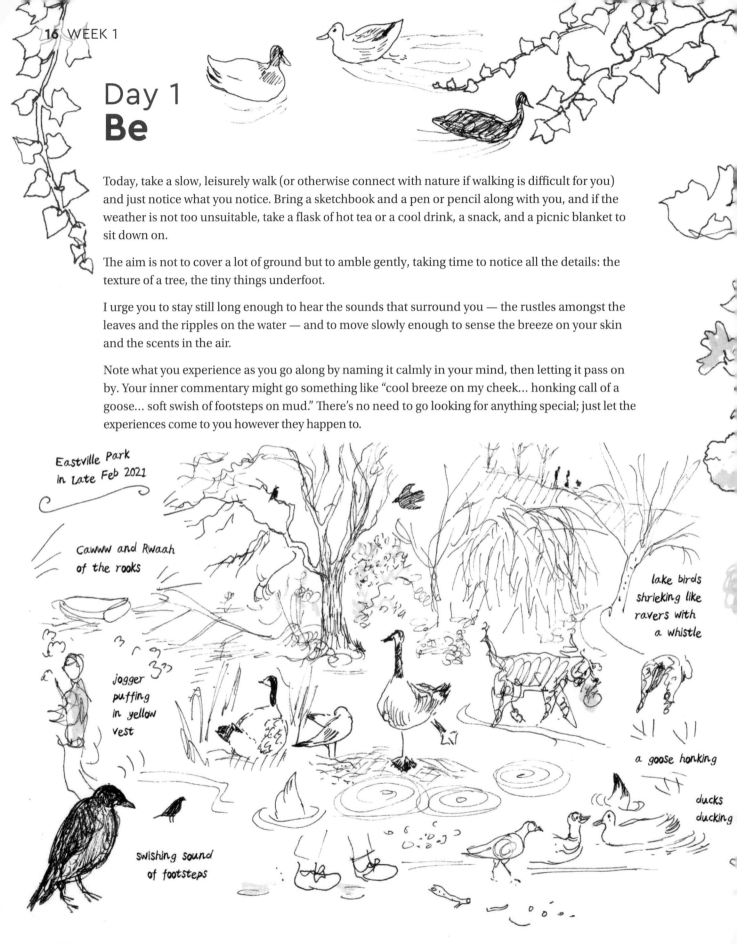

Eastville Park
in Late Feb 2021

Cawww and Rwaah
of the rooks

lake birds
shrieking like
ravers with
a whistle

jogger
puffing
in yellow
vest

a goose honking

ducks
ducking

swishing sound
of footsteps

Creative Invitation: Note Whatever You Notice
Media: Pen or Pencil

If it's not too cold or wet to sit down, find yourself what forest bathers call "a sit spot" and begin to record what you notice in your sketchbook. If you hear a bird singing, use words or images to record that. If your eye is caught by the wake of a duck swimming through water, draw a line that evokes those lazy wavelets. Your images could be abstract symbols, shapes and lines, or more classical observational drawings.

We can get very caught up in what cartoonist Lynda Barry calls, ominously, "The Two Questions." She identifies these questions as "is it good?" and "does it suck?" Arguably, these are just two variations on one question! But the point is, fear of our artwork not being "good" or "good enough," of being judged unfavorably by others or even by ourselves, or of being sneered at for even daring to draw at all, can make it very difficult to put pen to paper. If this is happening to you and you've gone into a creative freeze, try to draw using the "no look" method (see box below).

Drawing without looking at the paper takes us away from the concerns of the everyday mind and helps us to re-focus on what lies beyond all that. We can let go of our need to be perfect, or good, or impressive, and become softly fascinated by the shapes, textures, and colors of this extraordinary world we are part of.

This page: *"No look" drawings. The first cowslips of spring and last umbellifers of autumn in fineliner black pen. I added a dash of colored pencil afterwards, once I'd allowed myself to look at what I had drawn.*

Opposite page: *Noticings in the park. You can see that there's a mix of written notes, abstract lines to represent sounds and the sensation of breeze on skin, "no look" drawings, and observational drawings. Although the sketch builds up to represent something that almost looks like a coherent scene, you may notice that several objects are out of proportion with one another. This is because I sketched here and there on the page in the order that I experienced events, without concern for perspective — hence the enormous dog with a yellow ball, and the giant goose!*

How to do the "no look" method:

Try to draw using just one continuous line, without looking at the paper. That's right. Look only at the object of your attention, be it a goose, a tree, or a flower. Let your eye travel around the edges of the subject, and let your hand faithfully record your eye's journey without concern for what might be appearing on the paper. Don't stop — keep your hand in motion — and don't peek at your sketchpad until you're done!

crocus

Day 2
Listen

We need quiet spaces where we can hear nature speak. The soundscapes of nature are tried-and-tested good medicine: the gentle burbling of a brook or the sound of the wind in the trees can physically change our mind and body, helping us to relax. Researchers have found that playing natural sounds soothes the bodily functions that control the fight-or-flight and rest-digest autonomic nervous systems, with positive effects on the resting activity of the brain.[2] Unfortunately, many of us have become desensitized to sound, and hearing loss is a real issue due to what is called the anthrophone — that is to say, the human-made noise that is almost entirely ubiquitous across the planet. There are thought to be fewer than a dozen sites in the USA where you can avoid hearing a human-made noise for even 15 minutes at dawn.[3] Even if we have become habituated to the din and scarcely notice the clatter of the world around us, studies sadly show that loud noises continue to have a negative impact on our bodies, even when we are asleep.[4]

Nevertheless, while the anthrophone stresses our system, the corollary is, thankfully, also true. It's great for our health to find a quiet place to unplug from society's constant feedback loop and allow the song of the nature-phone to work its magic.[5]

"In essence, tuning nature in helps to tune anxiety and depression out."[6]

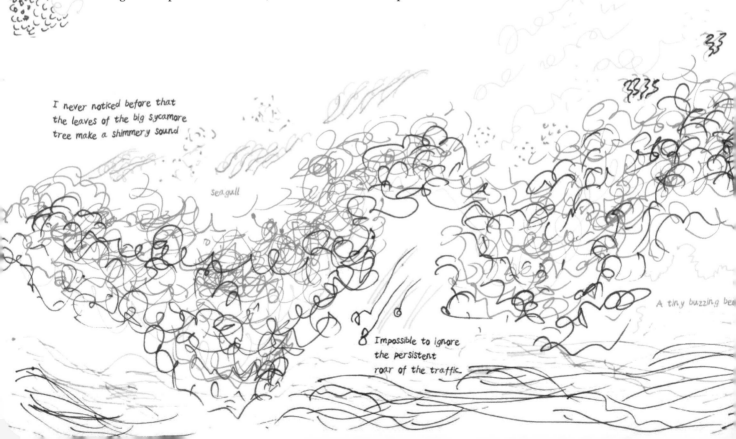

I never noticed before that the leaves of the big sycamore tree make a shimmery sound

seagull

Impossible to ignore the persistent roar of the traffic

A tiny buzzing bee

Creative Invitation: Tune Into Sound
Media: Colored pens or pencils

Take your sketchpad and some colored pencils or pens. Begin with a relaxed stroll through the park or woods, letting yourself "arrive." When you feel settled in, tune into your sense of hearing.

What sounds do you hear close by? What about far away? Above? Below? To the left? To the right? Can you hear a rustling in the undergrowth, the *tap-tap-tap* of a woodpecker in a tree, or the *flap-flap* of feathers as a pigeon launches itself into the sky? Can you hear sounds tiny and close-up? If you put an ear to the ground, can you hear the footsteps of insects going about their business? You may even hear sounds within the ecosystem of your own body — swallowing, gurgling, or rumbles in the belly.

Let the sounds arise and let them disappear. Taking your pencils, record what you hear as you sit quietly, just listening. Let yourself respond instinctively, choosing colors and making lines and shapes however you feel moved to — there's no correct way to draw a sound!

Caveat: If you live in an urban place, as most humans now do, you'll hear city noises. There's no need to filter them out: if they are what you're hearing, draw them too — but keep an ear cocked for those subtler sounds of birdsong and leaves which can so easily go unnoticed.

Thought: Did you know that humans share more of the genes that govern speech with songbirds than we do with other primates? Perhaps this is why we find birdsong so uplifting, and why scientific studies have recorded consistent improvements in mood and alertness when we listen to it. It must be acknowledged, however, that birds are far more sophisticated listeners than we are. A skylark's song, recorded and slowed down, reveals an astonishing complexity of subtle sounds indiscernible to the human ear when heard at normal speed.

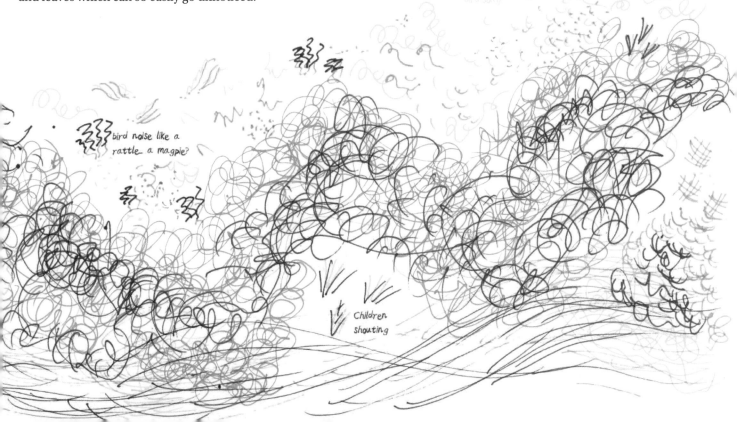

Day 3
Scent

Today, we focus on the sense of smell, opening up to the range of scent impressions that waft your way as you wander through your chosen forest, park, or wild place.

Smells can be powerfully evocative and mood-altering. Islamic "paradise gardens" in ancient Iran were filled with aromatic plants selected for their beautiful fragrances. The idea was to engage the noses of their visitors, rather than the eyes, and to support rest, reflection, and contemplation in the cool of the night. We've always known that smell can impact how we feel. In the days of the Roman Empire, Pliny the Elder sniffed a "garden of mint" and observed how the "very smell of it alone recovers and refreshes our spirits." We can all recall a moment of smelling something reminiscent of childhood — old comic books, granny's lavender soap, even something unpleasant but distinctive like cabbage mingled with disinfectant — and becoming flooded with memory and emotion.

Forest floor: Damp, mouldy, chocolatey-sweet, woody, pungent

There's some science to prove that certain natural scents ease anxiety and support resilience. In a virtual reality experiment, participants recovered faster from a small electric shock when they could smell the natural scents of a woodland — mushrooms and firs — than when they could smell urban odors of diesel, tar, and gunpowder (the latter is, oddly, a roadbuilding ingredient). [7]

Yew tree leaves: minty, salty, like the sea. Smoother and lighter than the earth-smell.

In another experiment, the scents of summer air (leaf alcohol) and beeswax were associated with feelings of happiness in participants, while a trial in a fragrant garden showed that odors derived from blooming plants increased calmness, alertness, and mood. The scents of lavender and spiced apple have even been shown to alter brainwave activity. [8]

I've used Inktense sticks today. They're very versatile, as they can be used as a mark-maker while dry, like crayons, or wet, by brushing water over the top of them. This is helpful if you'd like to achieve the effect of paints but don't feel like painting al fresco! If you do want to do some outdoor painting, bring along a jar of water and a brush, or try a refillable watercolor brush pen.

Yew tree bark: sweet, warm, light like honey or cinder-toffee. (I rubbed the bark for a stronger scent.)

Moss at the base of a tree: light, clean, soft. Like fresh bed sheets!

Creative Invitation: Scents and Sensibility
Media: Crayons, pastels or Inktense sticks

Gather some art materials and head for a green space. I like to take a hot flask of tea along too — maybe something scented and herbal would be an apt choice for today. Once you've arrived at a comfortable spot, begin tuning in to your sense of smell.

Perhaps you detect an overall ambient scent: it could be the beetrooty smell of earth after rain, or the delicious toffee smell of woods in autumn. It might even be mushrooms and firs. There's a close relationship between color and feeling, so scribble with your colors to record your emotional responses to the smells. Get curious and get specific. Embark on a scent trail: what does the bark of that nearby gnarly tree smell like? How about the earth around its roots? And what about the leaves of the creeper that winds delicately around its trunk?

Go for a wander to seek out new scents. If you're out in a wild space and you see a plant you don't recognize, bear in mind that it could possibly be poisonous, but if you're confident the plant is something you know and there's an abundance of it around, pick a leaf and crush it between your fingers to get a really rich, zingy scent. Don't be afraid to press your nose down to the earth or get up close and personal with a tree. To elicit a stronger smell, it can help to give the bark a vigorous rub or pick up a handful of soil and warm it in your palms.

Questions for reflection:
How has this exercise affected how you feel? What emotions, physical sensations and thoughts are you experiencing now? Do you think there are any changes in your mental/emotional state created by the focus on smelling, or by certain specific odors?[9]

Feather: animal, musty, like farmyards and eggs

Tree bark: (I don't know the species: quite simple, savoury, bland, yeasty like bread

Bramble leaf: Lemony but also sweet like blackcurrant

Ivy leaf (crushed between fingers) Sharp, intense, heady, fresh, intoxicating (possibly a tiny bit toxic?) Hints of lemon, pine. a very rich scent!

Day 4
Touch

Touch is our very first sense. At just eight weeks from conception, the sense of touch begins to form inside the womb. Some say it is our most important sense — our primary conduit of pleasure and pain. While researching this book, I fell down a rabbit-hole of fascinating findings on touch and texture. Psychologists at Harvard and Yale discovered that the texture of an item can influence how a person thinks or even makes decisions. In one experiment, participants touched either a soft blanket or a hard block of wood. Those who felt the hard block rated an employee in a boss-employee interaction as being more rigid or unyielding (although they did not view the employee more negatively.) [10]

Meanwhile, quite astonishingly, researchers at Berkeley have proven that compassion, anger, love, and fear can be communicated through a one-second touch on the arm from a stranger concealed behind a barrier. They built a barrier in their lab that separated two strangers from each other. One person stuck their arm through the barrier and waited. The other person was given a list of emotions, and they had to convey each emotion through a one-second touch to the first person's arm.

The person whose arm was being touched was asked to guess the emotion. "Given the number of emotions being considered, the odds of guessing the right emotion by chance were about eight percent," writes professor of psychology, Dacher Keltner. "But remarkably, participants guessed compassion correctly nearly 60 percent of the time. Gratitude, anger, love, fear — they got those right more than 50 percent of the time as well." [11]

I'm curious as to whether when we touch non-human living beings, such as trees, we might also be exchanging feelings. I wonder, is communication between ourselves and other life forms happening all the time, even if we are not conscious of it? Today, I invite you to explore your sense of touch and your experience of texture, and notice what is being communicated, from you and to you.

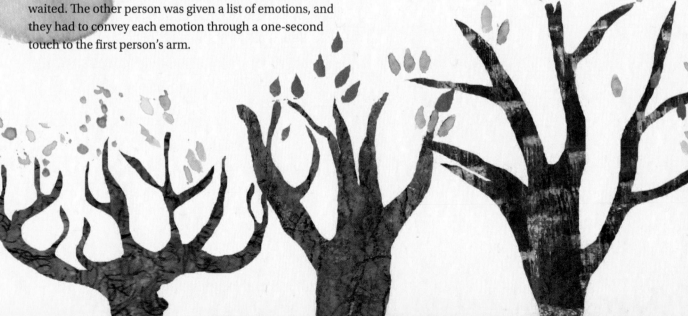

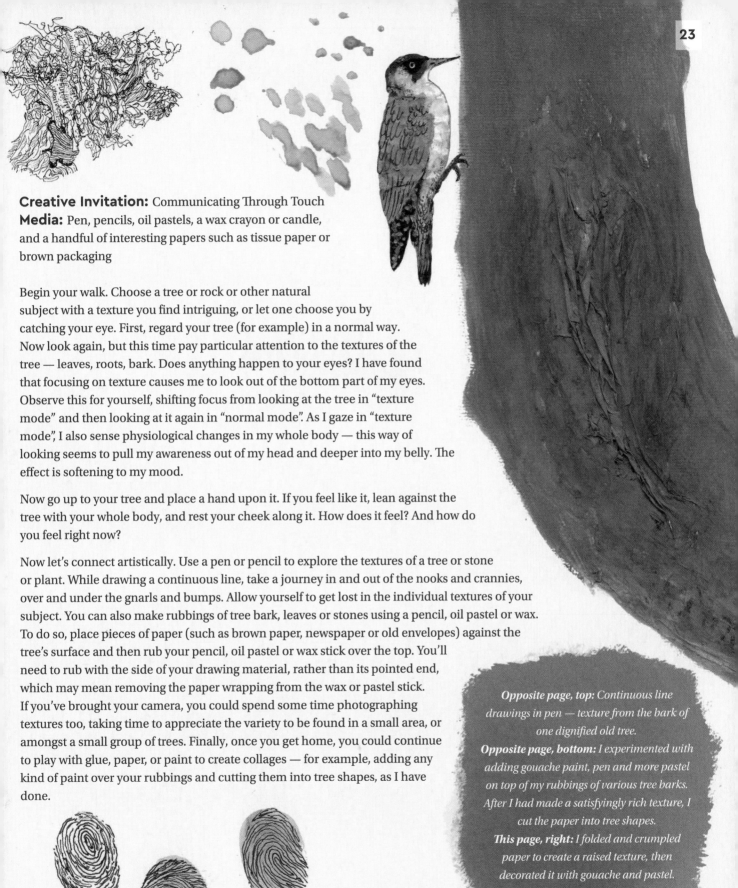

Creative Invitation: Communicating Through Touch
Media: Pen, pencils, oil pastels, a wax crayon or candle, and a handful of interesting papers such as tissue paper or brown packaging

Begin your walk. Choose a tree or rock or other natural subject with a texture you find intriguing, or let one choose you by catching your eye. First, regard your tree (for example) in a normal way. Now look again, but this time pay particular attention to the textures of the tree — leaves, roots, bark. Does anything happen to your eyes? I have found that focusing on texture causes me to look out of the bottom part of my eyes. Observe this for yourself, shifting focus from looking at the tree in "texture mode" and then looking at it again in "normal mode". As I gaze in "texture mode", I also sense physiological changes in my whole body — this way of looking seems to pull my awareness out of my head and deeper into my belly. The effect is softening to my mood.

Now go up to your tree and place a hand upon it. If you feel like it, lean against the tree with your whole body, and rest your cheek along it. How does it feel? And how do you feel right now?

Now let's connect artistically. Use a pen or pencil to explore the textures of a tree or stone or plant. While drawing a continuous line, take a journey in and out of the nooks and crannies, over and under the gnarls and bumps. Allow yourself to get lost in the individual textures of your subject. You can also make rubbings of tree bark, leaves or stones using a pencil, oil pastel or wax. To do so, place pieces of paper (such as brown paper, newspaper or old envelopes) against the tree's surface and then rub your pencil, oil pastel or wax stick over the top. You'll need to rub with the side of your drawing material, rather than its pointed end, which may mean removing the paper wrapping from the wax or pastel stick. If you've brought your camera, you could spend some time photographing textures too, taking time to appreciate the variety to be found in a small area, or amongst a small group of trees. Finally, once you get home, you could continue to play with glue, paper, or paint to create collages — for example, adding any kind of paint over your rubbings and cutting them into tree shapes, as I have done.

Opposite page, top: Continuous line drawings in pen — texture from the bark of one dignified old tree.
Opposite page, bottom: I experimented with adding gouache paint, pen and more pastel on top of my rubbings of various tree barks. After I had made a satisfyingly rich texture, I cut the paper into tree shapes.
This page, right: I folded and crumpled paper to create a raised texture, then decorated it with gouache and pastel.

Day 5
See in Color

We really don't need scientists to tell us that a vibrant color can lift our mood. As I write, spring is slowly emerging outside the window and I'm thirsty for those bright splashes of yellow — daffodils and celandines — popping up amongst the muted browns, grays, and greens of a long English winter. It feels like I'm drinking up a potion of hope — summer is coming!

In Ancient Greece and Egypt, healers regularly used color as medicine, prescribing colorful flowers, minerals, and salves, painting sanctuaries in carefully chosen tints, and recommending the wearing of clothes in specific hues to restore balance and treat disease. Nowadays, we have color therapists offering similar remedies. A recent scientific study found that color can impact the effectiveness of a drug, or even function as a drug by itself: red, yellow, and orange placebo pills were associated with a stimulant effect, while blue and green medicines were related to a tranquilizing effect.[12]

Tip:
There's no need to color between the lines. In fact, I encourage you to do the opposite — splosh it around, let one color run into another, and leave gaps of white paper to suggest sparkling light. Make sure you mix your watercolor very thoroughly with plenty of water before you begin: your solution should have the consistency of water with no sticky, lumpy or dry particles in it.

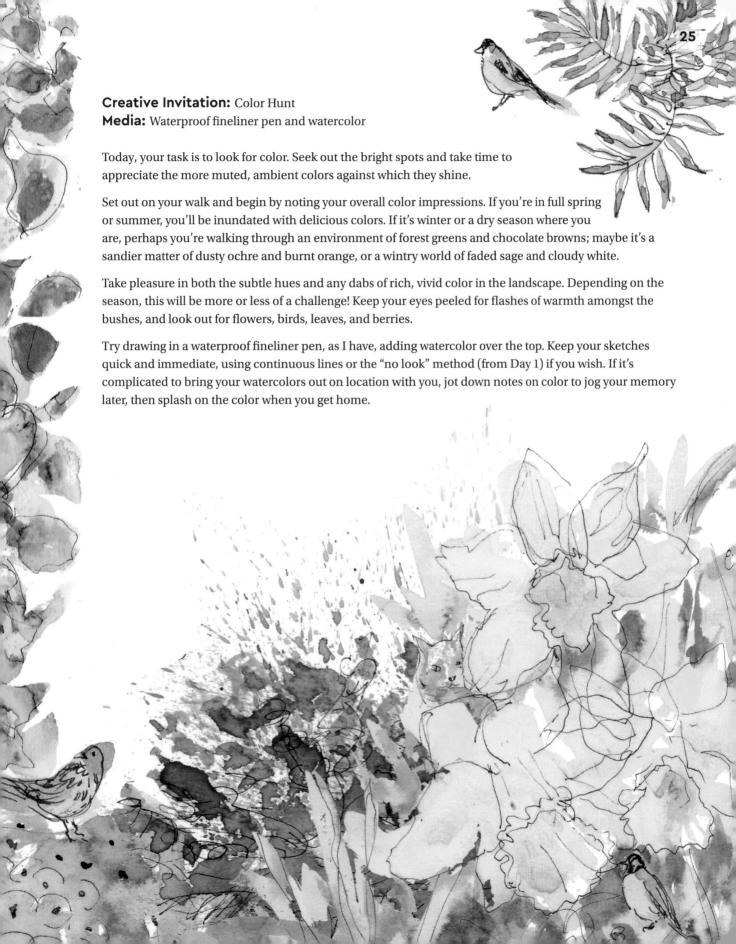

Creative Invitation: Color Hunt
Media: Waterproof fineliner pen and watercolor

Today, your task is to look for color. Seek out the bright spots and take time to appreciate the more muted, ambient colors against which they shine.

Set out on your walk and begin by noting your overall color impressions. If you're in full spring or summer, you'll be inundated with delicious colors. If it's winter or a dry season where you are, perhaps you're walking through an environment of forest greens and chocolate browns; maybe it's a sandier matter of dusty ochre and burnt orange, or a wintry world of faded sage and cloudy white.

Take pleasure in both the subtle hues and any dabs of rich, vivid color in the landscape. Depending on the season, this will be more or less of a challenge! Keep your eyes peeled for flashes of warmth amongst the bushes, and look out for flowers, birds, leaves, and berries.

Try drawing in a waterproof fineliner pen, as I have, adding watercolor over the top. Keep your sketches quick and immediate, using continuous lines or the "no look" method (from Day 1) if you wish. If it's complicated to bring your watercolors out on location with you, jot down notes on color to jog your memory later, then splash on the color when you get home.

Day 6
See in Line

Today, we'll attune to the lines of the land. Begin by taking a walk (or engaging with nature in your preferred method) as usual. Think of yourself as a paintbrush, creating a line across the landscape as you move. Notice the trails already traced across the earth, both close by and far away, natural and human-made, formed from animal tracks, hedgerows, ditches, and pathways. Follow the curves and grooves — the natural tracks made by weather patterns or by small creatures. How does your path intersect or echo the lines already visible? What about the lines growing all up, around, and across your path? See how the tangle of weeds forms an ornamental design of interlacing lines. Observe the bold strokes painted by tree limbs silhouetted against the sky. Note the delicate arabesques made by tiny plants trembling in the wind, rooted firmly as dancers.

Badger Lines and Human Lines: In his book *Linescapes*, author Hugh Warwick investigates the lines we humans have drawn across the country. Lines that were originally built by humans to divide, to assert ownership and contain livestock, have, over time, become homes and thoroughfares for nature instead.

"Take time to peer more deeply into a hedgerow, shift your perspective — and find abundance and diversity normally missed," says Hugh, "Or feel the life-holding vibrations of a drystone wall as the lichens slowly inch across the landscape, overtaken by the sneaky speed of a stoat on a mission." What lines can you find? Do you see evidence of rebellious life within the man-made boundaries around you?

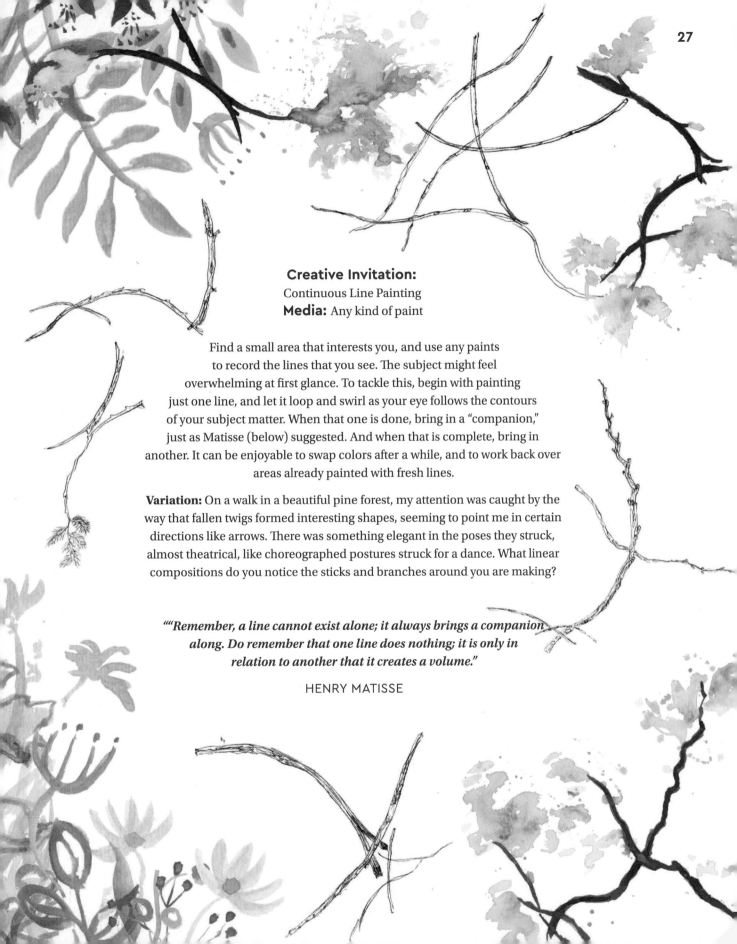

Creative Invitation:
Continuous Line Painting
Media: Any kind of paint

Find a small area that interests you, and use any paints to record the lines that you see. The subject might feel overwhelming at first glance. To tackle this, begin with painting just one line, and let it loop and swirl as your eye follows the contours of your subject matter. When that one is done, bring in a "companion," just as Matisse (below) suggested. And when that is complete, bring in another. It can be enjoyable to swap colors after a while, and to work back over areas already painted with fresh lines.

Variation: On a walk in a beautiful pine forest, my attention was caught by the way that fallen twigs formed interesting shapes, seeming to point me in certain directions like arrows. There was something elegant in the poses they struck, almost theatrical, like choreographed postures struck for a dance. What linear compositions do you notice the sticks and branches around you are making?

""Remember, a line cannot exist alone; it always brings a companion along. Do remember that one line does nothing; it is only in relation to another that it creates a volume."

HENRY MATISSE

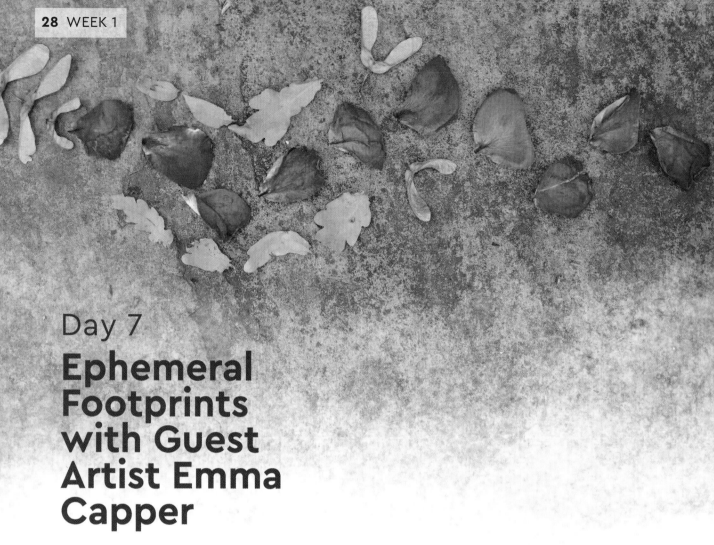

Day 7
Ephemeral Footprints with Guest Artist Emma Capper

Emma Capper is an expressive artist, craftswoman, and nature and forest therapy guide. In 2013 she founded her company, Creative Journeys in Nature, weaving her love of art and nature together to create woodland walks which connect people with their innate creativity and the world around them. I joined Emma for one of her artistic workshops in the woods, and later we shared some one-to-one time wandering together through sun-kissed meadows and ancient oak forest on one of the first sunny days of spring.

Emma reflects how spending time wandering in nature can offer her a different perspective: "I find my thoughts flow easier as I move along, and the beings I meet on the way offer their insights when I pause to listen."

We spent time consciously pausing, listening, and dropping into the deep relaxation that comes from tuning in to the forest. "Creativity arises effortlessly in a space of relaxed play," Emma says, and "when we take time to stop and tune in to our natural world through our senses, we find an abundance of awe-inspiring creativity in action."

Once we had eased into the slower pace of the woods, we did a bit of investigating, finding ourselves drawn towards the snaking roots of a holly tree, and enjoying the kaleidoscopic patterns and colors of a fallen leaf. "Investigation is a kind of play," Emma explained. "Try something out and see how it feels. This play naturally evokes our imagination, which is the root of creative thinking." I asked Emma to suggest an artistic exercise for readers of *Earth Color*, and she playfully invited me to make some "footprints" with her right there, using the path we stood on as our materials and canvas. Here is the creative invitation she offers to you to try.

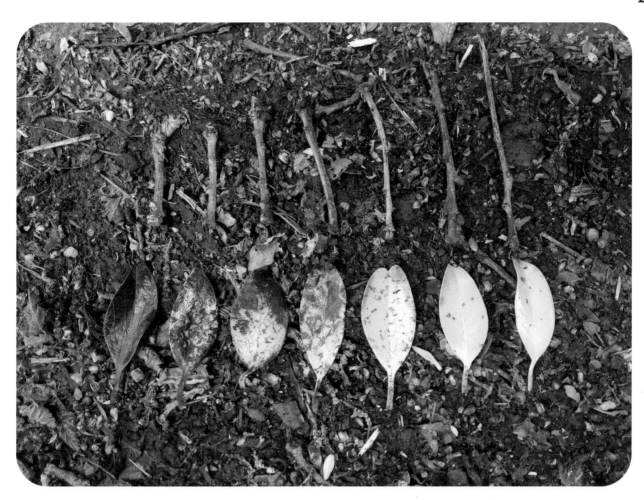

Creative Invitation: Ephemeral Footprints
Media: Whatever you find at your feet

As you wander in forest, park or garden, let your eye be caught by the tiny treasures underfoot — a mottled leaf, a yellow petal, a mossy twig, or a curling snail shell. Collect a few items within a one meter radius of your feet. Arrange them in a composition that pleases you. Take a few steps forward and repeat. Now repeat again. Leave a trail of "ephemeral footprints" behind you for the next walker to discover and enjoy!

"As an artist, I have always found time in the natural world to be my chief muse and refuge. I have learnt how miserable and lost I can become without my daily dose from Mother Nature."

EMMA CAPPER

Photos by Emma Burleigh.

WEEK 2
Earth

What does it mean to be grounded? What do we mean when we say someone is "down to earth" or has an "earthy" sense of humor? When we use metaphors of earth and ground, we describe a person who feels present in their body and at ease with the solid, material realm. Perhaps they are also known for making the kind of jokes that celebrate the more "disgusting" processes of the body and nature! Like a well-rooted tree, a grounded person stands centered and unshakeable no matter what wild winds are blowing around their heads. Conversely, an "ungrounded" person may feel more like a leaf in the wind, vulnerable to getting tossed around since they have nothing secure to sink into.

The qualities of earth are physical, heavy, and solid, and earthy colors lie in the denser range of black, brown, red and ochre. (Red is the slowest of all the wavelengths within the visible color spectrum.) In the Hindu/Yogic chakra system, this is the domain of the root chakra, which is concerned with stability, security, and our most basic physical and emotional needs.

This week, we'll find artistic ways to connect with the earth that supports us to meet our deep, foundational needs for nurture, grounding and stability.

orange ochre

radnor tan

brown ochre

clay green

"You speak like the very spirit of earth, imbued with a scent of freshly turned soil."

NATHANIEL HAWTHORNE

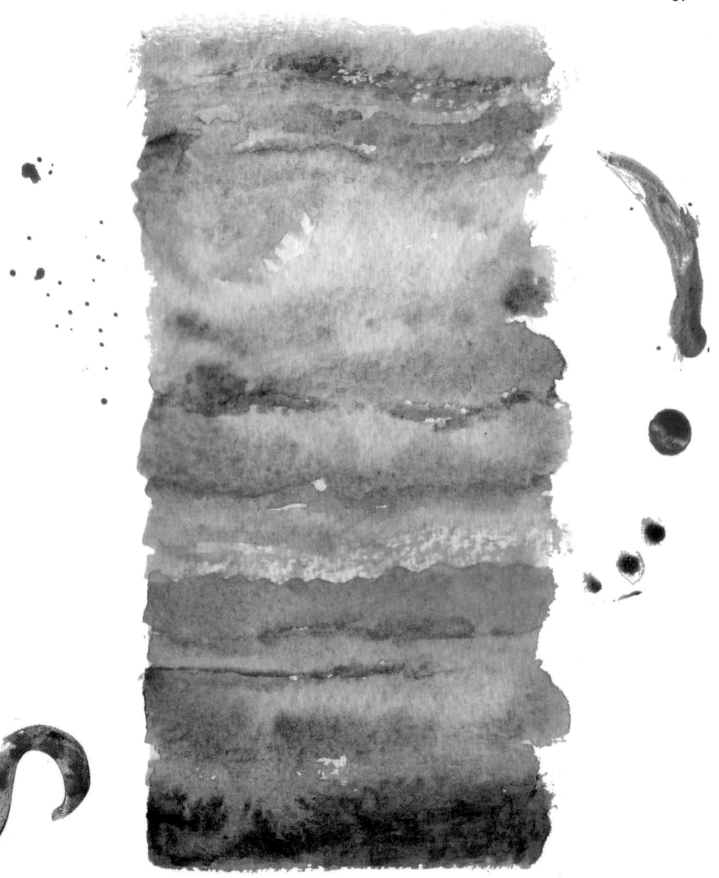

Day 1
Grounding

When I think about being "grounded", I recall a meditation teacher I was impressed by. Several times I observed first-hand her ability to remain centered and balanced despite a maelstrom of mini dramas erupting in real time around her. I once witnessed her simultaneously dealing with her broken-down car, a full room of seventy waiting students, and her two stressed-out, crying children, with complete and genuine composure. She told me that she had developed the art of being like a skittle or bowling pin, keeping her center of gravity low to the ground: you can hit her with an unexpected curveball and she'll wobble, she said, but she'll soon re-center and right herself smoothly.

This same teacher advised me to work on becoming more present in my body by walking barefoot on the earth. At that time, I was easily thrown off-balance and felt lost, as if I was drifting through life. Over the years I've learned to practice consciously grounding myself through walking in nature, feeling the earth meet the soles of my feet. When I first brought my attention to the sensation of foot meeting earth as a kind of walking meditation practice back in my early twenties, I was amazed to discover that I was habitually withholding my full weight from the ground: my feet were tensed up as if they believed we were walking on eggshells!

When we feel well grounded, we are like big, strong trees that trust the earth and have put down deep roots. If something happens around us, it doesn't shake us too much and we can continue to feel stable in our daily life. Today, we'll focus on developing this sense of groundedness and connection to the earth in our own bodies, and we'll spend some time learning from the trees, stones and other beings in nature who already know how to do this so well.

As you begin your walk today, notice what "earths" you. What feels solid, supportive and grounding in the environment? Pay attention to the sensation of the ground under your feet, holding you up. Practice giving your full weight to the earth with each step you make. Recognize how the ground is always there for you. If it's warm and safe enough, walk barefoot.

As you continue your walk, look around and ask yourself what makes you think of support. What embodies graceful stability? What emits a calm and steady energy? What is offering you a sense of security? Perhaps you come across an ancient tree, a comforting blanket of leaves on the forest floor, a sturdy log to rest on, or a rock that expresses immovable, timeless strength. Relax your back against a tree or lie down and surrender your whole body to the ground. Breathe in the scent of the earth — the root chakra is associated with the sense of smell.

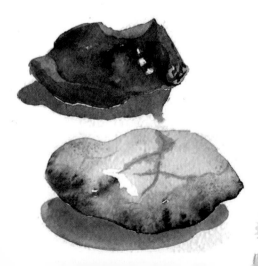

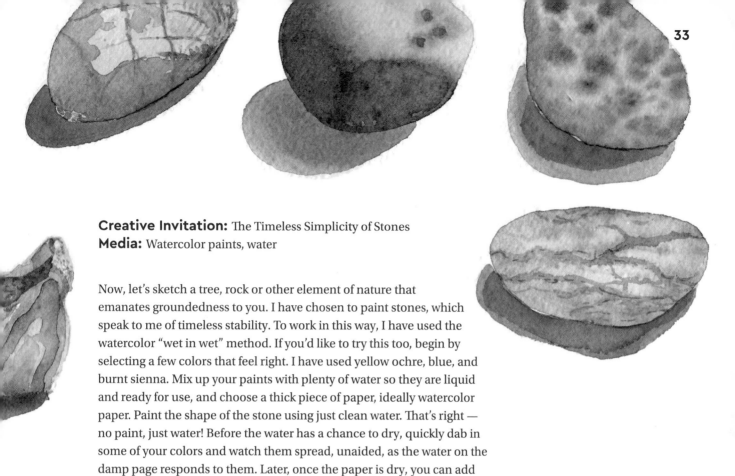

Creative Invitation: The Timeless Simplicity of Stones
Media: Watercolor paints, water

Now, let's sketch a tree, rock or other element of nature that emanates groundedness to you. I have chosen to paint stones, which speak to me of timeless stability. To work in this way, I have used the watercolor "wet in wet" method. If you'd like to try this too, begin by selecting a few colors that feel right. I have used yellow ochre, blue, and burnt sienna. Mix up your paints with plenty of water so they are liquid and ready for use, and choose a thick piece of paper, ideally watercolor paper. Paint the shape of the stone using just clean water. That's right — no paint, just water! Before the water has a chance to dry, quickly dab in some of your colors and watch them spread, unaided, as the water on the damp page responds to them. Later, once the paper is dry, you can add fine details in pen or paint.[1]

Day 2
The Hues of the Earth

Many thousands of years ago, our ancestors stencil-graffitied around their hands and blew earth pigments through bones onto the walls of their caves. We've been painting with substances sourced from the earth ever since, and many of us still love to use them. That said, "earth colors" do present as rather drab to the uninitiated eye, and so they tend to be the last tubes to run out in the average paint set, or the final crayons left in that pack where the red has worn down to a stump.

The earth colors you're most likely to find in your art kit will be the romantic quartet of raw sienna, yellow ochre, burnt sienna, and burnt umber. Raw sienna is a delicious, soft golden-toffee color, while yellow ochre bathes everything in a warm glow, like sunshine. As you may have guessed, sienna, evocative of sun-drenched Italian soil, was originally sourced from Siena in Tuscany. The sienna mines are empty now and it's produced synthetically, but some pigment is still taken from Sicily, Sardinia, and the Lehigh Gap in Pennsylvania. (If you want to know if your earth colors are made of the real thing, look for the pigment number: if genuine, it will say PBr 7.)

From the 19th century onwards many of our paints have been produced synthetically. Labels on art materials don't usually provide us with information about how they were made: it's almost impossible to find out about the origin of the raw materials, under what conditions they were extracted or produced, or what impact the manufacturing process has had on our environment. That's not to say synthetic production is necessarily worse than digging raw materials out of the earth, but we often don't know how our paints are made at all, and this in itself is a cue for a new way of doing business which reconnects us with nature.[2]

Creative Invitation: Explore Your Earth Palette
Media: Everything you have!

On your walk today, pay particular attention to the colors of
the earth, and the earthier colors around you. Look closely
at soil, stones, rocks, fungi and wood. Bring a range of art
materials and a sketchbook with you, or photograph and
make notes about the colors you see to jog your memory
when you get home. At home or at a comfy "sit spot" outside,
explore the potential of the earthier colors in your art
supplies, experimenting with a range of different materials.
You could try wet media such as gouache, ink, or watercolor,
dry media such as pastels or pencils, or collage materials
including ripped cardboard and brown packing paper. Enjoy
the rich range of hues that can be expressed within this
"limited" palette.

Tip: Don't feel you have to stick exclusively to your
earthiest colors; adding some vibrant dabs of orange,
blue, violet or red can really add some extra zest.
You might be wondering what counts as an "earth color"
anyway — it's a grey-brown area and I'd include black
and white within it. Cave artists used pigments from the
ground including red ochre, yellow ochre and umber,
along with charcoal from the fire (carbon black), burnt
bones (bone black) and white from ground calcite (lime
white). Involve whichever colors feel earthy to you.

Day 3
Forage For Your Paint

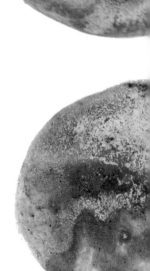

Yesterday, you explored the earth colors in your palette of personal art materials. But what about creating a palette directly from the earth itself?

If you happen to live near earth artist Jackie Yeomans, in North West Wales, you might see her heading up a hillside mysteriously equipped with a shovel and some small containers. Later you might spy her scrambling up a ridge, disappearing down a crevice, or digging down through layers of sediment.

Jackie forages for soil, keeping a keen eye out for a glimpse of iron-rich red mud at the base of a Welsh mountain, or some "Nash Ash Green" dirt between the upended roots of a fallen tree. She is careful to collect her many-hued samples thoughtfully, leaving no trace of human disruption.

Jackie tells me that the process of making her paints, which she does herself by hand, is "slow and physically engaging." Processes of refining, drying, grinding, sieving, and "mullering" are followed by layering paint into pans (with four days between each layer to prevent shrinkage), and a final two weeks of curing before they are ready to use. You can see a painting I made with Jackie's paints on the title page for this Week. On this page, I have made my own paints using various samples of soil collected from the area where I live, using the simplest possible method — just mix earth with water!

Playing with mud is really good for you! Recent research in Finland showed children who played with soil every day for a month developed significantly improved immune systems, including increased T-cells and a greater diversity of intestinal microbiota. The experiment involved planting up an urban playground with earth, grasses, heather and blueberries, to mimic a forest floor, then inviting children at a daycare center to play there every day. The results compared favorably to those of a control group of kids who continued to play in a concrete yard. The study supports the idea that contact with nature is linked to a well-functioning immune system.[3]

Creative Invitation: Make Your Own Earth Paints
Media: The earth

The process by which Jackie makes her beautiful paints is time consuming and quite complex, but she invites people to make paints from local soil in her workshops using a more straightforward procedure.

Begin, as always, by taking a walk. Bring a small trowel or find a stick for digging and take a few little containers along with you. On your walk, pay close attention to the ground. Do you notice any changes in color underfoot? Are there any places where a deeper layer of earth has been exposed, perhaps by land slippage, or the falling of an old oak? Does the soil change nearer to water, becoming denser like clay, or does it seem richer and darker in the heart of the forest? Aim to collect a few small samples to work with, each foraged from a different area.

At home or at a sit spot, add some water and, if you wish, a few drops of oil to help the soil particles bind together. Linseed oil is ideal but any vegetable oil you have at home will do. You could also try painting without any oil — just smear the earth directly onto paper to stain your page with color.

Historians hypothesize that cave artists applied paint by brushing, smearing, dabbing, and spraying. Marks were made with hands, twigs, and pads of lichen or moss. Jackie engages with her work in a very visceral way too, often painting with her fingertips. How does it feel to use your fingers, your hands, or even your whole body? Could you try smearing and dabbing with natural "brushes" made from sticks, leaves, and moss? Could you paint on a natural surface such as a wall of rock, a stone, or your own skin?

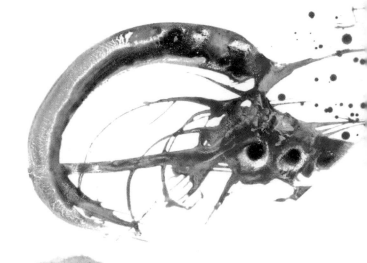

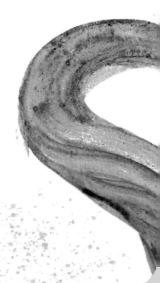

Making my own paints has made me more sensitive to the variety of colors that can be found in soil, which has piqued my interest. What accounts for these changes in pigment? The color can tell us about the presence of certain minerals in the ground — for example, red soil contains iron oxides; glauconite makes the soil look greenish; calcite can cause it to appear white; black earth may indicate manganese oxide, or charcoal, or very rich organic content.

Day 4
Earth Protectors with Guest Artist Jackie Yeomans

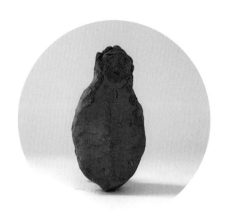

Artist Jackie Yeomans makes "seed protectors": tiny clay creatures each containing a seed tucked deep inside their heart. She places them outside in nature where they can break down gradually, releasing the seeds hidden inside to take root when the time is right. Reminiscent of Japanese netsuke, these earthy little "seed protectors" evolved in an organic way for Jackie. To begin with, she found herself making tiny votive objects out of clay and leaving them to decay naturally in beautiful spots she chose for them on her regular walks. They took form as emotional responses to tragic news of the terminal illness of her sons' father, Richard: "The making of the guardians nurtured my grief through the process of Richard dying. The clay in my hands absorbed my feelings and transferred them into each character, as they grew in their own unique way."

Around this time, Richard gifted Jackie his extensive collection of rare garden seeds. Jackie was ready to begin a new creative project and had been seeking inner guidance on what direction to take. Suddenly, "the choice became clear" she says, as the gift of the seeds showed her that the most important thing is to celebrate "the gift of life" and to care for "the seed of creation." To Jackie, seeds bring "healing and hope for the continuance of life." "I am also grateful," she adds, "that I had the opportunity to share my project with Richard before he died, and he loved it."

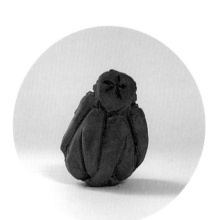

Questions for reflection:

Consider the universal cycle of life, death, and regeneration. In order for a seed to grow, its guardian must "die". As time goes on, the protective shell must fall away and release the seed so it can take root and flourish. Are there any parts of you that need to "die" to allow something else to flourish? Can you sense when the time is right for that "tough shell" part to let go, or whether its job is not quite done?

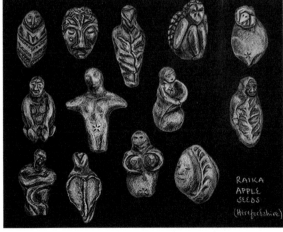

We talk about having the "seed of an idea." For something new and hopeful to happen, something which transcends our default programming, we must first imagine it. Charles Eisenstein points to this when he writes about the leading concept for his book, The More Beautiful World Our Hearts Know Is Possible. Consider how nurturing both the seeds of plants, and our own seeds of creativity, contribute to a more vibrant and life-affirming ecology.

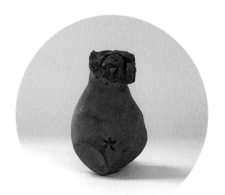

Creative Invitation: Clay Seed Protectors
Media: A large handful of clay or items found in nature

Is there a seed, actual or metaphorical, that you would like to protect? Do you have a wish for yourself, for another, or for the whole world that you would like to nurture? Is there something vulnerable inside you that needs to be recognized, valued, and carefully guarded?

Once you have found this inner seed, write or draw something to symbolize it, and then press this little slip of paper into the heart of a ball of clay for safekeeping. If you prefer, you could use an actual seed rather than paper, either to represent something inside you, or simply because a seed is precious for being itself. Begin to mold the clay, letting it form shapes and textures through the action of your hands. Let the clay absorb your feelings and show you what it wants to become.

If you don't have clay, while out walking you may be able to find some natural clay or sticky and malleable mud. Alternatively, find something from nature's own wealth of shielding containers: an acorn case, a conker shell, or a "mermaid's purse" from the beach. Or, make your container by weaving or twisting a bundle of grasses, leaves, and mud to construct a nest for your own delicate "eggs".

Take your guardian with you on your next walk. Find a place to leave it where it can decay peacefully. Trust that it will release your seed when the time is right for it to grow. Walk away knowing you have left your seed in the capable care of a protector.

"The idea is to create an object that is not intended to last; an ephemeral figurine whose purpose is to momentarily protect the seed. The guardian is, yet becomes more than, a metaphor. Seeds are continually under threat of being reduced to small, and patented, genetically modified agricultural varieties. Seeds are our heirlooms, our gifts from nature; they need saving, sharing, and tending to, for continuing abundance. We each can play a part in their protection."

JACKIE YEOMANS

Opposite page: Clay protectors and sketch of seed guardians by Jackie Yeomans. This page: Image by Emma Burleigh

Day 5
Roots, Rhizomes, Ancestors

The roots of a tree, unseen below the ground, are up to five times more extensive than the canopy overhead. We human beings, as a species and as individuals, have roots wide and deep, too. We are rooted in family histories, cultural lineages, biology and DNA, and, if we are lucky, a sense of place. Seminal psychologist Carl Jung compared the human psyche to an ancient rhizome, or root, from which the mind of the "modern man" sprouts like a fresh green shoot. He believed that it was worth digging down to the level of the rhizome to find out what the "two-million-year-old man" has to say. The best way to get in touch with this natural, ancient mind that forms the bedrock of who we are, he said, is to pay attention to our dreams.

A dream-like painting by the Mexican artist Frida Kahlo comes to mind. *Roots*, painted in 1943, shows Kahlo lying on a barren landscape. Pouring from her heart are green plants, flourishing and vibrant, springing out across the parched earth as if ready to take root and nourish the soil. At a time when Europe was a war-ravaged mud-scape of dead bodies and blasted tree stumps, Kahlo's image seems, to me, to reveal something hopeful about the capacity of the human heart, suggesting it can become a fertile ground in which healing can flourish and life can grow. This painting also strikes me as a reminder of the power of relationship: we are always in relationship with the land, and the Earth will respond to our love and our compassionate care.

"I have been taught that I must look pretty and be nice. I am valued when I display my intelligence and confidence out in the world. I am welcomed in its institutions and organizations as long as I dress appropriately and control myself. I must control my sensitivity and the grief I feel when I experience the abuse of my body's wisdom and that of the Earth. I must control the rage I feel when I see the natural force of life trampled and distorted in the name of rules. I must sanitize my bloody mess, hide all chaos and decay. Control. I must control, so that nothing unexpected happens.

If, on the other hand, I withdrew my power from all the efforts to control it, and let it flow through my body, I would roar like a lioness. My womb would sprout roots running down my legs, through my feet and into the ground. I would delight in visions of snakes, mud, and roots swirling together to create an intimacy of dark love."

AGATA KRAJEWSKA

Creative Invitation: Explore Your Roots
Media: Brown paper, charcoal, mud, or whatever earthy substance you choose

While you walk, search for interesting roots. Some old trees have incredible rooty systems just visible above the earth. Muse on this theme of roots and respond visually. I have used reddish-colored earth and natural charcoal, found amongst the roots I drew, on a piece of brown packing paper. You could do something similar, working on a rough, textured paper with charcoal, conte, or pastel, and any pigments you find in the landscape. Alternatively, you could take photographs, or work from your imagination and memory more symbolically, like Frida Kahlo.

Questions for reflection:

Where do your own roots lie? Do your roots extend into several lands, families and cultures? What are your spiritual, intellectual, emotional and artistic roots? Who influenced you as you grew up? From whom and from what have you drawn nourishment to help you grow?

Do we continue to put down roots throughout our life? If so, what roots are you growing now? Does anything stop you putting down roots — if so what, and why? Roots are for providing stability and for sourcing nourishment: what nourishes you? Where might you find healthy soil to put down new roots?

Are you a fertile soil for others to take root in — human or other-than-human? Who do you care for, who do you feed, and what would you like to nurture and grow in this life going forward? What can you sink into to strengthen your sense of belonging and security? Where lies a strata of good soul food for you?

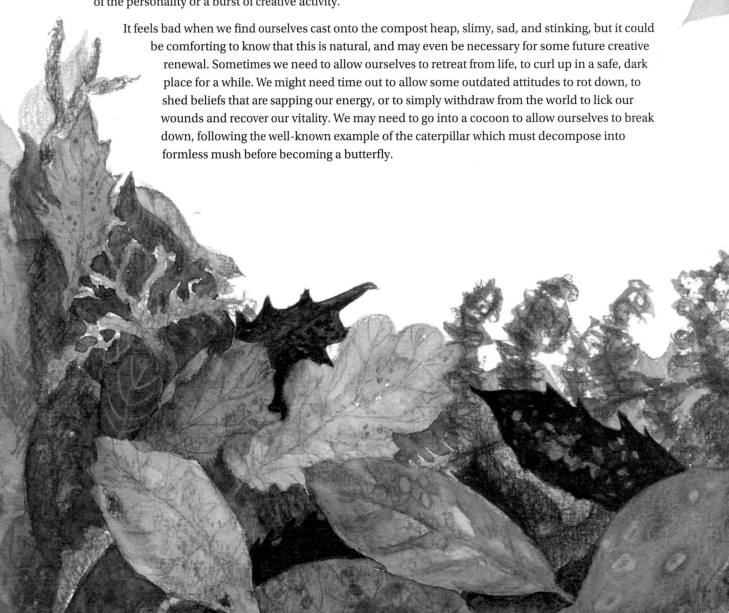

Day 6
Going Underground

Nature can be relied on to bring us "down to earth." Just one glance towards our feet reminds us we are in a continuous cycle of life and death — for every flower that bursts into joyous color, another is rotting down, slimy and smelly, albeit delicious to slugs. "Putrefactio" is a term Jung used to describe the composting process that also occurs in the human psyche. There are times in our life, and perhaps even phases of each month, when we'll feel the instinct to retreat, lie low, and mulch down into darkness.

Jung spoke about a "darkening of consciousness" which is experienced as a depression, a feeling of being pulled downward. He considered this kind of depression to be potentially fruitful, foreshadowing a renewal of the personality or a burst of creative activity.

It feels bad when we find ourselves cast onto the compost heap, slimy, sad, and stinking, but it could be comforting to know that this is natural, and may even be necessary for some future creative renewal. Sometimes we need to allow ourselves to retreat from life, to curl up in a safe, dark place for a while. We might need time out to allow some outdated attitudes to rot down, to shed beliefs that are sapping our energy, or to simply withdraw from the world to lick our wounds and recover our vitality. We may need to go into a cocoon to allow ourselves to break down, following the well-known example of the caterpillar which must decompose into formless mush before becoming a butterfly.

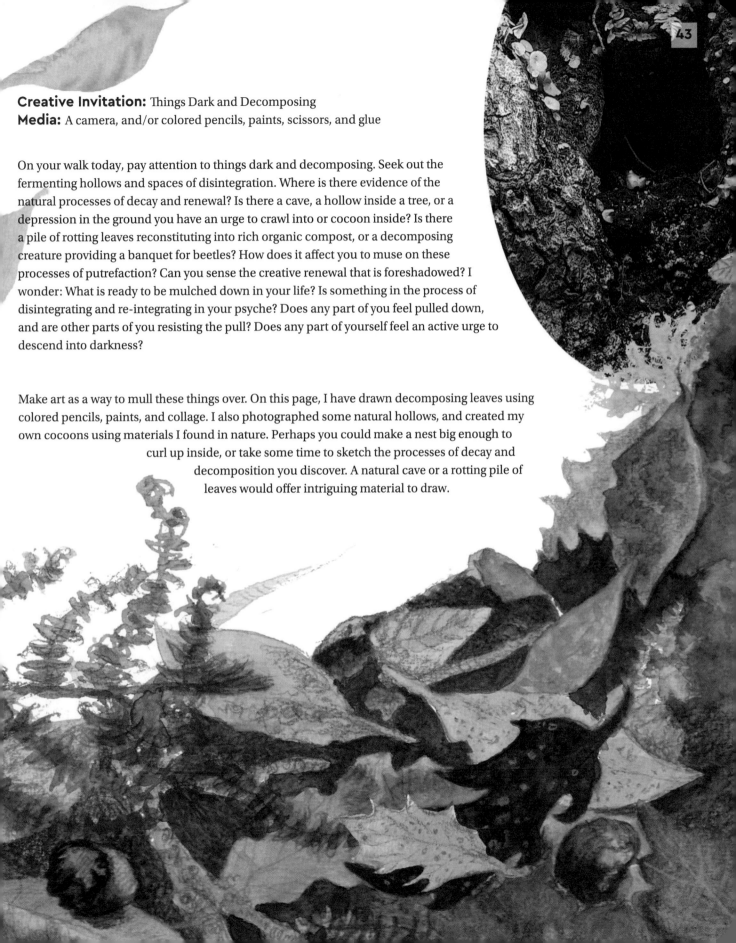

Creative Invitation: Things Dark and Decomposing
Media: A camera, and/or colored pencils, paints, scissors, and glue

On your walk today, pay attention to things dark and decomposing. Seek out the fermenting hollows and spaces of disintegration. Where is there evidence of the natural processes of decay and renewal? Is there a cave, a hollow inside a tree, or a depression in the ground you have an urge to crawl into or cocoon inside? Is there a pile of rotting leaves reconstituting into rich organic compost, or a decomposing creature providing a banquet for beetles? How does it affect you to muse on these processes of putrefaction? Can you sense the creative renewal that is foreshadowed? I wonder: What is ready to be mulched down in your life? Is something in the process of disintegrating and re-integrating in your psyche? Does any part of you feel pulled down, and are other parts of you resisting the pull? Does any part of yourself feel an active urge to descend into darkness?

Make art as a way to mull these things over. On this page, I have drawn decomposing leaves using colored pencils, paints, and collage. I also photographed some natural hollows, and created my own cocoons using materials I found in nature. Perhaps you could make a nest big enough to curl up inside, or take some time to sketch the processes of decay and decomposition you discover. A natural cave or a rotting pile of leaves would offer intriguing material to draw.

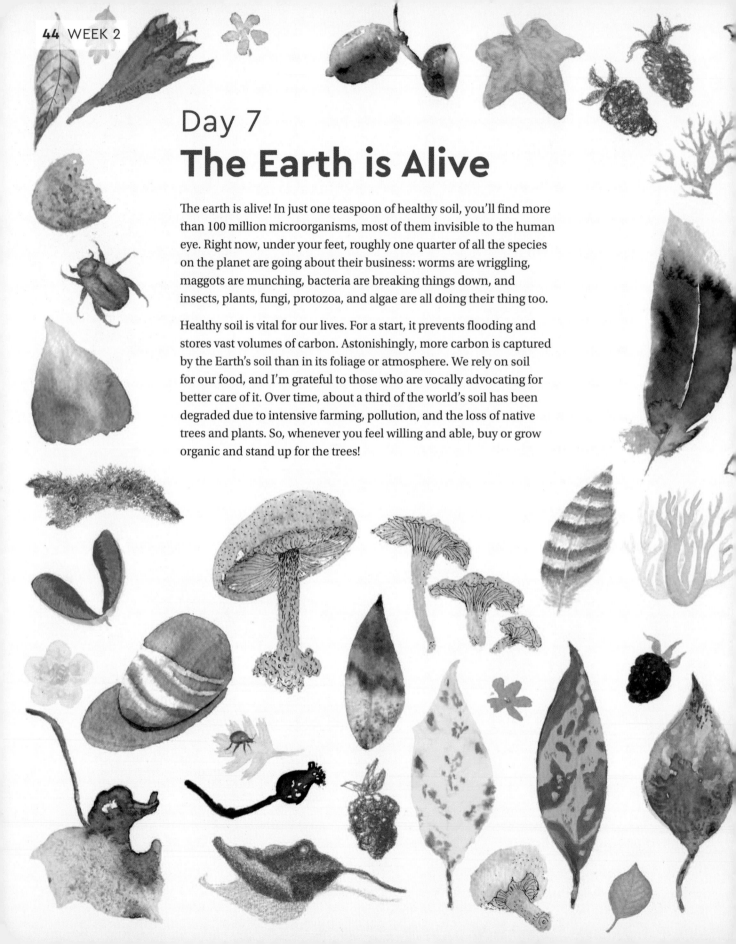

Day 7
The Earth is Alive

The earth is alive! In just one teaspoon of healthy soil, you'll find more than 100 million microorganisms, most of them invisible to the human eye. Right now, under your feet, roughly one quarter of all the species on the planet are going about their business: worms are wriggling, maggots are munching, bacteria are breaking things down, and insects, plants, fungi, protozoa, and algae are all doing their thing too.

Healthy soil is vital for our lives. For a start, it prevents flooding and stores vast volumes of carbon. Astonishingly, more carbon is captured by the Earth's soil than in its foliage or atmosphere. We rely on soil for our food, and I'm grateful to those who are vocally advocating for better care of it. Over time, about a third of the world's soil has been degraded due to intensive farming, pollution, and the loss of native trees and plants. So, whenever you feel willing and able, buy or grow organic and stand up for the trees!

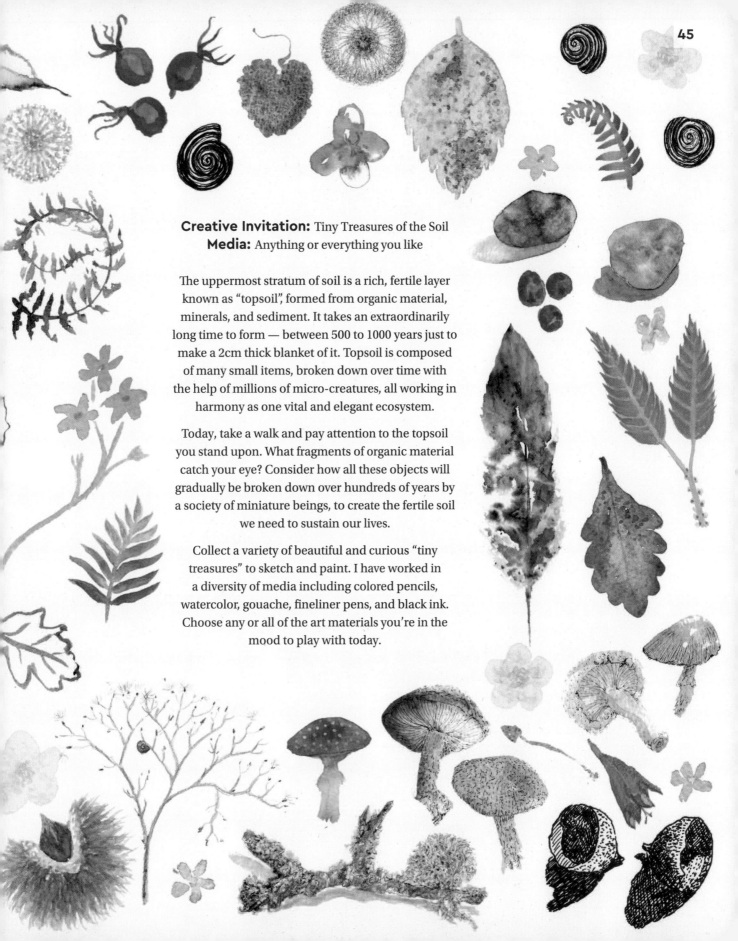

Creative Invitation: Tiny Treasures of the Soil
Media: Anything or everything you like

The uppermost stratum of soil is a rich, fertile layer known as "topsoil", formed from organic material, minerals, and sediment. It takes an extraordinarily long time to form — between 500 to 1000 years just to make a 2cm thick blanket of it. Topsoil is composed of many small items, broken down over time with the help of millions of micro-creatures, all working in harmony as one vital and elegant ecosystem.

Today, take a walk and pay attention to the topsoil you stand upon. What fragments of organic material catch your eye? Consider how all these objects will gradually be broken down over hundreds of years by a society of miniature beings, to create the fertile soil we need to sustain our lives.

Collect a variety of beautiful and curious "tiny treasures" to sketch and paint. I have worked in a diversity of media including colored pencils, watercolor, gouache, fineliner pens, and black ink. Choose any or all of the art materials you're in the mood to play with today.

Rainy Day Bonus Page

If there's a day during this course when you can't get outside, I encourage you to use it to dig deep into your imagination instead.

The soil is full of weird and wonderful inhabitants, and so far, biologists believe they have only identified about 1 percent of them! You can find a brief introduction to a few of the critters we do know something about below.

Here are a few of the microorganisms currently known to humans...

Water Bears (aka Tardigrades): One of the most resilient creatures on Earth, they can survive temperatures below freezing and above boiling, and live for 30 years without food or water. They can even withstand the vacuum of space! Measuring less than one millimeter in size, they consume organic matter and recycle nutrients back into the soil.

Nematodes: Tiny worm-like beings who decompose organic matter and recycle nutrients.

Protozoa: Single-celled aquatic animals who live in tiny particles of water in the earth. They consume bacteria and release nitrogen into the soil in a form digestible to plants.

Bacteria: They decompose organic material, recycle nutrients back into the soil, and convert nitrogen into a form that plants can absorb.

Fungi: These grow underground in web-like strands called mycelium, which over time form vast networks. Fascinatingly, trees and plants use these networks of fungi to communicate with each other in what has been dubbed the "wood-wide-web."[4]

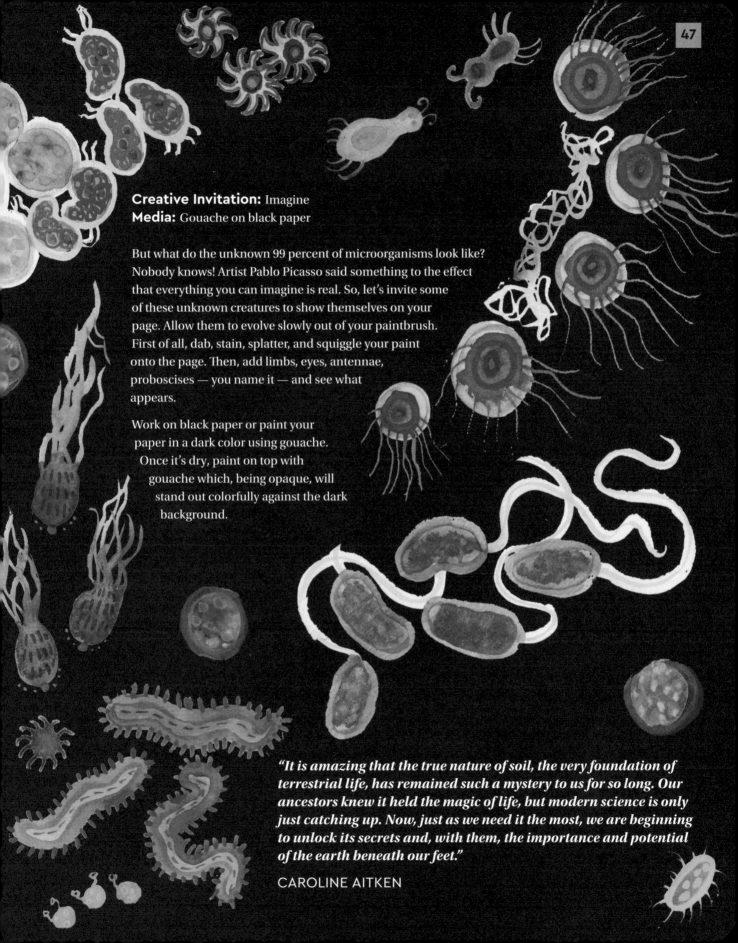

Creative Invitation: Imagine
Media: Gouache on black paper

But what do the unknown 99 percent of microorganisms look like? Nobody knows! Artist Pablo Picasso said something to the effect that everything you can imagine is real. So, let's invite some of these unknown creatures to show themselves on your page. Allow them to evolve slowly out of your paintbrush. First of all, dab, stain, splatter, and squiggle your paint onto the page. Then, add limbs, eyes, antennae, proboscises — you name it — and see what appears.

Work on black paper or paint your paper in a dark color using gouache. Once it's dry, paint on top with gouache which, being opaque, will stand out colorfully against the dark background.

"It is amazing that the true nature of soil, the very foundation of terrestrial life, has remained such a mystery to us for so long. Our ancestors knew it held the magic of life, but modern science is only just catching up. Now, just as we need it the most, we are beginning to unlock its secrets and, with them, the importance and potential of the earth beneath our feet."

CAROLINE AITKEN

WEEK 3
Water

This week, we explore the qualities of water. Receptive, cleansing, and mutable, water flows. It can swell into powerful crashing waves or fall softly in gentle rain. In the tarot, the element of water relates to the suit of Cups, which represent the realm of feeling, empathy, and compassion. The Hindu chakra associated with water is the second, or "sacral" chakra, which is similarly concerned with relationships and the emotional level of consciousness, as well as sensuality and creativity. This week, we'll spend time appreciating water in all its many forms, nurture our capacity for creative flow, and dive into the sea of feeling and connection.

> *"Nothing is softer or more flexible than water, yet nothing can resist it."*
> LAO TZU

Day 1
Follow the Flow

What if water was creative, and could suggest things to you that you could never have consciously imagined or expressed? What if water itself could paint? I sometimes talk about entering into "watercolor mind" as a way of explaining the dance that takes place between myself and the medium of water when I paint. I like the media I work with to be really wet and runny, and I'm attracted to watercolor because it allows the water itself to be so expressive. The water becomes my co-artist, as it puddles and pools in surprising shapes I could not have planned and creates curious patterns and edges as it dries.

Jung associated water with the unconscious mind, and today we'll try a method of working which will allow these waters of the unconscious to flow freely. We'll relegate the planning and controlling part of the mind to the background, in order to make space for some unexpected creations to surface.

You may have already come across ways of working that are designed to encourage images and ideas to flow without interference from the conscious, controlling part of the mind. To explore the inner depths of his patients' minds, psychoanalyst Sigmund Freud used free association and "automatic" drawing and writing. Surrealist artists of that time ran with this idea to develop free-association collages, paintings and poetry. More recently, Julia Cameron recommends the practice of writing daily "morning pages" to allow whatever is on your mind to flow out without censorship. Michelle Cassou shares her method of spontaneous "point zero painting," and Pat B. Allen offers her "studio process," wherein the artist is invited to follow the energetic "lead" of the image. It's all interesting stuff that is well worth exploring.

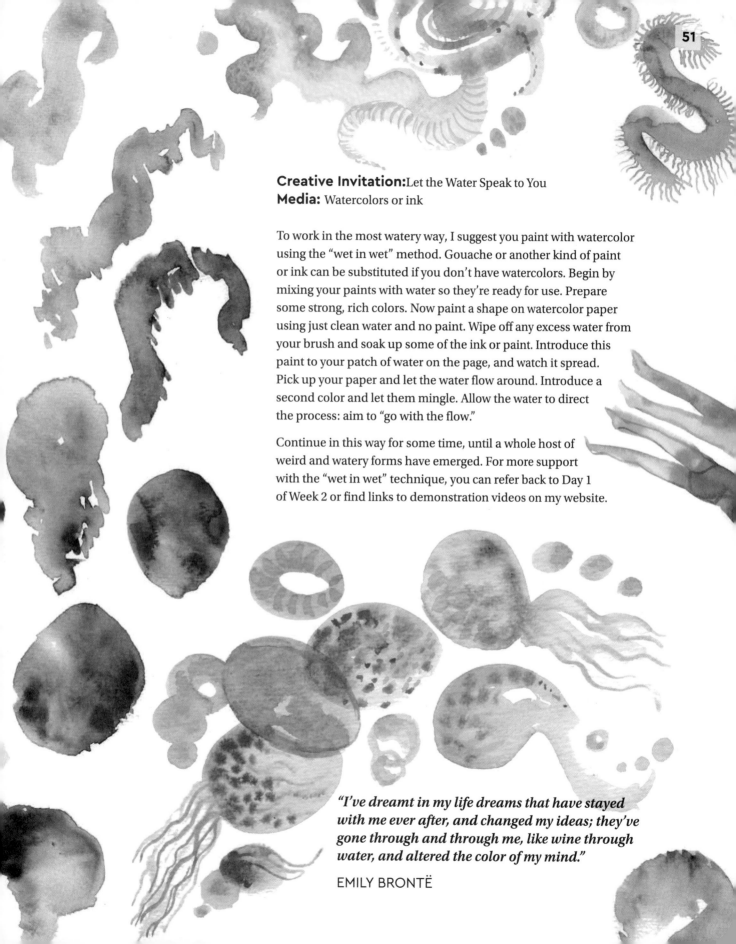

Creative Invitation: Let the Water Speak to You
Media: Watercolors or ink

To work in the most watery way, I suggest you paint with watercolor using the "wet in wet" method. Gouache or another kind of paint or ink can be substituted if you don't have watercolors. Begin by mixing your paints with water so they're ready for use. Prepare some strong, rich colors. Now paint a shape on watercolor paper using just clean water and no paint. Wipe off any excess water from your brush and soak up some of the ink or paint. Introduce this paint to your patch of water on the page, and watch it spread. Pick up your paper and let the water flow around. Introduce a second color and let them mingle. Allow the water to direct the process: aim to "go with the flow."

Continue in this way for some time, until a whole host of weird and watery forms have emerged. For more support with the "wet in wet" technique, you can refer back to Day 1 of Week 2 or find links to demonstration videos on my website.

"I've dreamt in my life dreams that have stayed with me ever after, and changed my ideas; they've gone through and through me, like wine through water, and altered the color of my mind."

EMILY BRONTË

Day 2
Wild Waters with Guest Artist Stewart Edmondson

Water can be awesomely stormy and exhilaratingly feral. "I love colossally bad weather and great sweeps of storm powering down to earth," says landscape painter Stewart Edmondson, who creates breathtaking images in response to the stormy seas and lashing rains of Devon, UK. Stewart describes his work to me as being an "energetic exchange" between himself and the landscape. For his artistic method, it's all the better when the weather is particularly, spectacularly bad, as the ferocious rain and crashing waves become his co-painters, directly sloshing themselves onto the canvas. I met up with Stewart at a blusterous expanse of rocky beach in Devon, and had the pleasure of watching him paint, aided by the wind and rain. I was struck by what a physical experience painting is for him, as he battled to hold his artwork to the ground whenever it threatened to take off into the sea like a great, paint-splattered sail.

"I hate to hear you talk about all women as if they were fine ladies instead of rational creatures. None of us want to be in calm waters all our lives."

JANE AUSTEN

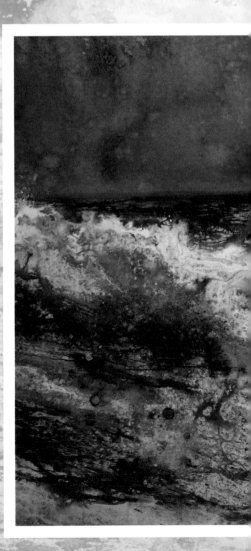

RUSHING WATER is great for your health! When air molecules break apart from moving water, as happens when waves crash or rain falls, negative ions are generated in large quantities. Researchers say that exposure to a good splash of negative ions can positively affect our metabolism, immune system, digestion, blood pressure, sleep, and mental health. The ions increase serotonin levels to boost our mood and energy, alleviate depression and relieve stress.[1]

Creative Invitation: Paint Like You Are the Wild Weather
Media: Watercolors, inks, and/or gouache

We all feel the urge to leap into wild waters sometimes, as Jane Austen pointedly wrote. Today, visit the wildest water you can find. Perhaps you'll be lucky enough to take a walk in the pouring rain, or to find a weir, a waterfall, or a windswept sea. If not, how about a local stream, or even a public fountain or another easily accessible source of running water? If the weather is calm and you don't have access to a body of moving water, don't worry. Fortunately, we have our imaginations, and you could also look for videos or images online to inspire you. You might like to look up Edmondson's work, too. If you're in good health, work outside and invite the rain or waves to co-paint with you. There's no need to render a photographic or realistic record of what you see — instead, focus on expressing your sensory, bodily experience. Try to make contact with that wildness which we know Jane Austen's women craved, when cooped up in their regency parlors (her heroines did love to walk in the rain to the horror of the neighbors!) Make marks and shapes that convey the sensations of salt spray on your skin, the splashing of a stream, rain pelting around your head, or the thrilling boom of crashing waves. Explore watery ways of applying your paint, such as flicking, sloshing, pouring, and dripping. Don't just paint the sea, paint as if you are the sea!

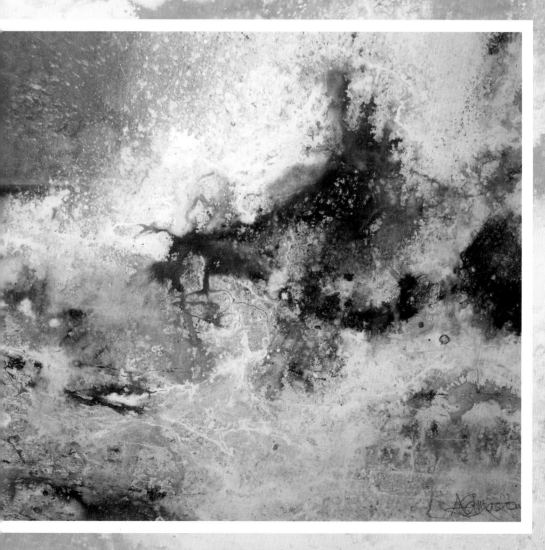

TIPS FROM STEWART
Don't try to paint everything you see. Just focus on one thing that interests you and make your painting a response to that. Be willing to try new things that might not work out; that's how you'll progress. Let the weather get involved in your painting too!

Left page: Bright Storm, mixed media.

This page: With All of This, mixed media.

Day 3
A Clear Forest Pool

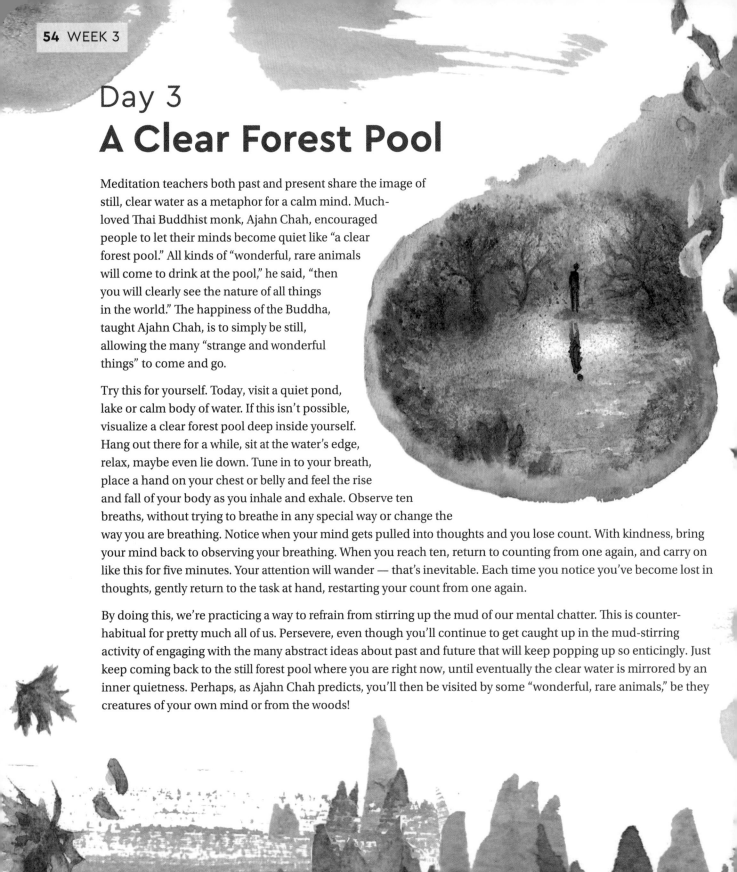

Meditation teachers both past and present share the image of still, clear water as a metaphor for a calm mind. Much-loved Thai Buddhist monk, Ajahn Chah, encouraged people to let their minds become quiet like "a clear forest pool." All kinds of "wonderful, rare animals will come to drink at the pool," he said, "then you will clearly see the nature of all things in the world." The happiness of the Buddha, taught Ajahn Chah, is to simply be still, allowing the many "strange and wonderful things" to come and go.

Try this for yourself. Today, visit a quiet pond, lake or calm body of water. If this isn't possible, visualize a clear forest pool deep inside yourself. Hang out there for a while, sit at the water's edge, relax, maybe even lie down. Tune in to your breath, place a hand on your chest or belly and feel the rise and fall of your body as you inhale and exhale. Observe ten breaths, without trying to breathe in any special way or change the way you are breathing. Notice when your mind gets pulled into thoughts and you lose count. With kindness, bring your mind back to observing your breathing. When you reach ten, return to counting from one again, and carry on like this for five minutes. Your attention will wander — that's inevitable. Each time you notice you've become lost in thoughts, gently return to the task at hand, restarting your count from one again.

By doing this, we're practicing a way to refrain from stirring up the mud of our mental chatter. This is counter-habitual for pretty much all of us. Persevere, even though you'll continue to get caught up in the mud-stirring activity of engaging with the many abstract ideas about past and future that will keep popping up so enticingly. Just keep coming back to the still forest pool where you are right now, until eventually the clear water is mirrored by an inner quietness. Perhaps, as Ajahn Chah predicts, you'll then be visited by some "wonderful, rare animals," be they creatures of your own mind or from the woods!

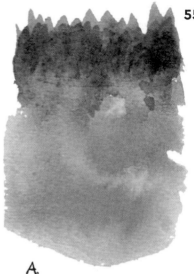

"These landscapes of water and reflections have become an obsession. It's quite beyond my powers at my age, and yet I want to succeed in expressing what I feel."

CLAUDE MONET

Creative Invitation: Calm Water, Calm Mind
Media: Watercolors, and a wax stick or candle

Counterproductively, the challenge of trying to paint calm water can sometimes create a mind that's more frustrated than calm. The absolute maestro of luscious lily ponds and reflected clouds drifting lazily across lakes, Claude Monet, warned that it could drive you crazy! "Take clear water with grass waving at the bottom," he said. "It's wonderful to look at, but to try to paint it is enough to make one insane." For this reason, I share a few tried-and-tested techniques to play with that I hope will support you to paint from a place of enjoyment and mental peace! Have a go at these different methods and see which ones best express what you feel. Set an intention to paint slowly and calmly, with a quiet mind...

A. This way is the simplest — just painting "wet in wet." Dampen your paper, then float in some watercolor, ink, or gouache, and add a few more drops of water for extra texture if you like. To encourage the flow, you can nudge the paint gently with your brush, or lift and move the paper around. To make the color of the pool, I mixed the green and the maroon from the trees together; thanks to the chemistry of color, red and green neutralize to form this gentle gray. When you paint the trees above, pull the green color down into the gray water — before the gray has fully dried — to make some blurry tree shapes suggestive of reflections.

A.

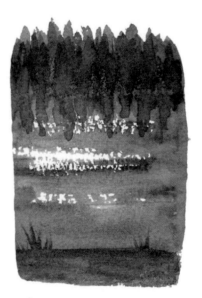

B. The "dry brush" method takes a little practice, so on a piece of scrap paper make lots of brushstrokes until you get the desired texture. You're aiming to make a brushstroke that leaves lots of tiny flecks of white paper showing through the paint. Your brush needs to be quite dry, without much paint on it. Your paper should be dry too, and a thick, textured paper such as watercolor paper is ideal to use. The white flecks will resemble sparkles of light on water. Carefully, around your dry brushstrokes, paint some wetter strokes to complete the pool.

B.

C. For this method, you need a wax candle or wax crayon. Roll it on its side so the paper picks up some of the wax — again, a textured watercolor paper with a bit of "tooth" is great to work on. Now, paint over the top with fluid brushstrokes, and notice how the wax resists the paint, creating the illusion of wind rippling, or light dancing, across the surface of the water.

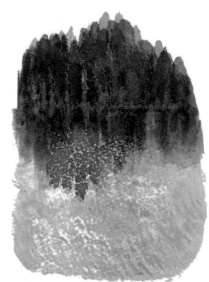

C.

Day 4
Belonging and Mystery with Guest Artist Jane Knight

Is water the most mysterious entity in the universe? Every single water molecule inside your body, and every single water molecule on our entire planet, is alien and ancient. The water coursing through your cells has cycled through dinosaurs, rocks, clouds, and animals since it first crash-landed on this Earth billions of years ago — and it got here by hitching a ride on an asteroid or a comet hurled from the furthest reaches of our solar system.

The same river runs through us all. Not only has this body of water been here aeons longer than humanity, it has been through every one of us that ever lived, multiple times, forming our blood, sustaining our organs, nourishing our lives. "Water is life and water is alive," says Navajo and Lakota activist Pat McCabe. At this time in history, many of us have a broken connection to land; we may not feel rooted in any specific place due to events in our own lives, or the wanderings and troubles of our ancestors. Many of us have moved multiple times for work or love or opportunities, and some of us have been forced to move as a culture or as a race. In response to this, McCabe invites us to open to a sense of belonging to water: water is everywhere and, no matter where we are, this living water supports, connects, and flows through us all.

Artist and designer Jane Knight can chart her own ancestral line across the world from China to India to Hong Kong to the UK. Jane feels a deep connection to water and spends time wild swimming in the sea whenever she can. She works in a range of media but has felt a particular affinity for watercolors recently, taking pleasure in their flowing, liquid quality. These works by Jane were created on location by the water's edge.

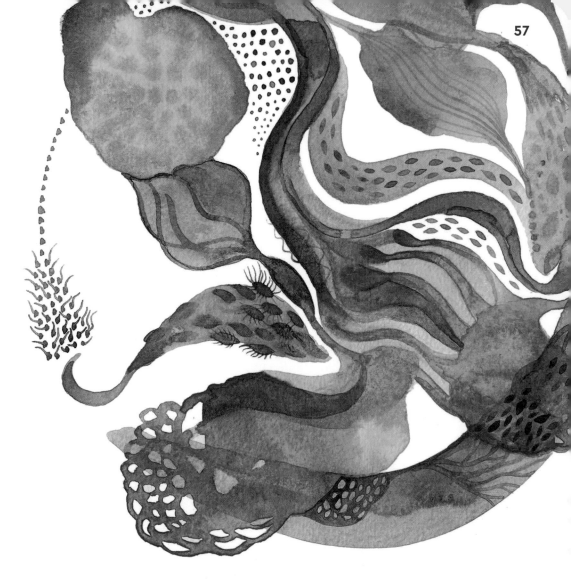

Creative Invitation: We Are Made of Water
Media: Watercolors or inks

Visualize the cycle of water, from sea to mist to cloud to rain to river and back again. Contemplate how water washes through us and sustains our bodies. Consider how 70 percent of the planet is composed of ocean, and how this is mirrored by the 60 percent water content of our own bodies (or 78 percent for a newborn baby). Reflect on how a baby begins in the water of the womb, and how the first life on land crawled out of the water. Can you see with the eyes of Pat McCabe; how would it feel to know you belong to water? Can you think of yourself as the child of water? Mull over the fact that water existed on the planet long before us, and how every molecule in your body has been here since life began — or before — and has traveled through every being, past and present, including all your friends, your enemies and your ancestors.

What if you were to suspend judgement, and to play with taking on Pat McCabe's belief that water is alive — conscious and sentient? What if water is interested in being in a relationship with you? By McCabe's reasoning, what you think of as "you" cannot be separated from water. Make some visual responses as you ponder these watery images of blood, seas, mist, comets of burning ice, and the liquid cycle that connects us all through time and space. Let yourself doodle in a stream of consciousness, free-form and poetic. Allow visual thoughts to flow, as one line or brushstroke follows another.

All images by Jane Knight, watercolor on paper.

Day 5
Emotional Waters

Water can embrace our grief, our pain, and our shame without judgement. We let go through tears. We cleanse and refresh ourselves through bathing. The healing qualities of water have long been understood by human communities across the world. Entering into water to become renewed, received, and whole again is a ritual common to almost all spiritual traditions.

I wonder if there is something inside you that is ready to be surrendered to the embrace of water? I'm moved by a particular Hindu *puja* ritual, wherein people create or buy little boats, made from leaves and filled with flowers, and float them off into the river with a lit candle on top.

I don't know what others who practice this pray for, but I spent some time in India after I lost my father, and I found the *puja* ritual comforting as a remembrance, wishing for him to be safe and happy wherever he is now while acknowledging my own deep grief.

Maybe you're in a good place right now and don't feel the need to let go of anything painful. If so, perhaps you have plenty of joy inside yourself that you can offer to the water instead. On World Water Day this year, myself and Anna (a young friend) made offerings of thanks to a local stream. We wove tiny rafts from flowers and twigs, and spoke our appreciation to the stream for uplifting our spirits, for being beautiful, and for sustaining our bodies and all life on Earth.

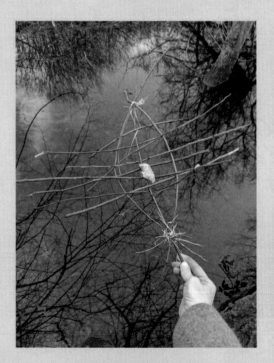

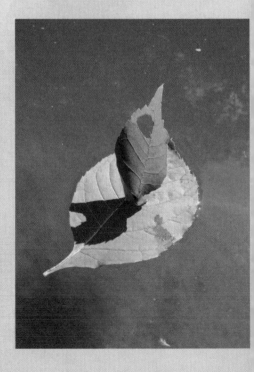

Creative Invitation: Surrendering Sadness or Offering Appreciation
Media: Leaves, twigs, water

I invite you to construct a boat, or a raft, to serve as a vessel for the feelings you would like to release into the water. These could be feelings of appreciation, or of sadness, or of something else. They could be emotions about your relationships with people or other beings. Or you could release feelings of grief or gratitude for the sufferings or joys of the Earth.

There are many ways to make your vessel. One way is to gather some twigs and bind them together to form a raft. Long grass may serve as string; alternatively, you could use a piece of raffia or undyed string. If you want to make something more boat-shaped, seek out some fresher, bendier twigs. If you have a garden and need to prune away some new growth, this will provide you with suitably springy sticks. Once your vessel has taken shape, place flowers on top, or weave leaves and feathers between the sticks.

Another simple and elegant option is to make a leaf boat. Take two leaves, and push the stem of one leaf through the middle of the other. Carefully pull the leaf stem through until it stands up like a sail, with the leaf underneath forming the base of the boat.

When you are ready, load up your boat with the cargo of feelings you wish to release into the water. Allow the water to receive and embrace your emotional load completely.

"Neatly folding waves

So simple yet so complex

Wash the pain away"

ED BURLEIGH

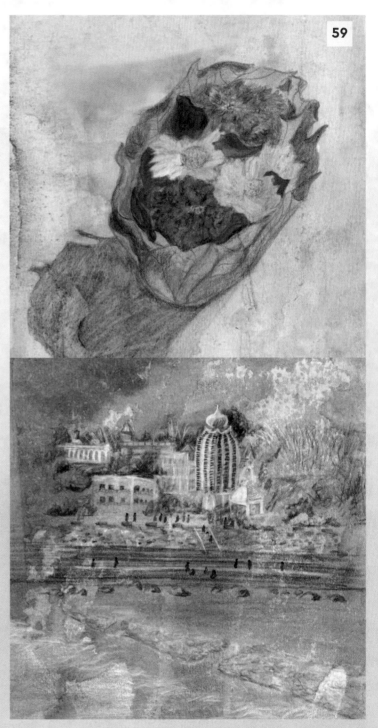

Opposite page: 1) Boat constructed by artist-participant Flora Bain, showing how you can fasten with raffia at either end and how, by weaving twigs across the structure, you can create something sturdy enough to carry a stone. 2) Boat made from forsythia twigs — nice and bendy. 3) Leaf boat.

This page: Sketch of a handmade Indian prayer boat filled with flowers, and sketches of the River Ganges in Rishikesh, India.

Day 6
Filling the Reservoir

Sometimes we feel drained, as if the life juice has been sucked out of us. Maybe the demands of our daily business have become too much, or we're emotionally and energetically depleted from having endured a particularly intense phase of our life.

Other times, we may actually have been having lots of fun, dashing from one exciting event to the next, or taking the lead on a brilliant creative project — and yet, still, one day we wake up feeling flat and empty, with no energy left.

Ian Siddons Heginworth is an environmental arts therapist who shares some beautiful thoughts on "filling the reservoir" when we have run dry. When we get too busy, explains Ian, even if we're enjoying feeling alive and inspired while flying "like Mercury on his winged sandals" from festival to party to project, there's a risk we will "stop listening to our hearts and lose our connection to the very source that inspires us."

What is the source that can revitalize us?

Nature, of course.

"Nature refills us with herself because Nature is the outward manifestation of our own feminine," says Ian, and she has myriad ways of replenishing us.

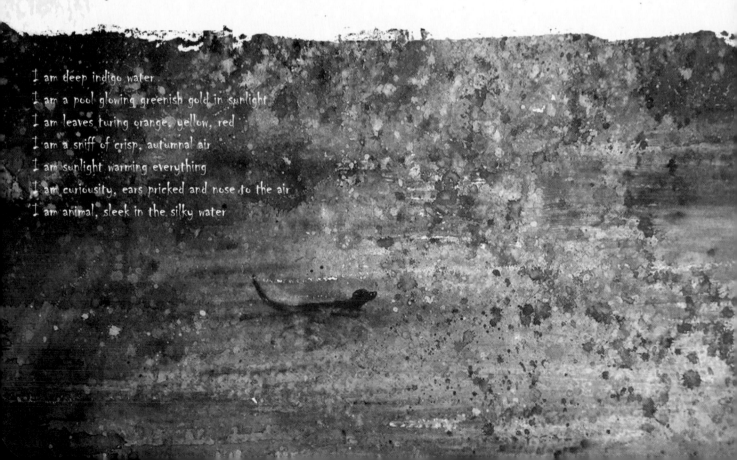

I am deep indigo water.
I am a pool glowing greenish gold in sunlight
I am leaves turing orange, yellow, red
I am a sniff of crisp, autumnal air
I am sunlight warming everything
I am curiousity, ears pricked and nose to the air
I am animal, sleek in the silky water

Creative Invitation: Let Nature Restore You, Let Water Replenish
Media: Photos, magazine images or sketches, oil pastels or gouache paint, and a pen

This is an exercise I've adapted from Ian's own work, called "The Seven Wonders." Begin your walk, perhaps by the water's edge, and keep an eye out for any "wonders" of nature. Each time you find something, note it down in your sketchbook and preface your note with the words "I am." Make a visual record, too: a sketch or a photo. Keep going until you have noted down at least seven wonders. Read your words out loud to yourself and see how you have written a poem that reflects the sensitive, creative, feminine Self within you. "Behold yourself," says Ian. "Anywhere we go, anything we meet, it is ourselves we encounter."

If you wish, develop your poem into an illustration, a collage, or an art-journal page, blending word and image together. You could combine photographs you've taken, images cut from magazines, or your own sketches. Gouache paint or pastels are helpful for softening the edges of photos and knitting everything together. You could also experiment with stencilling or painting your lettering by hand.

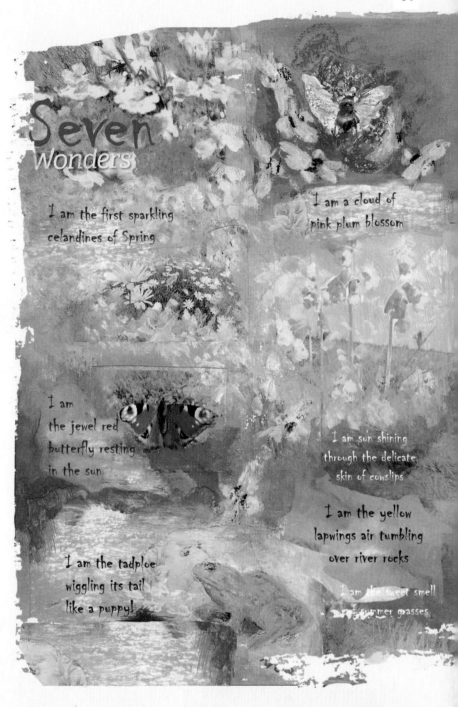

Seven Wonders

I am the first sparkling celandines of Spring

I am a cloud of pink plum blossom

I am the jewel red butterfly resting in the sun

I am sun shining through the delicate skin of cowslips

I am the yellow lapwings air tumbling over river rocks

I am the tadploe wiggling its tail like a puppy!

I am the sweet smell of summer grasses

"Nature has many ways of refilling us. When we awake to the glory of a beautiful sunrise, she fills us with hope. When we play like children in the waterfall, she fills us with joy. When we answer her thunder with our own, she fills us with power. When we kneel by the river and surrender an image of our lost one to its currents, she fills us with grief... And when the work is done and we stand alone on the hillside beneath the stars, she fills us with grace."

IAN SIDDONS HEGINWORTH

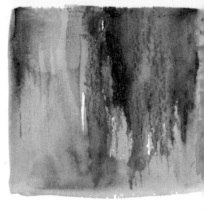

Day 7
Smear and Plonk!

Today we will follow the instructions of a 19th century art critic and do some smearing and plonking! On Day 3, I mentioned the French artist, Monet, who painted water so expressively. Although much appreciated now, in his own time some critics were a little more, well… critical. "Smear a panel with grey, plonk some black and yellow lines across it, and the enlightened few, the visionaries, exclaim: Isn't that a perfect impression of the Bois de Meudon?" sneered reviewer Emile Cardon in 1874, dripping with scorn for this new-fangled nonsense known as "Impressionism." Monet himself put it this way: "When you go out to paint," he said, "try to forget what objects you have before you, a tree, a house, a field or whatever. Merely think here is a little square of blue, here an oblong of pink, here a streak of yellow, and paint it just as it looks to you, the exact color and shape."

Creative Invitation: Abstract play
Media: Gouache or thick paint

Today, you'll need some reasonably thick paint and tough paper or card. I have used gouache paints, which are more opaque than watercolors. Poster paint (popular for children) is fine too, or if you happen to have some oils or acrylics then they will work very well. (I don't buy acrylic myself though, as I'm not confident about its impact on the environment.) You could even try a bit of leftover house paint from the garden shed — if you only have white then tint it with ink or whatever else you've got on hand to make a few different colors. You also need an old plastic store card, cut into a few different-sized strips.

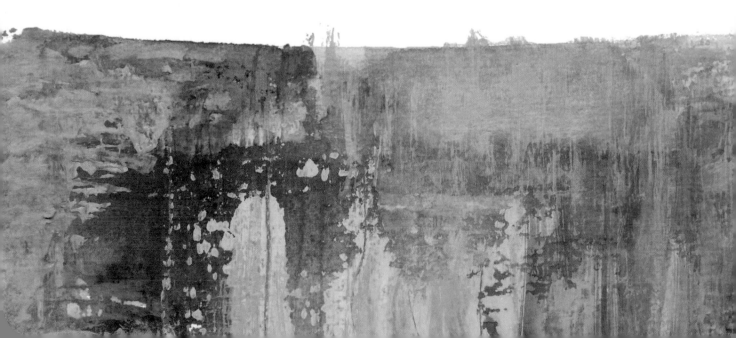

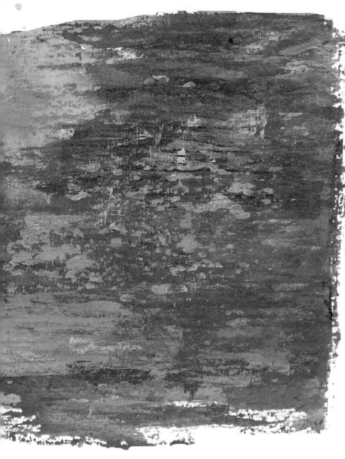

Tip: Paint can go a bit murky-brown if too many wet colors are smeared on top of each other, but the same colors will look vibrant if you slow down and layer them one by one over previous layers of dried paint. I like to work on a few small paintings at once so that while one is drying, I can work on another.

Instead of thick paint, you can alternatively work in layers of oil pastel, in combination with paint or on their own.

Next, "go out to paint," just as Monet suggested, and settle yourself near water, perhaps a river or lake. Again, taking Monet's lead, see if you can see the whole vista as pure color and shape. Squinting your eyes can help you to see the full *gestalt*. It's a matter of forgetting the details and allowing yourself to receive an "impression."

Take your piece of plastic and use it to "smear", scrape and "plonk" paint onto the paper — as the critic so artfully put it. Let your impression build up in layers, allowing some drying time in between. Notice how water tends to lie in horizontal lines, which the reflections of trees intersect with their own vertical lines; show this through the direction of the marks you make. Don't worry about accuracy: aim for a "felt sense" response and bring it to life with color. Set the intention to completely surrender any perfectionistic tendencies to make your work look like something — I am not recommending you paint something that looks like "a Monet," but rather to paint in the way that Monet himself encouraged!

Opposite page, top right: Examples of how your first one or two layers will look. I have smeared green and blue gouache paint onto a thick piece of paper using an old plastic store card. Pull your card straight down or across the page, and if you like, add a little wiggling motion to suggest ripples, as I have done with green paint on the immediate right.

This page and opposite: After many more layers of smearing and plonking, you will be able to build up a rich and colorful texture.

WEEK 4
Fire and Air

This week, we'll bathe in sunshine and soft breezes. We'll also brave the wilder extremes of fire and air, venturing into fierce and stormy weather within and without. The element of fire connects to the third chakra, which is the source of our personal power, that "fire in the belly" we need for self-esteem, purpose, and the energy of transformation. The element of air relates to the fourth chakra, which sits at the heart. Air, like love, is within and all around us, and when we are in tune with the air element, we find that love and compassion flow freely. We can sense our integration with all sentient beings through the intimacy of breathing — the same air leaves our body, travels through all creatures, is absorbed and purified by living plants, and effortlessly re-enters our lungs.

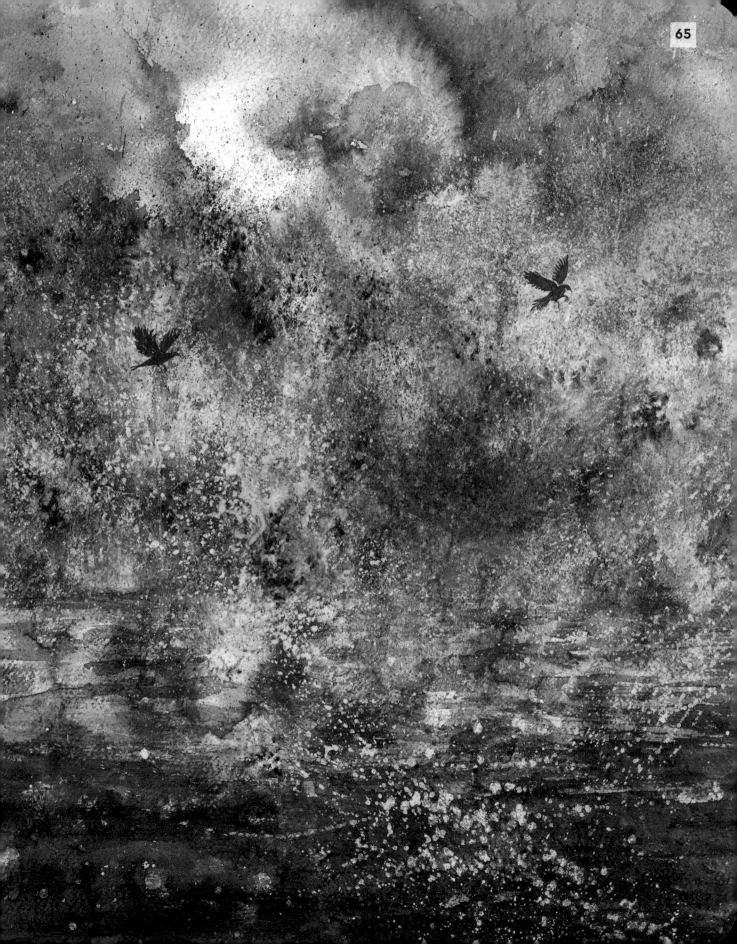

Day 1
Fire in the Sky

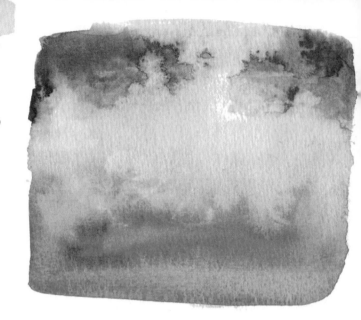

"I feel so full of love to-day after having seen the sun rise," noted the Modernist author Katherine Mansfield in her journal. "A lovely apricot sky with flames in it and then solemn pink. Heavens, how beautiful."

Today, let us greet the sun at dawn, or, if we missed it, let us bid goodbye to it at sunset. Let us appreciate the manifold hues of apricot, rose, and violet, and note the everyday miracle of flames licking across the sky. "A sleeper can wake and be lured out of bed by the sorcery of the sky as day is dawning," says writer Diane Ackerman. "Time well spent."

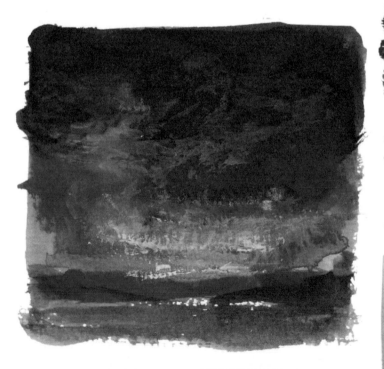

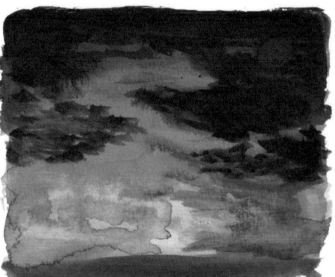

As you can see in the images...

Gouache needs to be mixed well with water rather than applied directly from tube to paper. At first, try mixing a pea-sized blob of gouache with just a little water, so that it is not sticky but has the consistency of single cream and appears opaque. Once you have got the hang of that, you could also experiment with adding more water to make it appear translucent like watercolor. Explore creating different textures using gouache. You could apply paint using a dry brush, and then a wet brush. Try painting on dampened paper, as well as on dry paper. Let each color merge its edges with another. Once your painting is dry, you could add a few highlights by using opaque gouache, oil pastel or soft pastel on top. Enjoy the various atmospheric results you will produce.

The sun really does make you feel good! Exposure to sunlight increases the brain's release of serotonin, the mood-boosting hormone, while ultraviolet radiation may cause an endorphin release akin to the euphoric feeling you'd experience if you'd taken some opiate drugs![1]

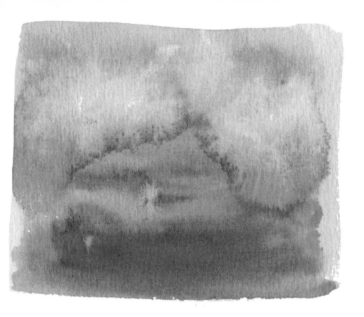

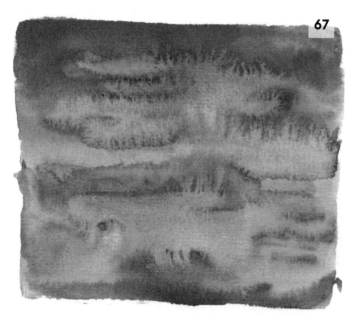

Creative Invitation: Sunrise Haikus
Media: Gouache, or other paints and pastels

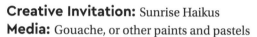

Gouache can be a great way to respond spontaneously to the beauty of a quickly shifting sky. Rather than painting just one image, make several small ones, using just a few brushstrokes per painting. You could think of them as sunrise "haikus," each one expressing something of the fleeting glory of the golden sky through a few energetic sweeps of the brush. Gouache can be applied, watered down like watercolor for floaty and merging effects, or layered on more thickly to cover up underlying layers. The latter technique allows you to swish light, bright colors over dark ones, something that's not possible with watercolor. If you don't have gouache, oil pastels or soft pastels on top of watercolor are a good alternative.

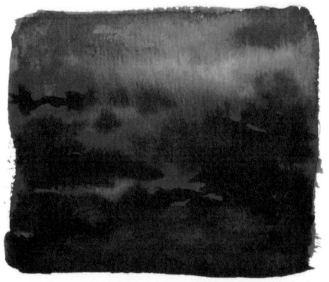

If you want to, work from observation, but if you can't get out at the right time of day, or you live somewhere like Britain where the sun is frequently obscured behind clouds, fear not — this is also a beautiful exercise to do using just your memory and your imagination.

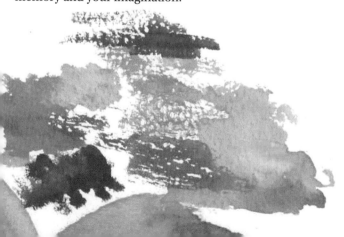

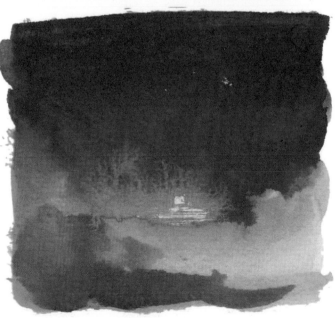

Day 2
Be the Air

Today, I invite you to pay close attention to the air as you take your walk. Play with moving across the land as if you yourself are the flowing air. Find a place to stand or sit and close your eyes. Focus on the caress of the breeze and the sense of sunlight on your skin. Perhaps there are strong sensations of being swept up in a fierce wind or of melting under a hot sun. If you are enjoying a less dramatic day, tune in to the subtler feeling of warm light on your eyelids or a gentle gust of wind against your cheek.

As you pay close attention to these sensations, notice how the air not only touches the skin boundary of your body, but also flows right inside your body as you breathe. Observe how the inflow and outflow of breath is happening quite naturally, without any special effort from you. When you pay attention like this, comments environmental activist and Buddhist, Joanna Macy, you realize that you're "not just a separate organism sitting here breathing. You are not only breathing but being breathed." Experience the sensation of "being breathed" by this mysterious planet. "You need an oxygen-producing web of life for you to breathe — you need trees, you need plankton," says Macy. When you really pay attention, you see that you are "part of the whole web of life."

Creative Invitation 1: Sense the Air and the Sun
Media: A soft pastel or pencil

Close your eyes again, and pick up your pastel or pencil. Begin to record these sensations of light and air that you are feeling on your skin by drawing without looking. Let your receptivity to the touch of the elements become really subtle and intimate. Only look at your work once you have finished!

Creative Invitation 2: Follow the Birds
Media: Paints or pastels

How would it feel to soar and wheel through the air like a bird? Take some time to lie back on the grass and follow the flight paths of birds circling overhead. You may have to relax and be patient, waiting for a bird to appear. When you're ready, let your pen or brush track the movements of birds in real time on your paper. Let your hand fly freely as if you were, by some mysterious alchemy, one with the bird soaring high above.

"Live in the sunshine, swim the sea

Drink the wild air's salubrity"

RALPH WALDO
EMERSON

Opposite page: Drawings of the feeling of air on my skin in soft pastel.

This page: Tracking the flight paths of birds in gouache.

flight paths
of birds
a snowy, sunny
day in April

Day 3
Remember your Wild Soul

"When the wild god arrives at the door,

You will probably fear him."

So writes poet Tom Hirons in his haunting poem, *Sometimes a Wild God*. The Wild God is a strange and uninvited guest, with "otters in his eyes" and a taste for your whiskey. He messes up your kitchen and gets under your skin, causing "ivy to take over your sideboard" and "snakes to nest in your voicebox." Hiron has commented that many people respond to his poem with tears of sadness, as the words prompt them to mourn for a part of their nature that they lost touch with long ago, while others weep for joy in recognition of a deeper part of themselves not previously seen or articulated.

Nearly a century ago, Carl Jung lamented that the modern human being no longer has a "bush soul" identifying him with a "wild animal." No longer does he see a snake as the "embodiment of wisdom," no more does he hear "the voice of God" in a roar of thunder. The sorry result, said Jung, is that we feel ourselves to be "isolated in the cosmos," bereft of the ability to speak or listen to nature.

Jung regarded this sinking of the wild, animalistic, animist self into unconsciousness as an "enormous loss." Does this resonate with you? Do you feel this loss? Today, let us see if we can recover something of what has been half forgotten and long forsaken. Let us track the forest for signs of our abandoned "bush souls."

"When we try to make wildness safe, by turning the forest into a nature park, caging the beast or repressing our truth, we diminish ourselves and rob the world of its soul. When we try to save wildness for its own sake, by protecting the wilderness and defending our right to freedom of expression, our mad and passionate spirit, our grief, our fury, and our love, we enrich ourselves and give the world back to itself."

IAN SIDDONS HEGINWORTH

Creative Invitation: Contact the Wild One
Media: Your choice

Could you make contact with your "bush soul"? Would you invite the Wild God into your home? If possible, begin today by reading or listening to Tom Hiron's poem, *Sometimes a Wild God*.[2] Let the poem brew in you. What feelings do the images evoke? Can you feel the stirrings of longing, or anger, or passion, or grief? Do you have an inkling of something missing that is wild and essential that you want to reclaim?

Now, as you set out for your walk, sense the wildness all around you. What if nature truly is alive? What if feral and fiery spirits are looking at and listening to you? Ask yourself, what in your inner state resonates with the wilderness all around you? Can you vibrate to the tune of wildness? Can you hear the voice of a goddess in the music of the river? Can you see the face of a wild god in the gnarled bark of an old tree? Can you imagine the ivy taking over your mind, and the vine twisting through your body the way it runs rampant around those branches? Could you tap into the fire energy of a wild woman incarnate in the irrepressible growth of summer weeds? Could you permit the life force to enter you and express herself through the soft animal of your own body? What is it like to move as this Wild One, and to look through her eyes? If she could paint, what would she create? What will she do with your inks and pens?

Take your brush, take a big sheet of paper, and find out. Perhaps you will smear paint like a slippery otter, or trample it with big feet like a bear. Maybe you'll hurl paint on paper like a vengeful lightning god, or make giant sinuous swirls as if possessed by a snake spirit. Let your process be as ugly, weird, and impolite as it wants to be. Scribble and scrape with your finger-claws; roll in the mud and use your body as a brush; fill huge sheets of paper; rip up all your work with your teeth… why not? Let your wild animal soul have its moment in the sun!

Does your civilized self put up some resistance to my suggestions? Perhaps the Civilized One within thinks you should not make a fool of yourself. She may fear that you will make "bad" art, ruin your work and look ridiculous. Perhaps she is concerned that you will lose control or become unsafe. Does she worry that you will become too big, too crazy, too furious or madly passionate? If you are having these kinds of concerns, ask the concerned part of yourself this question: How terrible would it be to turn things upside down, just for an hour, after which order can, of course, be resumed? Think of it as a festival for the feral self, to let something out of your system. Invite the Civilized One to take a hard-earned break from being in charge, just for a little while.

You do not need to let go of all your inhibitions at once, and of course, wild animals are often cautious and shy, but perhaps there is something you would quite like to try but have been holding back from doing. Ask yourself what that might be. Would you like to throw some paint? Work on a bigger sheet of paper than usual? Use bright and unrealistic colors? Let your work be messy? Paint with your hands?

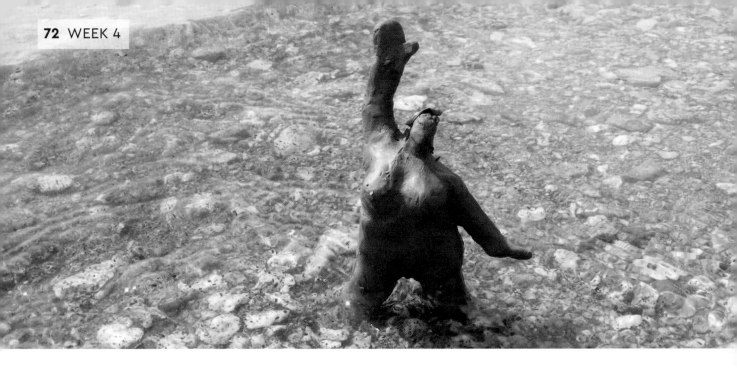

Day 4
Eliza Freespirit with Guest Artist Lizzie Stevens

Lizzie Stevens is an artist who, in her own words, has been "on the search for meaningful, accessible, and, where possible, uplifting ways of expressing idea and feeling." For many years she was drawn to the fun, simple, and colorful medium of plasticine.

At the age of sixty, Lizzie explains how she was "at a crossroads in my life" and feeling "incredibly low and stuck." It was at this time that she received a free bus pass and "realized how different and refreshing a world can be viewed from a bus, and particularly from the upstairs of a double-decker." Lizzie took to drawing on the bus, but one day was dismayed to find she had left her drawing things at home. However, all was not lost: "instead I discovered a lump of dusty plasticine at the bottom of my bag and, as the bus sped through the darkening landscape, I held the lump in my hand. As it warmed, it morphed into… a little hand, severed at the wrist. I curled the hand around the handlebar of the seat in front of me. I decided to leave it there."

This brought Lizzie such delight "and uplift from my gloominess" that she set to replicating the experience. "However, rather than repeating this somewhat macabre subject, this now rather exciting project morphed into a figure, at first androgenous, then slowly female, very female!"

"I repeated making the figure, each time with one strip of plasticine, until I realized this character had become my alter ego, that she could physically express all that I wanted about being female, about feeling free, about finding the fire in the belly. I named her Eliza Freespirit."

Lizzie's fellow bus travelers started taking an interest in what she was doing too, voicing amusement and interest. That was the start of the "Eliza Project". Eliza has since exhibited singly and in multiples, informally and formally (including in Guerilla Galleries) around the UK, and has placed herself in extraordinary situations around the world.

Creative Invitation: Let Clay Evolve
Media: Clay

Take a chunk of about 100g clay of any sort and allow
the medium to evolve in your hands. Give it time. If your
hand is warm, you may need to add a little water for
moisture. Allow the substance to morph into whatever
it wants to be. Can you consciously tap into a sense
of warmth or "fire in the belly", no matter how teeny a
flame? Let your lump of clay take shape slowly, and do
not worry about what it is going to become. Let it be
free, and let it surprise you!

All images by Lizzie Stevens.

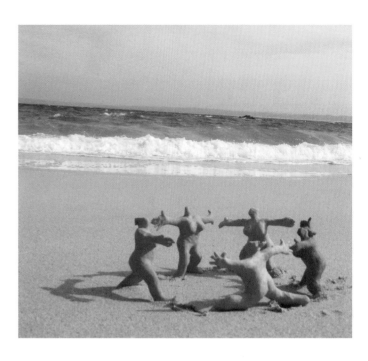

Day 5
Let Nature take the Lead

Dylan Thomas believed that the same force driving water through rocks also drove the blood through his veins. Our creativity is simply nature pouring through us: what else could it be? Our bones, flesh, and blood are made from water, earth, air, and fire — and animated by the same mysterious life force. People meditate to dissolve an over-identification with the ego, that aspect of our self which feels like a separate self that stands apart from nature. Today, I'm curious about whether it is possible to let go of our role as the egoic "one who makes art," and instead place ourselves in a background role as a kind of facilitator to the "artist also known as nature."

Could we invite the elements themselves to become the artists, making space for them to express their vitality in their own way, center stage, with our human hands offering only a little light support?

"You will have to experiment and try things out for yourself and you will not be sure of what you are doing. That's all right, you are feeling your way into the thing."

EMILY CARR

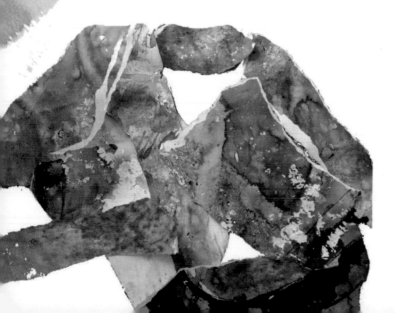

Creative Invitation: Facilitate the Forces of Nature
Media: Paper, inks or paints, the elements

Today let's find ways to facilitate the forces of nature to get creative on the canvas, so to speak! In the image I share on the right, I began by leaving a large sheet of paper outside, exposed to sun, air and rain for several days. When I returned to see what had happened, I found intriguing textures including tiny lacy trails nibbled by woodlice, and cloud like shapes where wind or rain had worn away at the paper. Later I went out in a rainstorm to drop black ink into puddles pooling on the paper, and watched the wind blow it into streaks and lash it with falling twigs. On a sunnier day I rubbed fallen petals from a few violet hollyhocks and golden dandelions into the surface for colour. By now the paper was looking pretty tattered and so I ripped it up and reassembled it into a collage that, on completion, brought to mind a scene of weathered stone and windswept, heather strewn moor.

I don't have any prescriptive instructions to offer you – the idea is to experiment with ways of making space for nature to speak. Work with the elements that are active right now. That said, here are a few suggestions to get you started. If you have a fire, let ashes from the fire combine with water to make cloud-storms on black paper or encourage tongues of flame to lick the edges of your work. If it's windy let pools of ink on paper be whipped and flapped around. If you have time, leave paper in the rain or in the shed to be frayed or nibbled. If you have no outdoor space, leave paper in a well-used area of the kitchen, bathroom or even on your desk where you usually place a cup of coffee to let organic stains accrue.

Day 6
Dwelling on the Edge with Guest Artist Rima Staines

Panagia, "the all holy," artist Rima Staines explains, is a term traditionally used for Orthodox depictions of the Mother of God, but also the holy bread and sacred womb. "In my painting, which began as a drawing in damson-colored ink and progressed to oil paints, this holy mother just seemed to make herself present and necessary on the paper," says Rima. "She is the ultimate life-giver: sustainer and holder, powerful and grieving, blood cells and stars, ancient and immanent, seed and darkness, weaver and land, in us and of us and under us and over us and around us always." While she painted, Rima listened ("on repeat for weeks") to two "heart-crackingly beautiful and moving" orthodox hymns to Panagia.

To Rima, both of these pieces of music "seemed to encapsulate the deep and lasting praise that we must offer to our Earth, our Life, our Mother, the very milk-giver, vineyard, sustainer and holder of everything... The beauty and ancient wisdom in these songs have fed this painting, as have my pain and overwhelming and deep and unfathomable love for my children and grief for these strange, strange times we are walking through."

For Rima, art is a spiritual practice that takes commitment. "You have to hone your craft: it's about skill and high craftsmanship and beauty. This is a process, a long apprenticeship to honor the goddesses and gods. Art is not a hobby," she explains, "it is a serious and reverent practice of communicating with holy beings." These beings might be "the spirits of plants, trees, rocks, waters, of places or happenings, or beings in and of themselves." Rima's perspective evokes a more ancient, animistic way of seeing the world. "A plant, even just one on your windowsill, has its own life, it's not-human life: it has its own life force."

Rima knows her art has been successful when she has "touched something." Speaking about the artwork of others that she connects with, she elaborates: "You can tell when it's got that spark, and the artist has gone down a few layers

and 'twanged' something inside me that I didn't expect. I love it when a painting speaks to me like that."

"Imagination isn't about making things up, it's more than that... It might be that you make something unseen become visible." Although Rima refines her skills through observational drawing, when it comes to creating a painting, she doesn't do a lot of planning or preliminary sketching, because it's important to remain open to what is coming through: "I want my main piece to be alive. If something interesting and potent happens, I want it to happen on the main piece, not in a sketch that I then try to repeat." Rima paints on the "edge of the unknown," so that each brushstroke is a discovery that may lead to something unexpected, something far deeper and more mysterious than her thinking mind could have planned in advance.

Creative Invitation: Painting on the Edge of the Unknown
Media: Your Choice

Rima invites you to get to know a particular plant, tree, or other being in nature. "Visit it often, befriend it. See who, or what, you feel drawn to: the water's edge, the weeds pushing through the cracks, a mountain or a cave... Discover what resonates with you." Make a few small observational sketches before moving into the realm of imagination. At this stage, Rima prefers to work at home or in her studio rather than outside, as she needs the quiet, contained space to be able to listen in with sensitivity. She also plays music to ease herself into a receptive, creative mind-state. Choose a comfortable place to be, inside or outside, and if you wish, select some music. Rima invites you to paint your rock, plant or river "as an icon, as a person, so that the character and communication of the being is translated into a relatable form and can be honored in an image in this way." Work in any media and stay open to the guiding inspiration of your newly-met friend.

Panagia by Rima Staines, 2020, inks and oils on paper.

Day 7
Atmospheric Mists and "Yugen"

The Japanese tongue can distinguish between many delicate flavors of beauty. I first came across the Japanese concept of *yugen* in Diane Ackerman's book, *Dawn Light*. Hard to define in English, this word points to a beauty that is mysterious, gentle, and profound. "It is like an autumn evening under a clear expanse of silent sky," wrote 13th century author Kamo no Chômei. "Somehow, as if for some reason that we should be able to recall, tears well uncontrollably." A half-forgotten memory, or a deep inner knowing, is stirred, and it is all the more poignant for being partially obscured. A hazy view, veiled in fog, is beautiful precisely because more is left to imagination.

"To stand upon the shore and gaze after a boat that disappears behind distant islands. To contemplate the flight of wild geese seen and lost among the clouds," sighed 14th century playwright, Zeami Motokiyo. It is the very indistinctness of the mountains glimpsed through an autumnal fog that evokes the essence of *yugen*, explained Kamo no Chômei: "Although few autumn leaves may be visible through the mist, the view is alluring." It is that which cannot be seen that touches us so deeply: "The limitless vista created in imagination far surpasses anything one can see more clearly."

Creative Invitation: The Taste of Yugen
Media: Watercolor

Today, we will develop sensitivity to the quality of *yugen* in the world around us. What stirs your soul today? What tugs at your imagination? What is half out of sight, or calling to you from the edge of your senses? The distant cry of a sea bird might provoke a mysterious, happy-sad emotion. A misty vista at dawn might gently twang a chord in your heart.

Watercolor is a good medium for today, as it lends itself so well to the creation of silky veils and suggestive, half-revealed imagery. On the right, I have painted a memory of frozen fields in mist. You could work from memory or observation but choose a subject that evokes *yugen* for you. Let your paints be fluid and allow one color to merge with another. Play with working partly on dry paper and partly on wet paper for a range of textures. For soft and hazy effects, work onto wet paper and mix your paints with a higher water ratio than usual so they look very delicate. Let things be blurry and indistinct. Consider leaving some simple swathes of pure color, or even unpainted white spaces — you want to leave plenty of mysterious territory for the imagination to wander into...

WEEK 5
Trees

Trees are woven into the imaginations of our childhoods and live at the heart of human culture. Since the dawn of civilization, trees were cherished as sacred beings. In ancient Europe, ceremonies took place in mystic groves and the Celtic "Tree of Life" was a potent spiritual symbol. In the Book of Genesis (the first book in the Torah and the Bible), God made trees on the third day of Creation, before humans were created. All of the Buddha's epiphanies arose in the company of trees, from the rose apple he lay under as a boy to the Bodhi tree beneath which he became enlightened. In Madagascar, the Baobab tree, which can live for several thousand years, is still revered as the "mother of the forest."

We are nothing without trees. Physically, culturally, and spiritually, we are utterly entwined with them. We breathe in their oxygen; they receive and store our carbon. They cool and clean our air, provide food, shade, and shelter for us, and regulate the climate in countless ways. Without trees, everything would fall apart, quite literally, with soil erosion, floods, the collapse of the ecosystem and mass extinction inevitable.

Trees can help us to heal, and this week, we will linger a little longer on the chakra of the heart. Soldiers suffering from PTSD took part in a study on the impact of trees at a forest garden in Denmark. [1] One war veteran reported that only in the company of trees did he feel safe enough to close his eyes. Another found that trees offered him complete acceptance without any expectations, while a third was drawn to a "mammoth tree," commenting that it brought him comfort and peace. Trees bring medicine to both the soul and the body — more on that later from this week's guest artist, Lindsay Alderton.

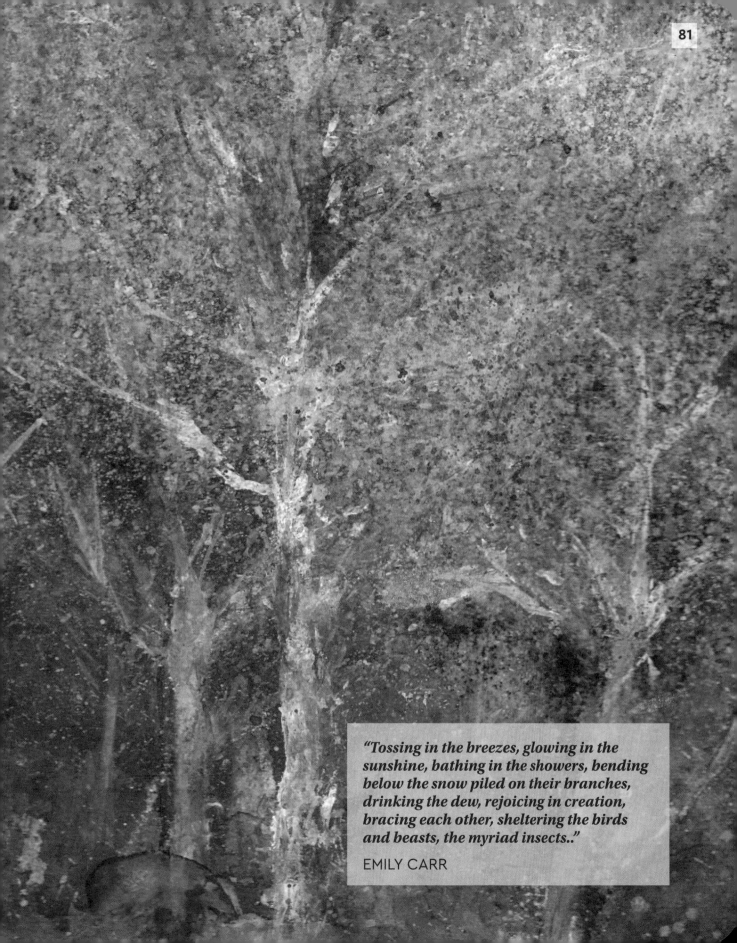

"Tossing in the breezes, glowing in the sunshine, bathing in the showers, bending below the snow piled on their branches, drinking the dew, rejoicing in creation, bracing each other, sheltering the birds and beasts, the myriad insects.."

EMILY CARR

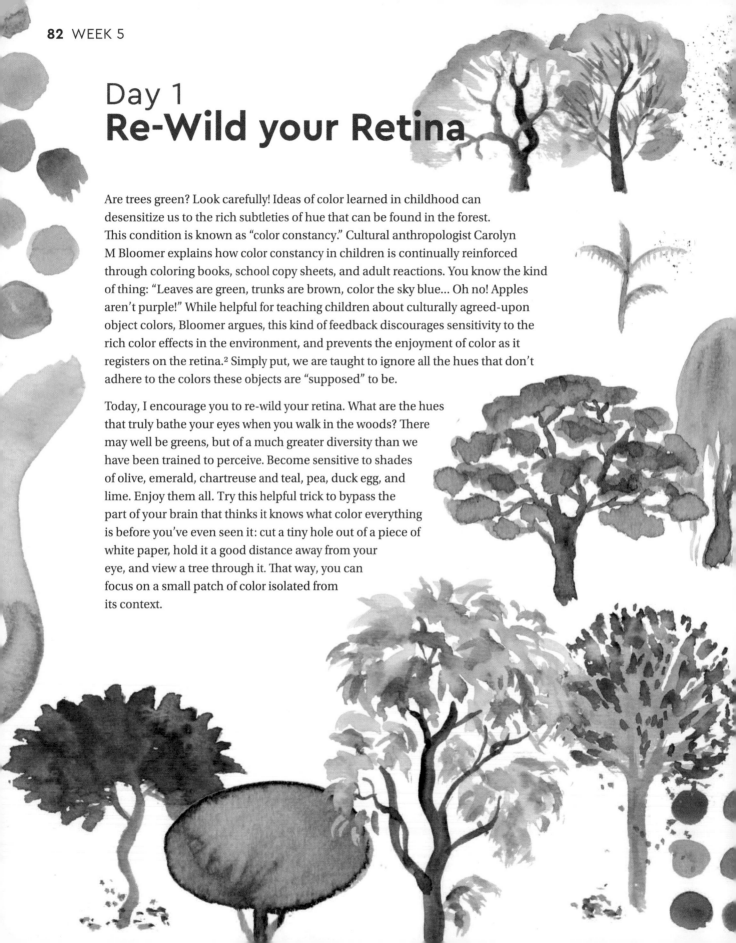

Day 1
Re-Wild your Retina

Are trees green? Look carefully! Ideas of color learned in childhood can desensitize us to the rich subtleties of hue that can be found in the forest. This condition is known as "color constancy." Cultural anthropologist Carolyn M Bloomer explains how color constancy in children is continually reinforced through coloring books, school copy sheets, and adult reactions. You know the kind of thing: "Leaves are green, trunks are brown, color the sky blue... Oh no! Apples aren't purple!" While helpful for teaching children about culturally agreed-upon object colors, Bloomer argues, this kind of feedback discourages sensitivity to the rich color effects in the environment, and prevents the enjoyment of color as it registers on the retina.[2] Simply put, we are taught to ignore all the hues that don't adhere to the colors these objects are "supposed" to be.

Today, I encourage you to re-wild your retina. What are the hues that truly bathe your eyes when you walk in the woods? There may well be greens, but of a much greater diversity than we have been trained to perceive. Become sensitive to shades of olive, emerald, chartreuse and teal, pea, duck egg, and lime. Enjoy them all. Try this helpful trick to bypass the part of your brain that thinks it knows what color everything is before you've even seen it: cut a tiny hole out of a piece of white paper, hold it a good distance away from your eye, and view a tree through it. That way, you can focus on a small patch of color isolated from its context.

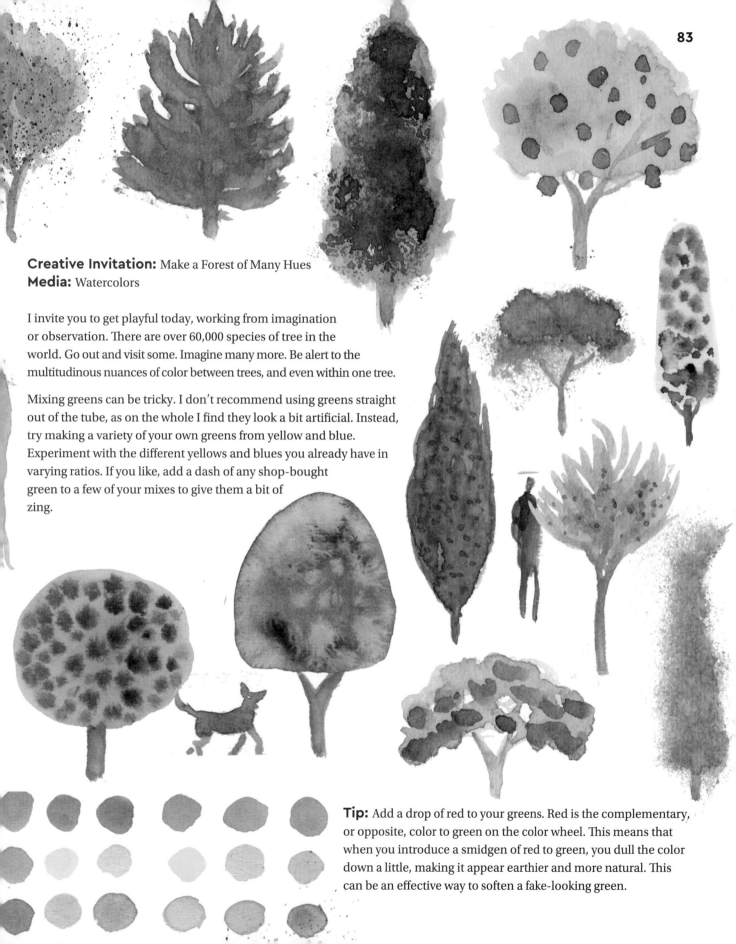

Creative Invitation: Make a Forest of Many Hues
Media: Watercolors

I invite you to get playful today, working from imagination or observation. There are over 60,000 species of tree in the world. Go out and visit some. Imagine many more. Be alert to the multitudinous nuances of color between trees, and even within one tree.

Mixing greens can be tricky. I don't recommend using greens straight out of the tube, as on the whole I find they look a bit artificial. Instead, try making a variety of your own greens from yellow and blue. Experiment with the different yellows and blues you already have in varying ratios. If you like, add a dash of any shop-bought green to a few of your mixes to give them a bit of zing.

Tip: Add a drop of red to your greens. Red is the complementary, or opposite, color to green on the color wheel. This means that when you introduce a smidgen of red to green, you dull the color down a little, making it appear earthier and more natural. This can be an effective way to soften a fake-looking green.

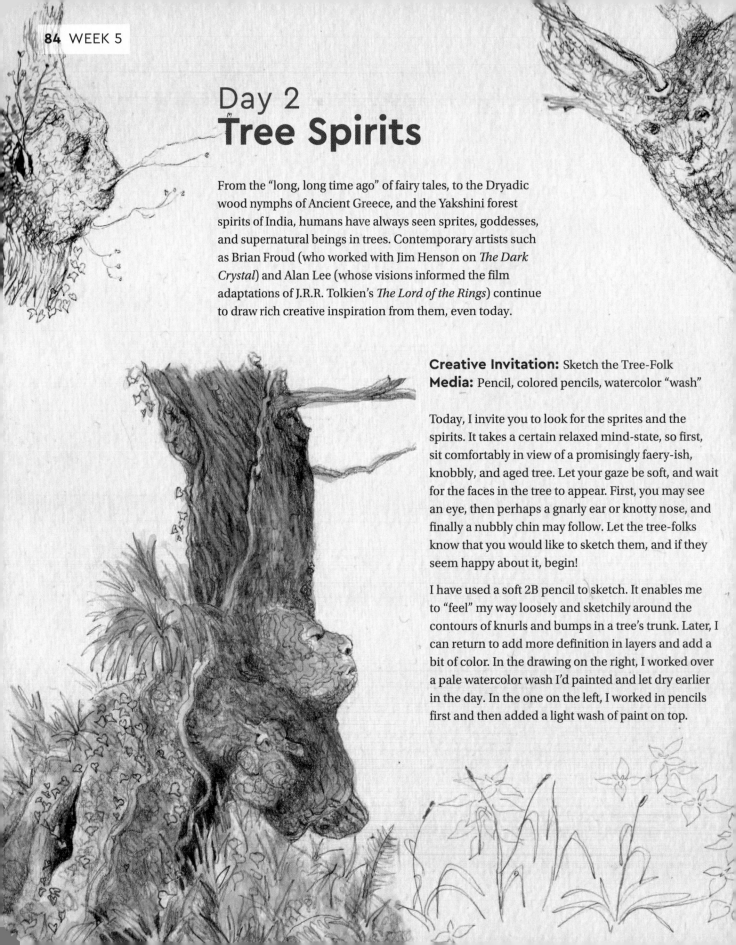

Day 2
Tree Spirits

From the "long, long time ago" of fairy tales, to the Dryadic wood nymphs of Ancient Greece, and the Yakshini forest spirits of India, humans have always seen sprites, goddesses, and supernatural beings in trees. Contemporary artists such as Brian Froud (who worked with Jim Henson on *The Dark Crystal*) and Alan Lee (whose visions informed the film adaptations of J.R.R. Tolkien's *The Lord of the Rings*) continue to draw rich creative inspiration from them, even today.

Creative Invitation: Sketch the Tree-Folk
Media: Pencil, colored pencils, watercolor "wash"

Today, I invite you to look for the sprites and the spirits. It takes a certain relaxed mind-state, so first, sit comfortably in view of a promisingly faery-ish, knobbly, and aged tree. Let your gaze be soft, and wait for the faces in the tree to appear. First, you may see an eye, then perhaps a gnarly ear or knotty nose, and finally a nubbly chin may follow. Let the tree-folks know that you would like to sketch them, and if they seem happy about it, begin!

I have used a soft 2B pencil to sketch. It enables me to "feel" my way loosely and sketchily around the contours of knurls and bumps in a tree's trunk. Later, I can return to add more definition in layers and add a bit of color. In the drawing on the right, I worked over a pale watercolor wash I'd painted and let dry earlier in the day. In the one on the left, I worked in pencils first and then added a light wash of paint on top.

Tip: What is a wash? It's basically just a word to describe your background layer of watercolor paint. Using your biggest brush, dilute your paint with plenty of water so that you get a light, all-over covering of paint on paper. Yellow ochre is a good choice for an unobtrusive wash: you want your background to be soft and supportive rather than attention-seeking.

Why do we talk about "touching wood" in the UK, or "knocking on wood" in the US, and why do we say similar things in many other countries around the world too? One explanation traces the phenomenon back to ancient pagan cultures such as that of the Celts. Touching a tree trunk may have been a way of invoking support from the spirit of the tree, or thanking it for protection already provided.

I admit to participating in this practice of touching wood — if I am telling someone my good news, especially if it's not yet fully materialized, I always place my hand on a nearby tree, table or chair leg for reassurance that it's not going to go wrong. I've done it as long as I can remember!

Fascinatingly, a recent study demonstrated that wood really does provide reassurance. A research paper in 2017 showed that positive physiological responses can be gained from simply touching a piece of wood.

In the study, people placed their palm on untreated white oak, marble, tile, and stainless steel with their eyes closed for 90 seconds. Touching the oak led to responses that you might normally expect to see when out in an actual forest. By measuring for heart rate variability, people were found to be experiencing clear physiological relaxation.[3] There's something to that old habit: wood really does soothe our fears!

Day 3
Respect for Our Elders

Gnarly and wizened trees, centuries old, form rich worlds for a wealth of creatures. Ancient woodlands create complex ecosystems. A rugged old oak, split and rotting in places, provides a honeycomb of hollows and holes for beetles, mammals, and birds to shelter in. Badgers burrow beneath. Bats roost in crevices in the trunk. Microscopic beings swim in tiny pockets of water pooling between branches. Lichens and mosses grow ever so slowly along the nubbly surfaces. Woodpeckers drill holes in the soft, elderly wood. Bees, wasps, sawflies, and moths munch the mouldering bark and bank voles feast on the fruiting fungi that grows there.

"There's no substitute for an ancient tree, or an ancient anything else," says writer George Monbiot. "Big old trees are the 'keystone structures' of forests, on which many other species depend."[4] It turns out that even dead trees are full of life! "The very trees that foresters have tended to weed out — forked, twisted, lightning-struck, rotten, dead — are those that harbor the most life." By way of example, Monbiot points out that Dryad's Saddle, which is just one of the many species of fungus that thrive on rotten branches, harbors 246 species of beetle alone.

Monbiot advocates for "a new and deeper respect for the entanglements of nature," and proposes a general preservation order for all trees, living or dead, greater than 100 years old, so that people would need express permission to fell one. If you live in the UK, you can register a tree you suspect is ancient and special with the Woodland Trust who will visit, verify, and try to protect it.

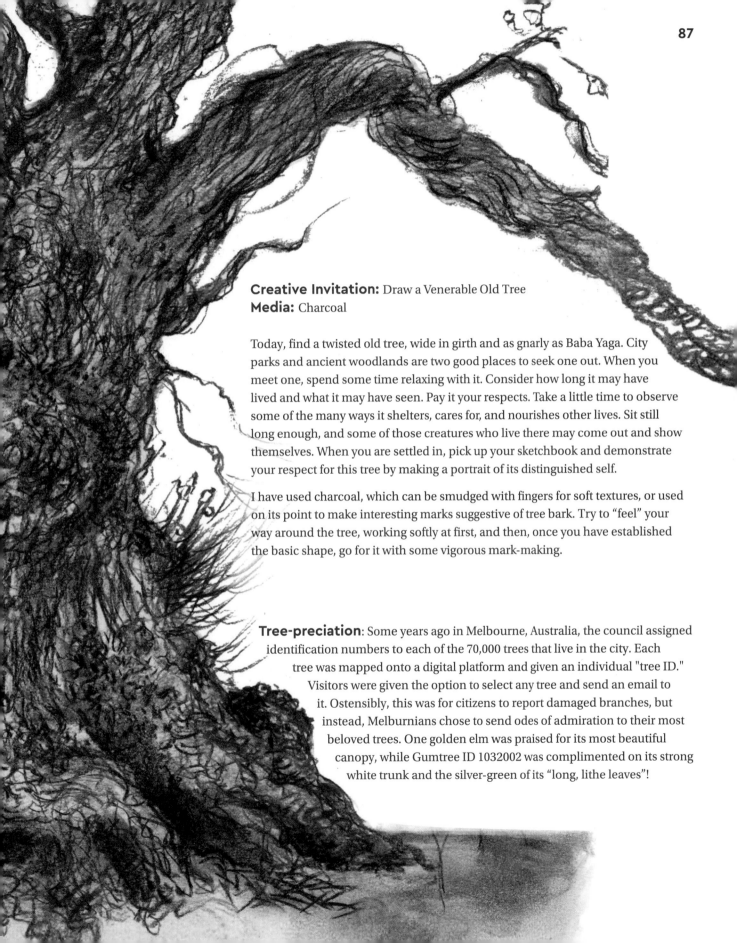

Creative Invitation: Draw a Venerable Old Tree
Media: Charcoal

Today, find a twisted old tree, wide in girth and as gnarly as Baba Yaga. City parks and ancient woodlands are two good places to seek one out. When you meet one, spend some time relaxing with it. Consider how long it may have lived and what it may have seen. Pay it your respects. Take a little time to observe some of the many ways it shelters, cares for, and nourishes other lives. Sit still long enough, and some of those creatures who live there may come out and show themselves. When you are settled in, pick up your sketchbook and demonstrate your respect for this tree by making a portrait of its distinguished self.

I have used charcoal, which can be smudged with fingers for soft textures, or used on its point to make interesting marks suggestive of tree bark. Try to "feel" your way around the tree, working softly at first, and then, once you have established the basic shape, go for it with some vigorous mark-making.

Tree-preciation: Some years ago in Melbourne, Australia, the council assigned identification numbers to each of the 70,000 trees that live in the city. Each tree was mapped onto a digital platform and given an individual "tree ID." Visitors were given the option to select any tree and send an email to it. Ostensibly, this was for citizens to report damaged branches, but instead, Melburnians chose to send odes of admiration to their most beloved trees. One golden elm was praised for its most beautiful canopy, while Gumtree ID 1032002 was complimented on its strong white trunk and the silver-green of its "long, lithe leaves"!

Day 4
Get Curious About a Tree

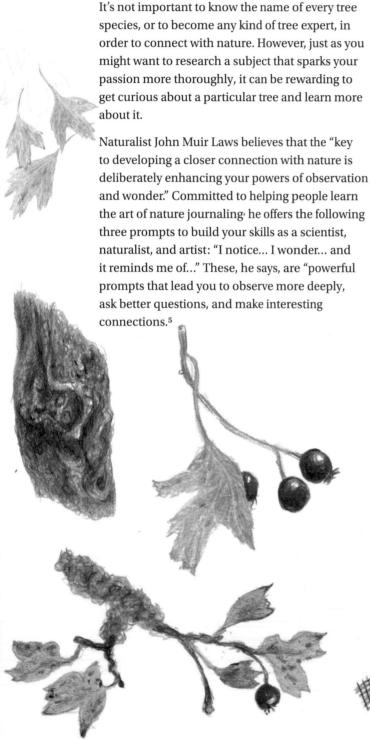

It's not important to know the name of every tree species, or to become any kind of tree expert, in order to connect with nature. However, just as you might want to research a subject that sparks your passion more thoroughly, it can be rewarding to get curious about a particular tree and learn more about it.

Naturalist John Muir Laws believes that the "key to developing a closer connection with nature is deliberately enhancing your powers of observation and wonder." Committed to helping people learn the art of nature journaling, he offers the following three prompts to build your skills as a scientist, naturalist, and artist: "I notice... I wonder... and it reminds me of..." These, he says, are "powerful prompts that lead you to observe more deeply, ask better questions, and make interesting connections.[5]

Creative Invitation: Curiousi-tree
Media: Colored pencils, ink

Begin by finding a tree you'd like to get to know better. Start with your own observations: what do you see, feel, and hear? What does your tree smell like, what are the shape and color of its leaves, and how does the texture of its bark feel? Try listening for the sound its leaves make in the wind. John Muir Laws comments that the leaves of different kinds of trees make unique sounds: some whistle, some rustle, others clatter.

Is it big or small, growing alone or in a group? What do you deduce about its likes and dislikes — is it thriving in sun or shade, does it seem well-rooted in rich soil or does it prefer stony ground? Try noticing ten things about your tree and record these as visual or written notes.

Now, move on to wondering... What do you not yet know, but wonder about this tree? Is it a native tree? How might this leaf shape help the tree to survive? Can you find any evidence of it being used by animals? Is it producing fruits, flowers, or seeds right now? Might any parts of it have medicinal properties, or be good to eat?

And finally, does this tree remind you of anything? Perhaps the shape of the seed pods reminds you of apples, or beans, or a grinning mouth, or a spaceship. Perhaps the tree evokes memories and old stories. I have chosen to draw a trio of hawthorn trees; they remind me of old fairy tales, the illustrations of Arthur Rackham, and — although these ones live in a park in Bristol — happy times spent roaming the romantic, misty moors of Devon where many of their relations make a home.

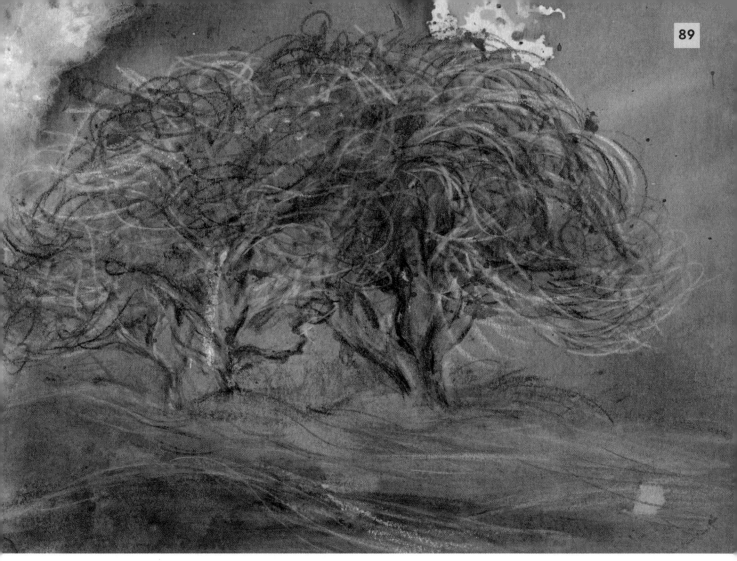

I have used colored pencils over an inky pink background wash. Try gently building up layers of pencil: keep your pencils sharp and let one color overlap another. For richer textures, play with a few techniques such as:

Stippling — make lots of tiny dots on your paper, close together or far apart.

Hatching — draw a series of parallel lines, all going in the same direction.

Cross-hatching — hatch first, then draw another series of parallel lines going in a different direction on top of the first set of lines.

Scumbling — make continuous circular marks on your paper, without lifting your pencil.

"A world of infinite beauty and discovery waits just beyond the point where we usually stop paying attention. Nature offers us peace, a rich and meaningful place to learn. There is no computer program that can replicate the richness of seeing a flower up close, the intrigue of geeking out with bugs, or the calm of laying on your back and watching clouds."

JOHN MUIR LAWS

Day 5
Enter a Dark Wood

"In the middle of the journey of our life," wrote Dante, "I came to myself, in a dark wood, where the direct way was lost. It is a hard thing to speak of, how wild, harsh, and impenetrable that wood was, so that thinking of it recreates the fear." Nevertheless, Dante knew he must carry on with the tale in order to also tell "of the good that I found there." At the heart of so many old stories and myths there lies a deep, dark wood. There, the protagonist must face witches and wolves, but will also receive the help of woodland creatures along with other precious gifts. Ultimately, the hero will develop in knowledge and maturity, coming out wiser and more empowered than when they went in. Jungian thinkers say that these fairy forests serve as metaphors for the unknown regions of the psyche. At the forest's edge, we cross the boundary into our unexplored inner life, face our shadows and find our gold.

Creative Invitation: The Forest Inside You
Media: Watercolor, or any media of your choice

Have you ever had a dream about being in a forest? What were you doing? Were you lost or did you know where you were going? Were you scared, or comforted, or filled with wonder? Did you meet anyone along your way? If you don't recall a dream, that's fine — we can actively daydream right now by painting from our imagination.

Begin a painting or drawing on the theme of entering the forest. Do not plan it in advance: simply start as if you actually were entering an unknown forest and allow what's there to gradually reveal itself as you go along. Do not concern yourself with whether this will become a "good" painting or not. Let it be a process, an open-minded wandering in the woods amongst the shadows and sunshine of your psyche.

Tip:
If you use plenty of water and a reasonably stiff brush, you can lift dry watercolor paint off your painting. Scrub at the area with your brush so the paint dissolves into the water, then blot it with a clean tissue. As well as being a useful "cheat" to erase small mistakes, you can do some "negative painting" in this way, which is what I have done to pick out these ghostly, moonlit roots.

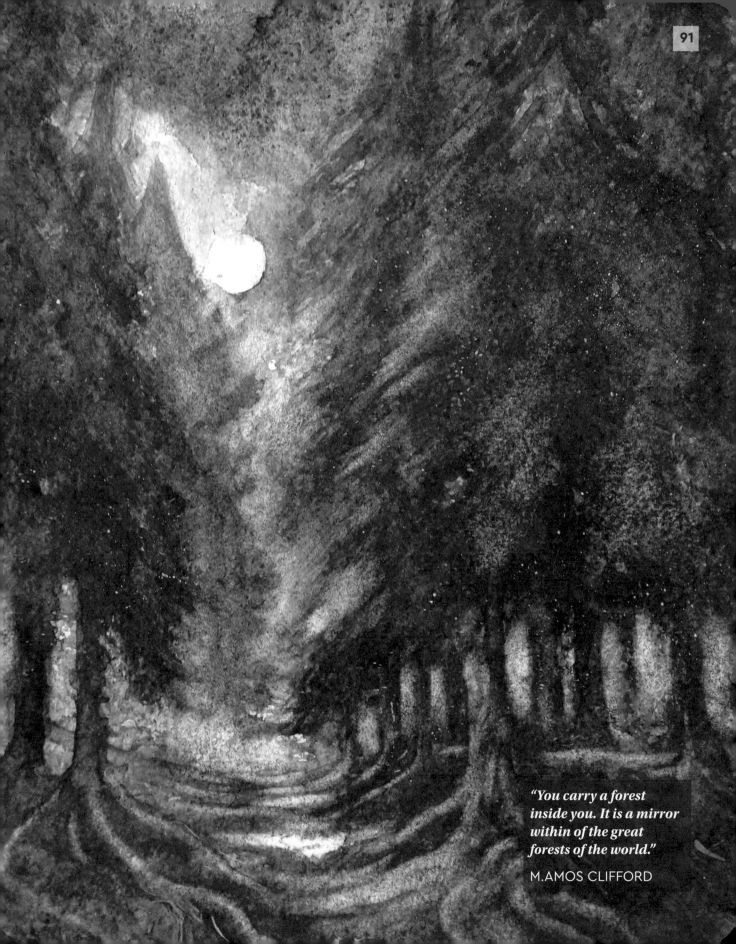

"You carry a forest inside you. It is a mirror within of the great forests of the world."

M.AMOS CLIFFORD

Day 6
Trees That Heal with Guest Artist Lindsay Alderton

Certain trees have always held special significance across human cultures, and the yew tree, with its extraordinary ability to live for thousands of years, has much to teach humans about healing and regeneration. Yews have an amazing capacity for renewal and endurance, being able to return to life from apparent decay, and have borne witness through the eons to the fluctuating patterns and shaping of human civilization.

Whilst undergoing treatment for breast cancer in 2019, Lindsay Alderton learned, from cancer nurse Mandy Edwards, that the chemotherapy drug Taxol is derived from the yew tree. This transformed her story from one of fear to "curiosity and wonder," and she made a pledge that when her body was well enough, she would make a yew tree pilgrimage across Britain, to say thank you and gather stories about these remarkable trees.

Lindsay's "pilgrimage of praise" involves an exploration of artistic mediums to support coming back into the right relationship with nature. This includes movement, poetry, and the crafting and offering of ritual objects. As she walks between one yew and the next, she makes totems of thankfulness gathered from the landscape around her, which she describes as "garlands of gratitude to give back to the land." These are "as much a way of weaving a story of love between the trees as resituating the usual framework of human accumulation as central," says Lindsay. "For years, I would gather up pretty things as I'd walk, feathers and stones which spoke to different memories and stories. It is a different kind of orientation when the intention is not to keep, but to offer back in return."

Some say that every time a gift is given, pressed from one hand into another, it is enlivened and regenerated through the new meaning it kindles in both the giver and the receiver. Lindsay asks us: "How might the same apply when a gift is passed from hand to root, branch, or bark? What opens in the mind, heart and body when we give away something we'd quite like to keep? What occurs in the relational field between human and more-than-human? What gift is received in the giving away?"

Creative Invitation: Give a Gift to a Tree
Media: Thread or string, a knife, pencils

Gather some binding tools — some thread or string (made from natural substances, like hemp) and a knife — then take your pencils and notebook and take a walk, perhaps towards a tree you already know or one you would like to know better. Let your attention settle into the rhythmic act of walking, but notice when particular objects in the landscape attract your attention: that leaf, that stone, that feather, that flower. Start to gather a few of them up, but choose carefully — resist the temptation to pick up everything! (Perhaps only choose the things that you'd like to keep yourself.) On arrival at the tree, close your eyes and settle for a while (or do some gentle movements — whatever brings you more fully into an embodied place) and place the objects in front of you. Begin to let your hands craft the objects together into a shape or form that is pleasing to your eyes and heart, perhaps enchanting it with words of well-wishing and protection for the tree. Photograph or draw what you have made, then ask the tree for permission and listen to where it would like to have the object placed. Pay attention over the next day to the feelings, images, and dreams which may arise.

All photographs by Lindsay Alderton; yew illustrations by Emma Burleigh.

Day 7
Trees of Imagination

"The tree which moves some to tears of joy is in the eyes of others only a green thing that stands in the way. Some see nature all ridicule and deformity... and some scarce see nature at all. But to the eyes of the man of imagination, nature is imagination itself."

WILLIAM BLAKE

Trees have ignited the creative imagination of many a writer and many a reader. Which of your favorite stories from childhood involve trees? I remember Enid Blyton's enchanted *Magic Faraway Tree*, Tokien's tall Treebeard of Fangorn with a "green flicker" in his eye, and the valuable but violent Whomping Willow of Hogwarts. I also recall many a happy hour spent playing on the tumble-down apple tree in my grandparents' garden, the perfect ship or castle or palomino pony. Not long ago, a friend's six-year-old daughter pointed out a "dragon" to me in the park. I looked carefully for her dragon and saw she was quite right: seen with the eye of imagination, the decaying, old, fallen tree was indeed flaring its nostrils and fixing us with a fearsome stare.

The scientific term for the perception of friendly faces, frightful creatures, divine deities, and other surprising images in random objects is "pareidolia". Certain early psychiatrists were rather wary of the practice, believing it to be a harbinger of mental illness. But long before their time, Leonardo da Vinci was promoting the art of pareidolia, noting in his journal that if you look at "any walls spotted with various stains or ... different kinds of stones," you will be able to see "landscapes adorned with mountains, rivers, rocks, trees, plains, wide valleys... figures in quick movement, and strange expressions of faces, and outlandish costumes, and an infinite number of things." Today, neuroscientists at the University of Bern are investigating the connection between creativity and seeing faces in clouds, noting a clear link between higher creativity and a heightened ability to perceive these images.[6] In my own experience as a teacher and an artist, I believe the ability to see in this way can be cultivated. I think we all have it in childhood, but for various reasons a lot of us learn to shut it down as we grow older.

Creative Invitation: Look with the Eye of Imagination
Media: Felt tips, inks, pastels or your choice

William Blake said that to the eye of the man of imagination, nature is imagination herself. What did he mean? Is a tree ever just a tree? Is it ever simply a "green thing that stands in the way?" Some might say beauty is in the eye of the beholder, and others might say that the person who does not see beauty is missing something vital, meaningful, and life-giving. What kind of world opens up to a person who values their imagination?

Today, find a tree that sparks a flight of fancy and sketch it with the "eye of imagination." Perhaps it reminds you of something from your childhood, or a story you once read. Maybe you can visualize building a fabulous treehouse high up in its branches, or dream up a bunch of magical characters who live within its cavities. Maybe, like my friend's daughter, you spy a dragon lurking in a toppled poplar, or detect a 16th century galleon trapped inside the twisted trunk of a beached oak.

Opposite page: bottom, this page top: *I've drawn a wonderful old fallen tree in felt tips I borrowed from a child, and an imaginary treehouse using ink and soft pastels.*

WEEK 6
Plants

Our focus this week is on growth, flowering, and self-expression. The qualities of easeful communication, inspiration and the energy of seeking and speaking our truth, which connect to the fifth chakra, will guide our investigations. We'll explore the wonders of plants, fruits, flowers, and gardens, and resonate with their powers of vitality, resilience and joy.

"Keep love in your heart. A life without it is like a sunless garden when the flowers are dead. The consciousness of loving and being loved brings a warmth and a richness to life that nothing else can bring."

OSCAR WILDE

Day 1
Mandalas and Microbiota with Guest Artist Mayumi Nakabayashi

Mayumi makes flower mandalas. She's also a singer, forager, and therapist who has a special interest in microbiota and gut health. The human microbiota consists of the 10–100 trillion symbiotic microorganisms such as bacteria, fungi, and viruses that reside in the gut. Beyond the human body, microbes can be found everywhere, and they were here on the planet long before any human beings appeared. Once we arrived, however, they moved right in: our intestines are one of the most densely populated microbial habitats known on Earth. Gut microbiota functions are manifold: they defend us against harmful microorganisms, digest certain foods for us, and facilitate absorption of minerals such as calcium and iron. Fascinatingly, as Mayumi explains, they even shape our emotional mood and behavior. When we go out, meet other people, move into different environments or eat new foods, our microbiota change. They are an ever-shifting, ephemeral population. For

Mayumi, the finely tuned ecosystems of the planet all around us mirror these sensitive, internal ecosystems in our bodies. The macroverse and the microverse follow the same graceful patterns.

Making mandalas gives Mayumi space to reflect on these patterns and processes of change, and she loves to share the practice of mandala-making with participants who attend her workshops on gut health and microbiota. Mayumi makes a mandala every two or three days, at home in her kitchen or on the floor. She often receives "help" from her son or her cats. She assures me that their interventions really are helpful, preventing her from becoming too "precious" about the work, and reminding her of the ephemerality of life and its continuing processes of change, decay, and renewal. "If I'm getting annoyed by the wind or the animals, I have to question why I'm doing it. It's about the process, not the outcome."

Creative Invitation: Make a Mandala
Media: Flowers

Mayumi invites you to source some flowers. If you don't have your own garden, you could take a few from plants that are in abundance, or collect fallen flowerheads, petals, and leaves from a park or meadow. Take only what you need, and remember not to pick wildflowers that are needed by the birds and bees when they are scarce. Look carefully at the blooms you've gathered. Notice the fine detail in every part. What shapes do the stamens, the pistils, and the stems make? What variations in color and texture do you see? Delicately take each flower apart if you feel moved to. Mayumi begins with no plan in mind. She suggests simply placing an item onto a flat surface such as table or floor, and then extending your design outwards from there. Let it be a slow and meditative practice, and let the positioning of each item suggest the next. Mayumi uses her hands to place everything, but if you're struggling with precision, try a small stick.

Questions for Reflection:

How do you like the result? Did you enjoy the making process? Mayumi asks: "What emotions, feelings, and thoughts arose as you made your mandala? And what would you like to do with those feelings — nurture them, ignore them, or simply be with them?" Jung considered a mandala to be a manifestation of our internal universe. Do you think your mandala might be reflecting something that's going on inside you? Could it be a mirror of your inner ecosystem, or even a message from your microbiota? Mayumi shared that the practice of making mandalas helps her with problem-solving. Working on a micro level with flowers to create a harmonious pattern helps her to tune into a sense of the shape and design of the universe at a larger scale. Just as a small floret of broccoli is the same shape as the whole broccoli head, we can observe how small things in life are tiny fractals of larger things. What if this applied to large and intractable issues of human psychology, public health, politics, and more? What if solving the small things within our personal control could impact the shape and order of the seemingly giant and unsolvable things?

"The reason why I'm so interested in microbiota comes from the intriguing fact that our body is made up of 90 percent microbiota and 10 percent human cells. John Cryan and Ted Dinan from APC Microbiome Institute at University College Cork say the ratio may even be 99 percent microbiota and 1 percent human cells! So, if our body is made of mostly invisible, small, and intelligent creatures, I feel that it is crucial to work with them to lead creative and fulfilling lives as humans. In our acts and thoughts, we often seem to separate ourselves from nature by manipulating and exploiting the natural reserves, or even by saying 'we have to protect nature.' Although the idea is honorable, it somehow still gives an impression of a division: nature vs human. We are also nature."

MAYUMI NAKABAYASHI

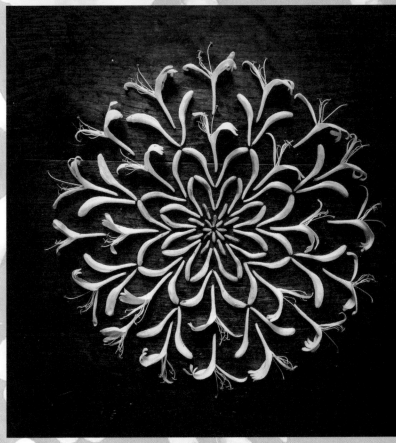

All mandalas by Mayumi Nakabayashi.

Day 2
Pavement Plants

Even if you live in a city, you may find a surprising diversity of plants pushing up through cracks in the pavement, clinging to toeholds in walls, and running riot along the edges of major roads. Projects such as *sauvages de ma rue* in France encourage us to pay attention to the wayside weeds that we usually ignore or dismiss by inviting us to discover more about them, share pictures of them on social media, and even label the plants we know with chalk graffiti on the pavement to enlighten the neighbors!

A few years ago, France took the radical step of banning pesticide use in parks, streets, and other public spaces, leading to a surge in awareness of urban wild plants and the insect life they support. Some French people have fully embraced the cause, sowing poppy and hollyhock seeds in concrete corners to beautify their streets. Historically, many councils and residents have seen weeds as something untidy to eliminate as quickly as possible with pesticides. However, a weedy city needn't look like the set for a post-apocalyptic wasteland movie, argues UK movement More Than Weeds, providing the weeds are managed well and in a nature-friendly way.

Scrappy city plants have a lot to offer, bringing beauty and biodiversity to our towns. Bees, bugs, and butterflies thrive on the humblest of so-called "weeds," from drinking rich dandelion nectar to laying eggs on bunches of neglected nettles. The Daubeney area of Hackney, East London, was declared glyphosate-free in 2019. In just one Hackney street, More Than Weeds counted 62 plant species from 26 different plant families; as their website says, just imagine how much more wildlife a street like this could support![1]

It's fascinating to hear the stories behind the most unloved of weeds. As I write this, in late summer, I notice my suburban front steps have become rather overrun with starry yellow ragwort flowers. Oxford ragwort, a common sight along railways and in cities, is descended from a plant that grows on the slopes of Mount Etna in Sicily. Ever since I learned this fact from a fellow weed enthusiast, I look at that riotous, sunshine-hued weed with newfound respect, as I visualize its volcanic Sicilian roots. The neighbors may not appreciate it just yet, but I will let the ragwort remain.

Creative Invitation: Gather, Print, and Hammer
Media: Ink or paint, and a hammer

Take a walk around your city today, or along a verge or roadside if you live in the country. Keep an eye out for flashes of green. They are most likely to be found in the liminal spaces — along the pavement edges, or in the cracks in stone, brick, and tarmac. If you like, photograph and share them on social media (#morethanweeds) to find out more about them from other weed enthusiasts.

Where you find an abundance of a certain weed, pick a leaf or two to bring home with you. Once you've gathered a variety of plant forms, you are ready to have some fun with printmaking!

Pour some ink (or paint if you don't have ink) onto a flat, waterproof surface — a lid from a plastic box or biscuit tin will do. Now, dip your leaves into the ink and, if necessary, use a brush to gently distribute it across the surface of the leaf. Carefully lift each leaf off the lid and place it onto some thick paper. (If the leaf has gotten all bunched up, try to spread it out gently with a paintbrush.) Place another sheet of paper over the top of the leaf and press down firmly, being sure to press down on all the edges of the leaf. Lift and see what you have got. You may have two prints, one on each layer of paper. One may be quite wet and runny; one may be drier in appearance. Experiment with different amounts of ink, in a range of colors, to get the perfect consistency.

To create a design, try building up layers of printed leaves on the same piece of paper or cutting out your best ones and collaging them together. Once the prints are dry, you can also paint in the usual way over the top with ink or watercolor to create a painting with an interesting printed underlayer (see the elliptical images on this page and also the title page for this chapter for examples of this.)

Variation – Hammering: You can also "hammer" leaves and flowers. This works best with leaves that are fine and dry rather than fleshy. Put the leaves between two thick pieces of paper, place on a flat surface, and bash hard on top with a hammer as if trying to flatten a sandwich. Peel back the paper to reveal an impression of the leaf. The plant on the immediate right-hand margin here is a hammered lemon balm leaf.

Day 3
Find a Local Treasure

One person's weed is another's exotic treasure. I was surprised to learn that dandelions, considered one of Britain's most stubborn and persistent weeds, are highly sought after in Singapore where the hot and humid climate makes them hard to grow. When I was a kid, my parents gave my brother and I a small patch of garden each, to make our own. I don't remember mine very well, but I recall my brother's vividly. He created a "weed garden" and filled it with all the rejected plants from the rest of the garden — dandelions galore! Funnily enough, my brother now lives in Singapore, where there's even a sculpture at the airport celebrating the perfect fluffy sphere of this rare beauty's seed head.[2]

Little did we imagine, when playing in my brother's weed garden back in the 1980s, that a garden full of weeds would be awarded a gold medal at a Royal Horticultural Society show in 2021. The plot, named Weed Thriller[3], received the award at Tatton Flower Show in Cheshire, UK. The growers, Rachel and Geoff Evatt and Sandra Nock, wanted to champion "wild plants that have been branded incorrectly as weeds" because "a weed is just a plant in the wrong place." Without these native plants, a lot of our insects and birds "just wouldn't cope." The star of the show? Ragwort — that same sunny yellow weed I mentioned yesterday, running amok in my own garden. This "controversial species" they declare to be "one of the most important sources of nectar for a wide variety of insects." I certainly don't think I'll be winning any awards for my weedy garden, but I do think the insects are happy.

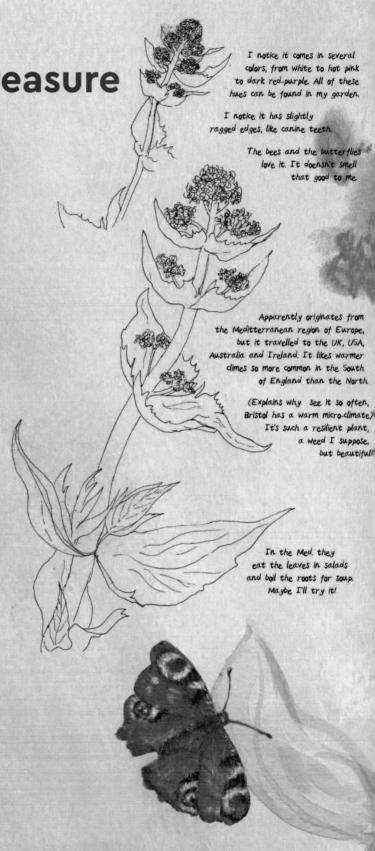

I notice it comes in several colors, from white to hot pink to dark red-purple. All of these hues can be found in my garden.

I notice it has slightly ragged edges, like canine teeth.

The bees and the butterflies love it. It doesn't smell that good to me.

Apparently originates from the Meditterranean region of Europe, but it travelled to the UK, USA, Australia and Ireland. It likes warmer climes so more common in the South of England than the North.

(Explains why see it so often, Bristol has a warm micro-climate) It's such a resilient plant, a weed I suppose, but beautiful!

In the Med. they eat the leaves in salads and boil the roots for soup. Maybe I'll try it!

Creative Invitation: Plant Journaling
Media: Pen, pencil, watercolor or paint, chalk

Today, I invite you to choose a favorite weed from the ones you noticed yesterday — a weed that you'd like to know more about. I have chosen valerian, which grows even more vigorously than ragwort on my local streets, adorning brick walls and concrete corners with cheerful clouds of pink.

Go out and look for your weed. Sit and draw it. Use the three prompts from John Muir Laws to make notes as you sketch: "I notice... I wonder... It reminds me of..." Find out more about your plant. To learn its name, you can download various free apps that will help identify a plant for you. Let your research be prompted by your wonderings. Before you go home, you could label the plant in chalk for the benefit of others!

I have worked with fineliner pen for detail, and used watercolor both to capture a sense of the plant's graceful movement, and to analyze the varied hues of pink that the valerian comes in. The butterfly was drawn in soft pastel on the back of an old brown envelope and then stuck onto the page.

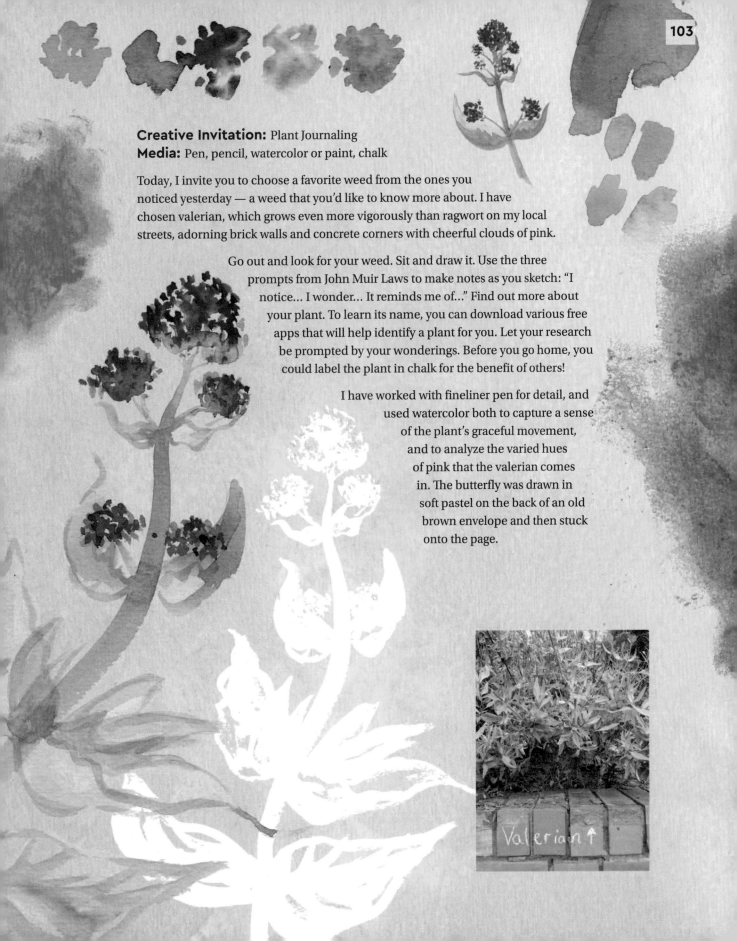

Day 4
Grassroots Growing

Dotted around my city, wedged in between roads and railways, lie a patchwork of allotments, vegetable beds, city farms, permaculture plots, and community food gardens. In urban areas across the world, the picture is the same: squeezed between shopping malls and cemeteries, tucked behind tower blocks and public buildings, you'll discover a range of vibrant answers to the problems of food poverty, soil degradation, urban ugliness, depression, and disempowered communities.

In Oroville, California, you can visit an urban food forest forged from an abandoned parking lot by gardener Matthew Trumm.[4] In the Bronx, you'll find the Food for Others Garden bursting out of a decommissioned city street, which generates over 5,000 pounds of vegetables every year to feed local families.[5] Astonishingly, an allotment holder or gardener can grow between four and eleven times the weight of produce you'd expect to get from an intensively farmed arable field.[6]

In towns all over the planet, you will find beds of vegetables you can help yourself to as you walk along the street or pop into a shop. Incredible Edible[7] was co-founded by Pam Warhurst around the kitchen table with friends, without a single "flippin' strategy document" in sight. The budding project group began by planting fruit trees, herbs, and vegetables around the doctor's surgery, and created a "sprouting cemetery" where the soil was found to be "extremely good!" From her small market town of Todmorden, UK, Pam's vision to grow edible landscapes where "our children can walk past their food," instead of buying it encased in plastic, has caught on and spread like bindweed.

Across the pond in the Bronx, teacher Stephen Ritz decided to learn, alongside his students, how to make an indoor "edible wall." This led to the birth of Green Bronx Machine,[8] which "teaches kids to re-vision their communities" through the medium of grassroots farming. Young people from "the poorest congressional district in America, the most migratory community in America" are growing food that feeds "hundreds of people without a food stamp or a fingerprint... moving kids into an economy they never imagined."

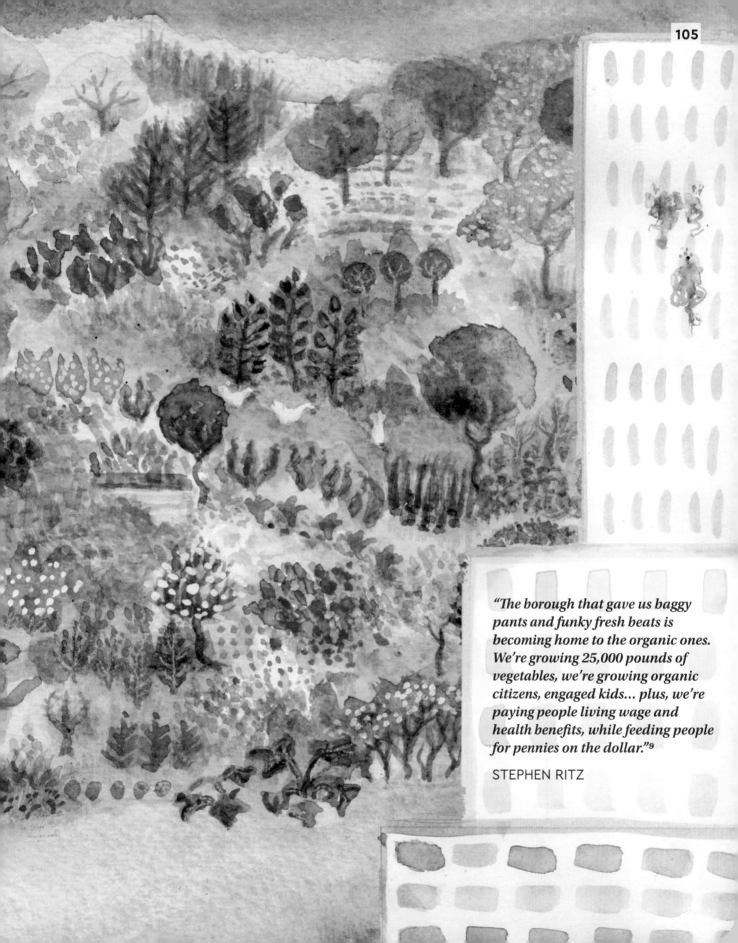

"*The borough that gave us baggy pants and funky fresh beats is becoming home to the organic ones. We're growing 25,000 pounds of vegetables, we're growing organic citizens, engaged kids... plus, we're paying people living wage and health benefits, while feeding people for pennies on the dollar.*"[9]

STEPHEN RITZ

Day 4 continued...
Grassroots Growing

Creative Invitation: Patchwork Veggies
Media: Watercolor

Make a visit to a food-growing project near you. The diversity of colors, forms and scents will be a treat for your eyes and nose, and also for your mind and body: there's evidence to show that the more biodiverse the environment, the better it is for your health and wellbeing. In my watercolor painting, opposite, I was inspired by the patchwork quilt-like appearance of plots at my local allotment. You could begin, as I did, by using watercolor, ink, or gouache to paint a patchwork of colors as a base layer (see example on the right). I suggest using just three colors to keep everything harmonious and coherent.

Once this layer has dried, you can have some fun adding the details of people, plants, and wildlife. Notice the patterns made by various crops and use these to give structure to each patch of your painting. Do not worry about being too true to life: let yourself be playful as you design patterns and shapes based on the plants that surround you. Think of it as embroidery.

"The liveness in me just loves to feel the liveness in growing things, in grass and rain and leaves and flowers and sun and feathers and furs and earth and sand and moss."

EMILY CARR

Day 5
'Roses and Castles' with Guest Artist Dr. Amy Goodwin:

In 19th century Britain, before railways became widespread, goods were ferried around via canals. The families who lived and worked on the narrowboats took pride in painting their boats with intricate designs. These days, many people (friends of mine included) still live on these boats, moored up on the waterways that criss-cross the UK. For those who have the practical nous and appreciate the close-to-nature lifestyle, with ducks paddling past the window, narrowboat living can be a good solution to the UK's affordable housing crisis.

The traditional style of boat painting is known as "Roses and Castles," although other kinds of flowers and romantic imagery such as rivers, lakes, and churches may also be featured. Nowadays, some people paint their boats in personal and modern styles, but others choose to have their boat painted in the traditional way by a skilled canal boat painter.

Although no one really knows how the folk art of Roses and Castles originated, links are made with Romani culture (as traditional Roma caravans often sport similar art styles), while other art historians have pointed out similarities with folk art from Germany and Asia.

Dr. Amy Goodwin grew up traveling steam fairgrounds in the West Country, and has been practicing and working as a traditional signwriter and fairground artist for the last decade. Amy has recently been learning canal and narrowboat art from master signwriter Phil Speight, immersing herself in the folk traditions and styles of this signwriting discipline.

"My signwriting approach is underpinned by heritage and tradition. As such, it felt imperative to learn Roses and Castles from an established signwriter in this field. I feel incredibly lucky to have spent time in Phil Speight's workshop, immersed in the canal boat way of life, learning the various styles of roses (and their origins), and surrounded by his collection of Roses and Castles. This application of signwriting is so different to my previous work: the same materials and brushes, but the flair of the brushstroke takes precedence. Allowing the brush to work out the composition to create the balance, blending colors quickly, and ensuring the work exudes [a certain] energy are all new techniques to me." — Dr. Amy Goodwin

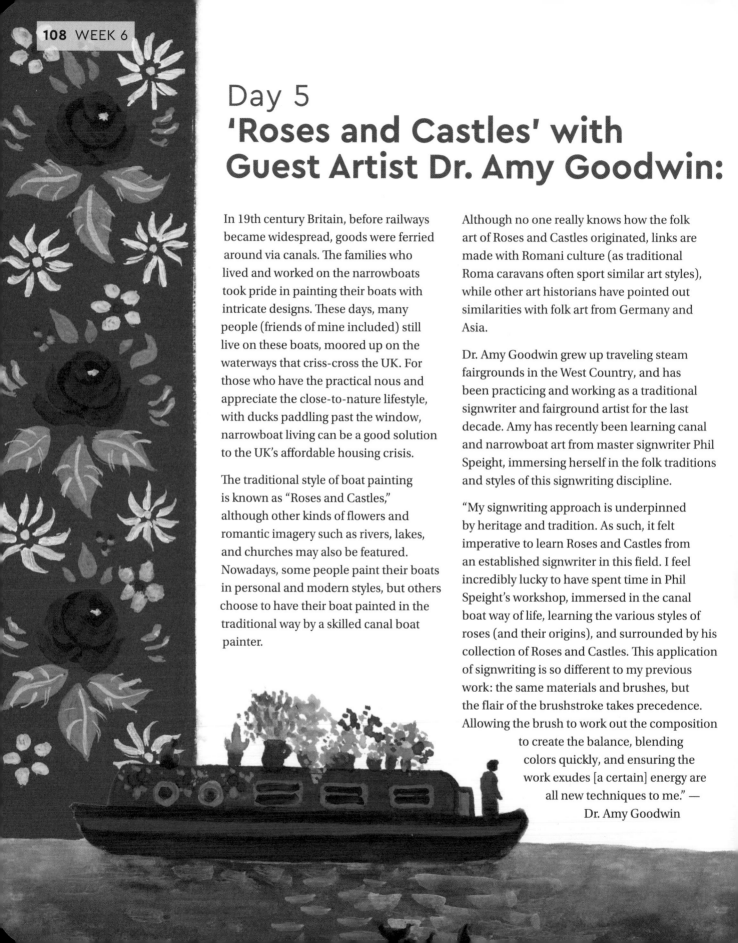

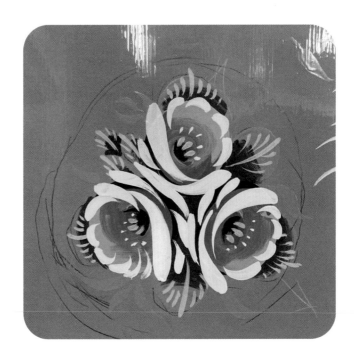

Creative Invitation: Research and Design
Media: Gouache paints

Research: What are the folk art traditions in the place where you live? Do you know anything about the traditional arts associated with your own personal cultural heritage? Often, folk art shows a celebration of the colors, shapes, and flowers found in the artist's local environment. Learn a bit more about traditional art styles connected to your home. Do you think that the colors, patterns, flowers or leaf shapes could be inspired by plants you know from the walks you take in your locality?

Design: I invite you to play with creating your own personal design, inspired by folk art tradition, that draws visual inspiration from the plants and flowers that are meaningful to you. Think about the plants that keep you company every day where you live: how would you abstract them into simple shapes and colors that could be repeated as motifs to build up a design? Choose a limited range of four or five colors, and settle on a few simple flower and leaf shapes. I suggest using gouache for this piece if you have some. Paint a background color first, and once it's dry, sketch and paint your leaves and flowers over the top. Let your brushwork be relaxed, have "flair," and exude energy.

This page, top right: Photo by Amy Goodwin of a sample from her own traditional Roses and Castles boat painting work. All other illustrations by Emma Burleigh, gouache on paper.

Day 6
The Flowering of Expression

American botanist Luther Burbank believed that "flowers always make people better, happier, and more helpful; they are sunshine, food and medicine to the mind." It is hard not to feel uplifted by a flower. Flowers seem to embody joy and, as Ralph Waldo Emerson saw it, "the earth laughs in flowers." We often use flowers as metaphors for the unfolding of our greatest potential. Canadian artist Emily Carr wrote of the "glory of growth" opening her up "like a flower to the light of a fuller consciousness." When we say a person or a culture is "flowering," we mean they are coming into their fullest, richest, creative expression. A person in "full bloom" is glowing with energy, life, and health.

12th century herbalist and mystic Hildegard of Bingen spoke often about something she called "viriditas," the divine greening force of nature expressed in a combination of the Latin words for "green" and "truth." Viriditas, she believed, is the natural driving force toward healing and wholeness, the vital power that sustains all life and makes us grow and blossom, spiritually as well as physically.

Hildegard also spoke about the capacity of viriditas to moisten and crack open the heart, calling forth compassion. There is something so tender about a flower, that it can touch us in times of grief and vulnerability as well as happiness. Today, let the flowers resonate with you in whatever emotional space you occupy.

"Dare to declare who you are. It is not far from the shores of silence to the boundaries of speech. The path is not long, but the way is deep. You must not only walk there, you must be prepared to leap."

HILDEGARD OF BINGEN

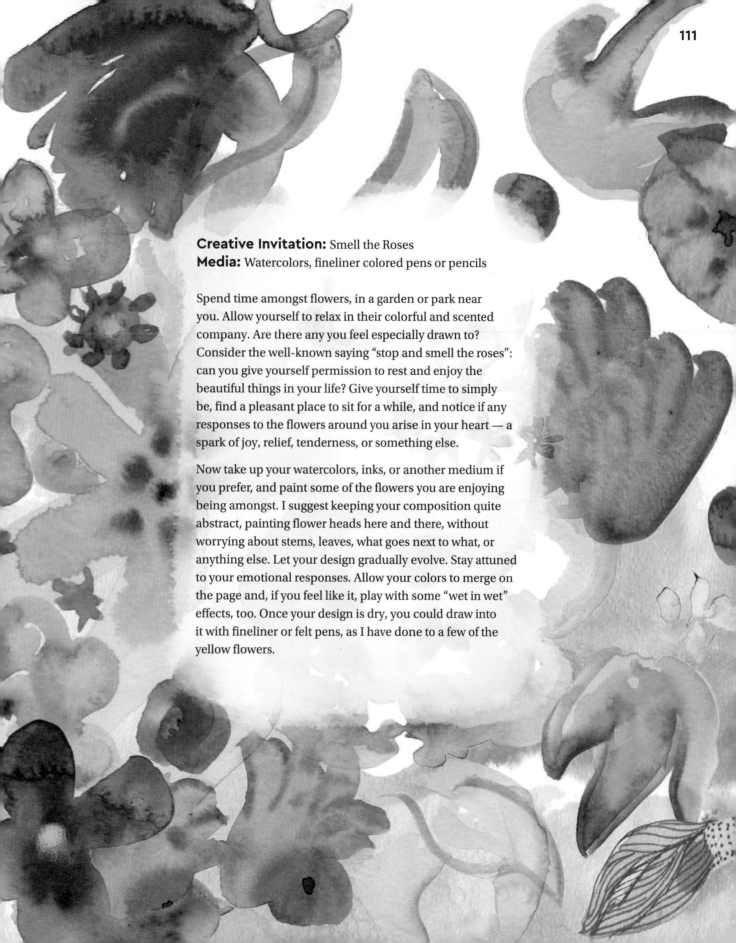

Creative Invitation: Smell the Roses
Media: Watercolors, fineliner colored pens or pencils

Spend time amongst flowers, in a garden or park near
you. Allow yourself to relax in their colorful and scented
company. Are there any you feel especially drawn to?
Consider the well-known saying "stop and smell the roses":
can you give yourself permission to rest and enjoy the
beautiful things in your life? Give yourself time to simply
be, find a pleasant place to sit for a while, and notice if any
responses to the flowers around you arise in your heart — a
spark of joy, relief, tenderness, or something else.

Now take up your watercolors, inks, or another medium if
you prefer, and paint some of the flowers you are enjoying
being amongst. I suggest keeping your composition quite
abstract, painting flower heads here and there, without
worrying about stems, leaves, what goes next to what, or
anything else. Let your design gradually evolve. Stay attuned
to your emotional responses. Allow your colors to merge on
the page and, if you feel like it, play with some "wet in wet"
effects, too. Once your design is dry, you could draw into
it with fineliner or felt pens, as I have done to a few of the
yellow flowers.

Day 7
Green Truth

Let's linger a little longer with Hildegard of Bingen, the 12th century German abbess I mentioned yesterday. I'm fascinated by Hildegard's fusion of the words "green" and "truth" in order to point to what she believed was a divine force. With her unorthodox view that the universe is like an "egg in the womb" of a, presumably feminine, God, and her passion for boiling up plant potions, she was fortunate not to have been born 200 years later, or anytime in the following three centuries; she'd have probably been burned as a witch during Europe's long purge of women who, some argue, included the wise, the healers, and the outspoken critics of patriarchal power.

I'm curious about the challenges we may encounter when we feel the urge to open up and "flower." What blocks our natural expressions — artistic or otherwise? Speaking the truth can be dangerous, especially to power, and many of us find ourselves holding back, reluctant to allow the full force of the river of "green truth" to flow through us. Plenty of us have built a lifetime of dams to obstruct the route, having learned all sorts of reasons why it is not safe to give expression to our thoughts and feelings. A lot of our blocks may be unconscious, long assimilated into our personality, or held in the body as tensions and aches.

Sometimes, when we do manage to take the plunge, we experience pushback. This pushback may come from outside of you, or from inside your own head in the form of an "inner critic," or both. I admire the warmth and strength of Aspen Baker, advocate of Pro Voice Practice,[10] who says that no conflict, no matter how important it is to you or your community, "should define or limit your ability to honestly express yourself and experience happiness and joy." To speak honestly, we need to foster wellbeing in ourselves: only then can we value the wellbeing of others, including those who may be trying to hurt or fight us. Self-care will help us to avoid reacting and throwing more pain back into the world, or at ourselves. One way to create a climate where true expression can flourish, says Baker, is to listen with empathy to ourselves and to others. Ask open-ended questions, she counsels, suggesting that you ask yourself or someone that you know

these three questions: "How are you feeling?" "What was that like?" "What do you hope for, now?"

Creative Invitation: Viriditas Collage
Media: Scissors, glue and watercolors (or any colorful inks, paints, or felt tips)

Do you have a sense of viriditas, that verdant, lush energy which Hildegarde said makes "all creatures green and vital"? Can you recognize it in the landscape around you? Can you feel that spark of green vitality mirrored within, by the energies of your own body? Is there a "green truth" bubbling up inside you that wants to come out? Can you allow it to express itself without censorship? What kind of climate do you need to feel safe enough to allow the creative force to flow freely through you and out onto your page today?

A flower needs a good environment to blossom — there must be water, light, shelter, and soil. What nurture do you need to unfurl? Try asking yourself some open questions and listen carefully to your answers. You could do this as a journaling exercise. It can be interesting to answer your questions with your non-dominant hand, as it tends to cut through to the more emotional, intuitive layer of yourself.

When you are ready, try this artistic exercise. Choose some flowers that resonate with you, and that seem to emanate viriditas. What are the three or four key colors of these plants? Cover a sheet of paper in each color, using inks, watercolors, sharpies, or any other media you like. Let the application of the media be streaky and messy. Now, cover another page with a background color — perhaps a dark forest green or chocolate earth. Once your background page is dry, draw a quick, continuous line sketch of your flowers onto it; keep your hand moving and let the image flow out of your pencil freely. You are now ready to cut or tear your brightly colored papers into shapes in order to create a collage of your flowers. Use your line drawing as a background and stick your torn or cut shapes onto it using a glue stick. Don't worry if the shapes you tear are a bit wonky — just go with it! Allow viriditas to unfurl on the page.

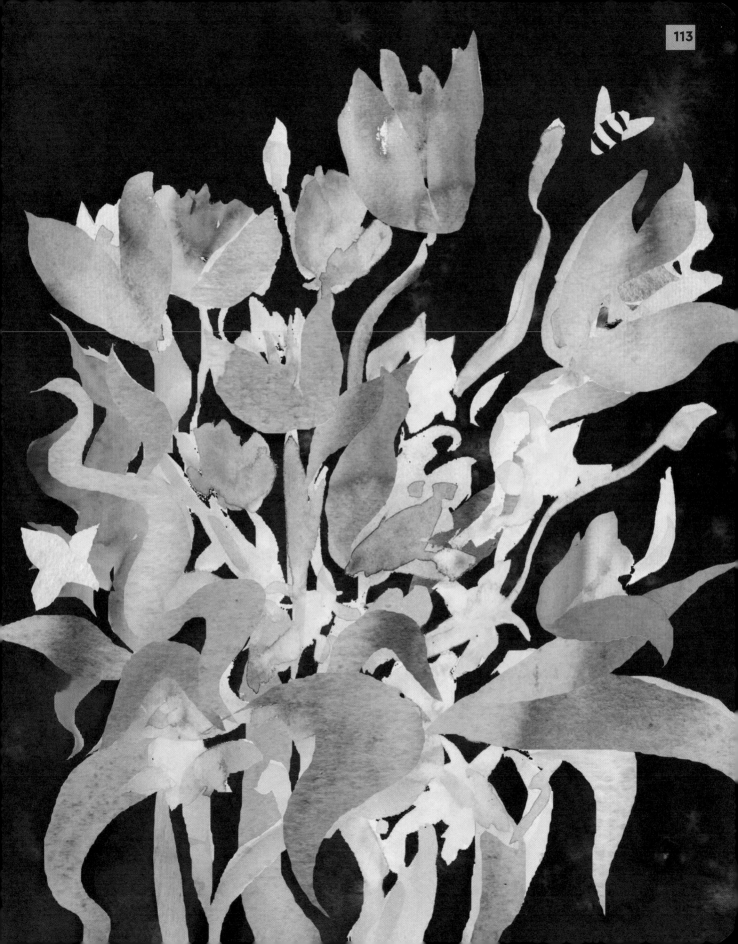

WEEK 7
Animals

This week, we look to our companions who are furred, feathered, or scaled; who hop, scuttle, or fly; who buzz, chirp, or roar. We'll combine this with attention to the energies associated with the sixth chakra, considered the center of intuition, expanded imagination, and dreaming.

In pre-technological times, we had to rely on signals from nature and a more primal, animal instinct to guide us through life. For many of us, the intuitive sense now lies somewhat dormant — we have lost touch with it, and lost trust in it. Cultivating a mind-state of spacious listening and heart-centeredness is key to its reawakening.

The work associated with this chakra is to look within, acknowledge our inner truth, and face the fear of our own shadows. This week, we'll contemplate endings as well as beginnings, reflect on the unknown, and explore ways to tune in to our inner wisdom and imagination. We will look to the animals for guidance on this. Understanding and receiving the wisdom of other life forms is essential to our survival, believed theologian Thomas Berry. Animal connection can help us to dispel our culture's human-exceptionalist, nature-destroying trance. The "deepest form of creative presence throughout the universe is wild," wrote Berry.[1] It can be heard through the imagination, and it may well speak to us in animal voices.

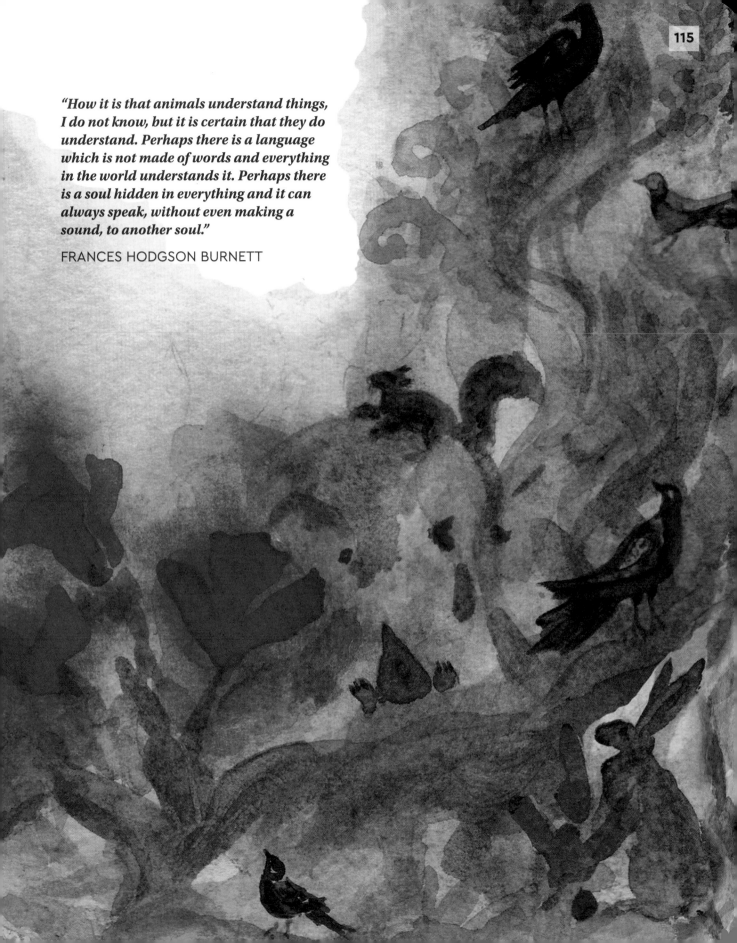

"How it is that animals understand things, I do not know, but it is certain that they do understand. Perhaps there is a language which is not made of words and everything in the world understands it. Perhaps there is a soul hidden in everything and it can always speak, without even making a sound, to another soul."

FRANCES HODGSON BURNETT

Day 1
The Blue Hour

Walking home at twilight on a summer evening after meeting friends in the park, a flash of movement in the bushes caught our attention. As our eyes adjusted to the dim light, there appeared not one, but three foxes. One sat motionless and alert in the long grass beside the playing field, a second peered at us from beneath an archway of brambles, and a third — the smallest — trotted across our path, unperturbed, towards the cherry trees and perhaps the bins beyond. Sometimes, I think of my home city of Bristol as the City of Foxes. There are thought to be around 16 foxes per square kilometre living in Bristol, and even more in London.[2] Like certain other species, foxes have found ways to thrive in habitats dense with humans all over the world.

Every evening, from her window, Bristolian artist Bethany Sewell[3] likes to photograph the wildlife on her doorstep: "Usually, I look out during blue hour; the sixty minutes which transition the world from night-time to daytime and vice versa. This form of visible light illuminates a time period of vibrant activity in nature: a time of feeding, moving, hunting, gathering, and migrating. During

this time, foxes play on the streets below, bringing a sense of magic to the concrete maze... It brings me a new sense of curiosity and wonder for the place in which I have lived all my life."

We are likely to discover an unexpected abundance of nature on our doorsteps, even in our cities. In heavily populated countries such as the UK, urban areas are forming an ever-more crucial part of many animals' habitats. Along canals and rivers in many towns, you may spot the sleek, wet head of an otter, or catch the teal and orange flash of a kingfisher, possibly perching atop an abandoned shopping trolley. If you look skywards, you might spy a pair of those two-hundred-mile-an-hour dive-bombers, peregrine falcons, roosting in a church spire, tall tower or even in the chimneys of London's iconic Battersea Power Station. So far, 372 bird species have been sighted in the UK capital, including exotic colonies of rose-ringed, lime green parakeets (escapee descendants of captive birds) who the peregrines consider quite a tasty snack.[4]

Further afield, you could meet coyotes in the Bronx, wild boars in Berlin, mountain lions around the fringes of San Francisco Bay, and metropolitan moose in the city of Anchorage, Alaska. Squirrels, skunks, and seagulls; rock doves, rats, and bats; robins, racoons, and red-tailed hawks... I wonder, who are your furred and feathered neighbors?

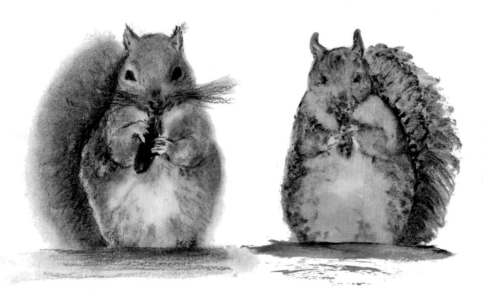

"It is just like man's vanity and impertinence to call an animal dumb because it is dumb to his dull perceptions."

MARK TWAIN

Creative Invitation: Meet Your Wild and Shy Neighbors
Media: Charcoal or soft B pencils

What animals live on your doorstep? Take a walk or watch from your garden or your window at the "blue hour," and see who comes along. Be sure to send them a "mental image of welcome," as advised by animal communicator Anna Breytenbach. I have sketched the animals I've met in charcoal, which is a great medium for smudging into soft, furry textures with your fingers. Of course, unless you want to draw animals in fleeting motion at high speed in semi-darkness, or your night-time photography skills are very good, you will probably need to refer to photos from other sources to draw from, as I have done. I like to look at photographs taken by others and do a bit of online research now and then, as it's so interesting to find out more about the wildlife in my area. You may not see many animals in just one twilight — unless you're very lucky — and if you're *un*lucky, you may see none at all. You might, however, feel inspired to make watching at the "blue hour" a regular event.

"Getting nose-to-nose with a real wild animal is important."

HUGH WARWICK

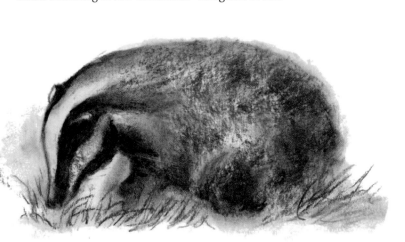

Day 2
Park Life

I walk along the lushly planted, tree-lined streets of my city, breathing deep lungfuls of cool, flower-scented air. I pick a plum, startling the birds who are tucking into the purple harvest hanging overhead. Every roof is green here, and the songs of birds last heard in my grandmother's time reverberate in a soundscape undisturbed by the roar of traffic. Cars are minimal, most people can get around easily by bike or bus, and the wildlife travel freely, too. Look up, or down, and you'll see wildlife bridges and tunnels offering foxes, badgers and deer safe passageway across major roads.

I wander into one of the many parks where people are sitting around and relaxing. There's plenty of green space for everyone; we learned how important it is to provide that in the pandemic. I stroll along areas of habitat set aside for different species — meadows, woods, and ponds — and turn into one of the "green corridors" created from a network of reclaimed streets leading me across the city to my carbon neutral workplace...

Ok, most of this is fantasy; although, to be fair, some cities have taken steps towards nurturing biodiversity. Take Edmonton in Canada, where a wildlife passage program helps deer, coyotes, beavers, skunks, porcupines, and the occasional moose get around. Whether you live in town or country, biodiversity matters. It's what keeps the planet functioning smoothly, like a gigantic and finely tuned living puzzle in which every piece has its place. From the tiniest microbes to forests and coral reefs, the kaleidoscopic interplay of life has made our home habitable for billions of years.

A rich multiformity of trees and birds is soothing to us humans and reduces anxiety.[5] On some deep level, perhaps we find biodiversity reassuring because we know in our bones that it means the Earth, our home, is well.[6]

We might be more used to thinking of biodiversity as something to be found in special places far away, but, with a bit of imagination, a town or city can host a biodiverse ecosystem, too. It's interesting to notice the animals already cohabiting alongside us, often quite symbiotically. Some lived here before our arrival, but others moved in to be with us. In my local park, I often see the crows fanning out across the field like a search party of black-jacketed detectives looking for picnic crumbs. Urban-dwelling scavengers such as rooks, crows, and coyotes provide a helpful sanitation service by cleaning up our food waste. Foxes keep down the rats, and gulls and magpies tidy up by snaffling roadkill. In areas of America where Lyme disease-infected ticks like to munch on white-footed mice, foxes hunt the mice and thus reduce the ticks. Opossums and raccoons help out too by eliminating thousands more ticks that attach to their fur every season. Meanwhile, with no need for chemicals, mosquito numbers are organically reduced by insect-eating bats and birds.[7] Do you know what roles the creatures near you play in the urban, suburban, or rural ecosystem where you live?

Creative Invitation: Life
Forms at Work and Play
Media: Colored pencils and
watercolors

When you go for your walk today,
think about the ecosystem in your
locality. How do humans and
other animals interact where you
are? How can we get along and
support each other as different
species living together? What
varieties of life do you observe
hard at work and play today? Find
a pleasant spot to sit in a park
or field, and watch the world go
by. Make a sketch or two, and, if
you like, use them to develop a
more stylized illustration. Your
illustration could share your
favorite observations, and/or
your vision of how things could
become better, more beautiful
and more biodiverse.

I did some sketching at the park in
colored pencils and pen, and then
went on to design a watercolor
image on the theme of "Our Green
City," inspired by activity I saw
on a nearby street bordering a
community garden. My design is
influenced by medieval "books of
hours." I love these prayer books
from the Middle Ages, which were
created for lay people to develop
a devotional practice, and which
integrated, in their rich, jewel-
like illustrations, images of the
everyday, the sacred, and the
downright quirky.

Day 3
Requiem or Rebirth?

"This is a dark time, filled with suffering and uncertainty. Like living cells in a larger body, it is natural that we feel the trauma of our world," says deep ecologist Joanna Macy. The significant question is how we respond to this suffering when it enters our awareness. Everyone is capable of compassion, affirms Macy, "and yet, everyone tends to avoid it because it's uncomfortable." Compassion comes from the Latin "compati," literally meaning to "suffer with." Our understandable reluctance to "suffer with" the pain of the world, our own "larger body," causes us to psychically "numb out" as a defense against feeling.

Jung was one of the first to point out that when we refuse to feel our grief, fear, rage and other anguishes of the heart, we get stuck in depression or neurosis. More recently, Macy has commented that our collective culture demonstrates a phobia of suffering leading to apathy (from the Greek *a-pathos*, "without suffering") and the equally dangerous neurosis of "social hysteria."

I feel drawn to the company of moths. They navigate through the confusion and uncertainty of the night by the feminine glow of the moon. They know how to seek out light in the darkness. The moth strikes me as a symbol of transformation, but unlike the butterfly, one that is at ease with the shadows. Can the symbolic moth who flies through the dark night of our collective soul teach me how to alchemize my own shadow of exiled feelings? Like the butterfly, the moth disintegrates to do the deep inner work of transformation inside an impenetrable pupa that it built for itself. This piece of the Earth's pain that I carry, unverbalized and unaccepted, is buried inside a deadening cocoon I have made from my own numbness. Making art helps us to sink down to a level that words can't reach, where we can register inchoately the sadness of our time and intuit our place within the web of life. Images can sometimes seem to have a reality of their own, speaking to us of what we could not say. I paint moths, I let these thoughts mull over in my mind, I try to allow the pain in my heart.

"There's a song that wants to sing itself through us," continues Macy. "We've just got to be available. Maybe the song that is to be sung through us is the most beautiful requiem for an irreplaceable planet, or maybe it's a song of joyous rebirth as we create a new culture that doesn't destroy its world." The moth dances at night, in the darkness, and it is too soon to say if it is dancing to the music of requiem or of rebirth.

Creative Invitation: Make Space to Feel Your Feelings
Media: Watercolors, ink, or clay, or your choice

Do you have feelings that have not been felt? How could you know? Do you intuit something unheard at a deeper layer of yourself? Is it possible you have built a cocoon around a part of your heart? Does the suggestion that you may be feeling unacknowledged grief for the pain of the world, and despair at how we humans are behaving, resonate with you? Does it feel true? Do you want to feel it? Why, and why not?

Meditate, or just sit quietly. Let your mind be as wide and empty as the night sky. Wait for an image. Is there an animal that comes to mind? Maybe one comes that makes no apparent sense — accept it anyway. Maybe nothing comes. That's ok too. Begin to work in any media that calls you, even if you have no image in mind, and no plan, no ideas. The tactility of clay can be therapeutic, releasing emotion and tapping into our subconscious wisdom. If you prefer to paint, as I have done, mix up some colors. You could begin by painting some moths, if these creatures speak to you, too. The process I used is pleasurable: start with the darkness — make a rich dark background in inks or paints. No need to let it dry. Now take some white paint to make the shapes of the moths appear, a little blurry and fuzzy-edged in the moist darkness. Next, you can add more details in earthy colors, again letting the paints bleed a little into the wet paper.

Day 4
Insect Musicians

Have you ever lain back in a meadow and watched the clouds drift overhead? I can't think of many pleasures more blissful than relaxing in a nest of summer grasses, surrounded by a sheltering wall of wildflowers and chirping crickets. While listening to these "tiny loiterers on the barley's beard,"[8] allowing my body to absorb the warmth of the sun and the strength of the ground, my mind falls as calm and receptive as a field of rippling grass, letting thoughts come and go like passing bees. I am content and at ease. I feel no compulsion to do anything or be anyone.

There's a rich tradition of insect appreciation in China and Japan. Ladies of the Tang Dynasty era liked to keep crickets beside their pillows so that they could be sung to sleep by these "insect musicians."[9] The haiku poets of Japan showed a tender attention to the tiniest of creatures including houseflies, fleas, and mosquitoes, and observed their invertebrate natures with a keen and lyrical eye.

We tend to hold these miniature beings in rather low regard, but if we humans vanished the ecosystem would adapt, and life would carry on pretty well without us. If, however, insects were to disappear, "the world would fall apart — there's no two ways about it," says entomologist, Professor Goggy Davidowitz.[10] As well as performing the vital act of pollinating the plants which we rely upon for our food, insects have some pretty weird and wonderful superpowers: houseflies have feet 10 million times more sensitive than human tongues,[11] certain moth caterpillars can deter their predators by posing as bird poo,[12] and to survive the winter many insects can replace all their bodily fluid content with a natural antifreeze called glycerol.[13]

Let's follow the lead of the revered Japanese poets today and take time to cherish these captivating and crucial critters.

it's all yours
butterfly, take a rest
on the mushroom

KOBAYASHI ISSA
TRANSLATION BY
DAVID G. LANOUE

summer cicada—
even in his lovemaking break
singing!

KOBAYASHI ISSA
TRANSLATION BY DAVID G. LANOUE

As autumn deepens,

a butterfly sips

chrysanthemum dew.

MATSUO BASHO
LOOSE TRANSLATION/
INTERPRETATION BY MICHAEL R.
BURCH

Creative Invitation: Bug Appreciation
Media: A waterproof fineliner pen or a dip-pen, and inks or watercolors

Sit, or even better lie, in a meadow or field. If it's damp, I recommend sourcing a picnic blanket with a waterproof underside. Let yourself relax, be idle, watch and listen to the world going by. Gradually focus your attention on the insects that surround you. Who is there? What are they up to? Follow, with your eyes, the path of one individual from flower to flower, up and down stalk, across leaf or into the undergrowth. Let your curiosity be piqued by these lives so very different from our own. How would it be to experience the world from a bug's perspective? How would life appear viewed through a grasshopper's enormous and complicated eyes?

Use ink-pen with an ink or watercolor wash to sketch some of the insects you are getting to know. Begin by drawing with a waterproof fineline pen, or a dip-pen (such as I have used) dipped in some black or brown waterproof ink. If you like, once the drawings are dry, splash on a little colored ink or bright watercolor. You might want to take a few photos on your phone camera to work from too if the insects are fast movers.

Day 5
The Shapes Birds Throw, with Guest Artist Hugh Warwick

Hedgehog-loving author and ecologist Hugh, often known as @hedgehoghugh, has written several books on wildlife and is the spokesperson for the British Hedgehog Preservation Society. But there is more to his passions than just this prickly mammal: he is also a keen photographer, and while his paid work tends to focus on choirs and orchestras, he has a keen eye for the beauty that visits his garden in Oxford, England. "Garden wildlife can often be overlooked as it is so mundane — it is the everyday," says Hugh. "But amazing things can happen. I managed to tame a robin to come and feed from my hand, for example. Though in retrospect, I wonder whether the robin trained me to feed him!"

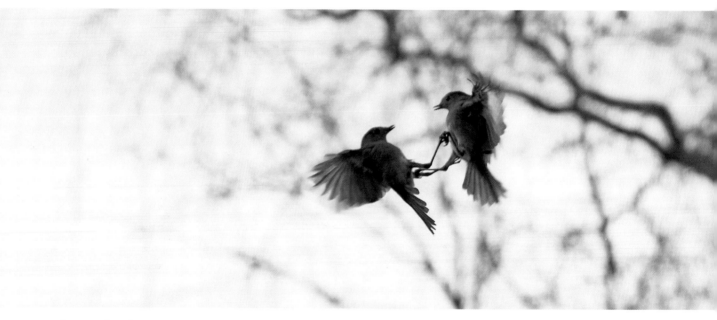

Creative Invitation: Paying Attention to the Birds
Media: Any camera

Sitting calmly and letting the wildlife come to you can be something of a mindfulness practice. You need "a bit of patience and the ability to sit quietly and listen," says Hugh. Animals don't tend to stand still for the camera, and are unlikely to show themselves at all until we've settled down. Aim to emit a gentle, peaceful, and relaxed vibe!

Hugh enjoys "the shapes birds throw," and suggests finding a relaxing spot in the garden or park to observe this for a while. Birds are a good subject to choose today; there are nearly always some around and even a flock of urban pigeons (rock doves who moved to the city) will do just fine. "Try to take photographs of the birds just as they take off or land," advises Hugh, "as this is when they make the most interesting shapes." Use any camera that you have: the one on your phone may actually be pretty good. You could try shooting in "burst mode," which lets you take a few photos continuously, so you don't have to worry about getting your timing perfect. Most phones will automatically take "burst" photos if you press and hold the shutter button.

As a lifelong advocate for wildlife, Hugh encourages us to find a few small ways we can support our other-than-human companions in the place where we live. After all, when they bring so much beauty and delight to us, it just seems like good manners to say thank you! "Think about what gifts we can give — they are not complicated," says Hugh. "The gift of water, a shallow dish on the ground, maybe one higher up as well, will sustain life. The gift of shelter: this is easy, don't tidy up too much. The gift of food: if you don't tidy, the food will come — the seeds, pollen, insects, will flourish. And the gift of care: check before lighting a fire that no one has made the pile a home, check the long grass before cutting, avoid pesticides. And you can spread the love further — if you don't have your own garden, or even if you do, how about asking your local authority to make your parks and roadside verges more wildlife-friendly too?"

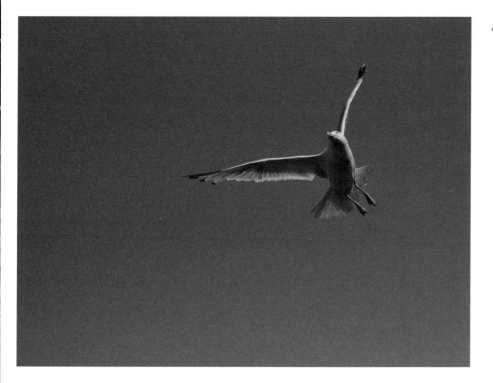

"We all need a little bit of wild in our lives, but that does not mean we need to head off on safari. Paying attention to the life around us can generate experiences as amazing as anything I have had with lions and elephants in Africa. And loving loca wildlifel has the added advantage that we will actively fight to protect what is in our community, so everyone benefits."

HUGH WARWICK

All photographs by Hugh Warwick.

Day 6
Behind the Words

There's a moment in the classic children's story, *The Secret Garden*, when Mary meets a robin. The encounter is meaningful to Mary — she "felt as if she had understood a robin and that he had understood her" — and a friendship is forged between the two of them. Free of coercion or self-preoccupation, they greet each other with a mutually curious "hello, who are you?"

Penelope Smith[14] is a non-fictional, present-day animal communicator, known as the "Grandmother of Interspecies Communication." While working as a counsellor for human clients, she realised that her skill of respectful, receptive listening was appreciated by animals too. Penelope rejects the mechanistic, behaviorist views of animals held by some, and asserts that human and non-human animals alike are on a spiritual journey: we are all "biological forms animated by spiritual beings or essences." We can connect with animals, whether domesticated or wild, if we are open, calm, and willing to feel into the place behind words. "We're born with the ability to understand other beings; we're born with the ability to get what's behind the words," says Penelope. We don't have words at birth, and yet we are feeling, sensitive, communicative beings from the get-go. For all its usefulness, our over-reliance on language has disconnected us from ourselves and from other species, and this has made us "miserable." If you'd like to connect with another animal, "sit down, be quiet, let go of all the socialized thoughts that 'we can't do this' and that 'it's only words that count,'" advises Penelope. "When we stop all the chatter and just open to another being of any species, we start to get who they are, how they feel, and we are connected to them." Once we start to look at animals "as fellow beings, as our friends who walk the earth with us," she adds, we also start to "get happier."

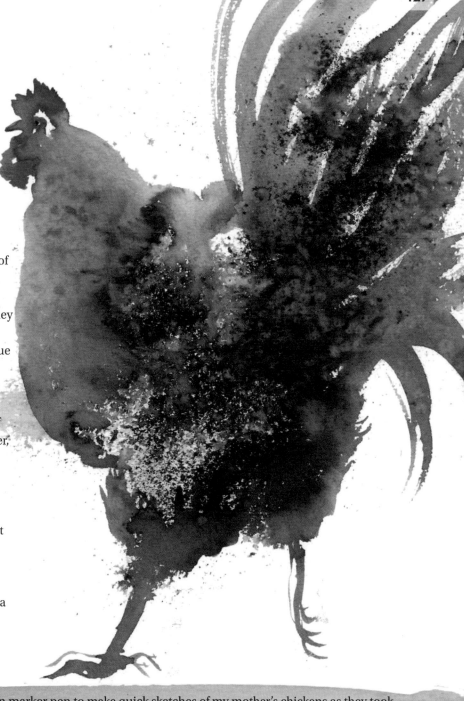

Creative Invitation: Hang Out With a Non-human Animal
Media: Pen, watercolors (and optional brusho)

Today, visit an animal and make a gesture of calm, receptive friendliness towards them. It could be as simple as saying "hello" and waiting peaceably for their reply, should they choose to respond. You could spend time with a friend's pet, visit an animal at a rescue sanctuary or city farm, or hang out with a garden bird. Do them the honor of making some sketches of them, if they don't mind, and take some time to sense the essence of their personality. See their unique character, notice their way of walking and talking, and observe what they like to do. Imagine life through their eyes. Receive their gaze, and extend an attitude of friendliness and approachability towards them: they are just as likely to be curious about you! Notice if you receive any mental impressions, for example in the form of pictures, colors, sounds or tactile sensations. This might be a message from your new animal friend.

I have used a brown marker pen to make quick sketches of my mother's chickens as they took their evening promenade around her garden in search of slugs to nibble. I also used brusho to make a larger painting, above. Brusho consists of small inky crystals that can be shaken out — a bit like table salt — onto a water-dampened shape on the page, where they will explode into vibrant colors. It's not cheap but you only need one or two pots to play with — I just used brown, but you can see how the color splits to make many shades and hues. You can also flick and splatter other inks and watercolors into the mix too: the little blue and yellow chicken was made in a similar way but without any brusho — I simply splattered lots of watercolor onto a page which I'd pre-dampened with water. An old toothbrush makes an excellent splattering tool.

Day 7
Animal Dreams

Do you remember dreaming of an animal? What was the encounter like? How did you relate to the animal — were you scared, or were you happy to see them? Did you feel an empathic connection or were you unsure of their feelings and intentions? Reconnecting to the animal presences in the psyche was important to Archetypal Psychologist James Hillman, who urged against reaching for the dream dictionary in order to nail down an interpretation, and instead recommended an approach he called "psychic ecology." Allow the animal in your dream to have its own psychic reality, let it be wild — a roamer of your imaginal world — alive and animate in the image-realm. Give the "life soul" back to your dream animal — a life soul you might have accidentally stripped away from it in your eagerness to analyze it.

Improving the human-animal relationship in our dreams is essential work towards the creation of a more equitable, animal-respecting waking world, believed Hillman. It is in our dreams, he said, that our darkest hidden parts can show up. Our "Cartesian alienation" from animals and arrogance toward them arises nightly in dreams where animals are feared, attacked, and eradicated so that the ego can awaken in the morning "as a self-centered hero" ready to begin the campaign of its daily business.[15] Fascinatingly, Hillman remarked that he had found people with the strongest sympathy toward animal causes still acted as "animal terrorists" in their dreams. I can attest to this: in particular, I have had two or three dreams wherein I try to hunt down and kill a horrifying snake, and yet in waking life, I like snakes and wish for them to live their lives un-assaulted.

Hillman understood that a healing change in consciousness can begin in dreams, when the dreamer faces the fear and allows the snarling dog or the hissing snake to approach. Intentionally changing consciousness within a dream requires a lot of lucidity, but an alternative I have found very interesting is to imagine a different outcome to such dreams once I am awake. What if I had not run after the snake and attacked it? What if I invite it to show me what it needs? What if I just let it be? What if it really does want to bite me, and I allow that? Giving space to the imagination to explore these options through art-making can be powerful. Working with your dreams might not sound very important to many people concerned with issues of Earth-justice, animal rights, and global peace, but Hillman's point that we need to make a profound change at the level of the psyche in order to come into right relationship with the more-than-human world makes sense to me.

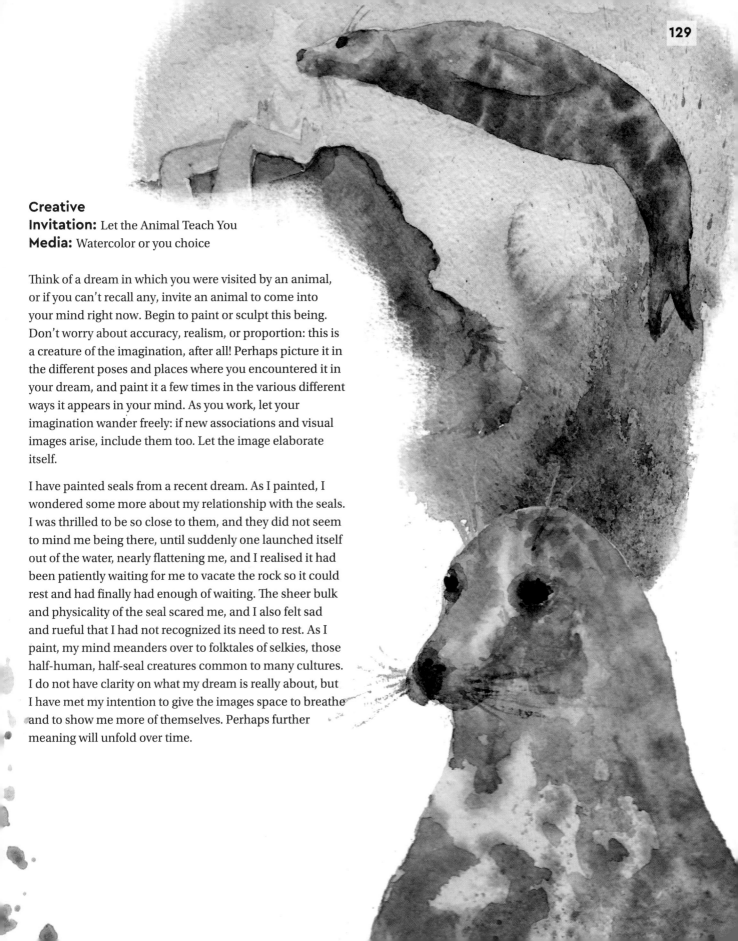

Creative
Invitation: Let the Animal Teach You
Media: Watercolor or you choice

Think of a dream in which you were visited by an animal, or if you can't recall any, invite an animal to come into your mind right now. Begin to paint or sculpt this being. Don't worry about accuracy, realism, or proportion: this is a creature of the imagination, after all! Perhaps picture it in the different poses and places where you encountered it in your dream, and paint it a few times in the various different ways it appears in your mind. As you work, let your imagination wander freely: if new associations and visual images arise, include them too. Let the image elaborate itself.

I have painted seals from a recent dream. As I painted, I wondered some more about my relationship with the seals. I was thrilled to be so close to them, and they did not seem to mind me being there, until suddenly one launched itself out of the water, nearly flattening me, and I realised it had been patiently waiting for me to vacate the rock so it could rest and had finally had enough of waiting. The sheer bulk and physicality of the seal scared me, and I also felt sad and rueful that I had not recognized its need to rest. As I paint, my mind meanders over to folktales of selkies, those half-human, half-seal creatures common to many cultures. I do not have clarity on what my dream is really about, but I have met my intention to give the images space to breathe and to show me more of themselves. Perhaps further meaning will unfold over time.

WEEK 8
Soul and Cosmos

In this final week, we open to the realms of experience symbolized by the crown, or seventh chakra. We will contemplate what Victor Hugo referred to as "the infinity of the soul and the infinity of the universe." We'll muse on the unity and interconnectivity of all things, and try to sense the mysterious energy that binds the universe together. We'll feel into the whole of this web of life that we are part of, and express our love and appreciation for this biosphere that breathes us.

"It seemed to be a necessary ritual that he should prepare himself for sleep by meditating under the solemnity of the night sky... a mysterious transaction between the infinity of the soul and the infinity of the universe."

VICTOR HUGO

Day 1
The Wisdom of the Garden

For a couple of years, I worked as the gardener at Gaia House, a meditation retreat center in the lush, rolling hills of South West England. The teachers there understood the healing and teaching powers of the garden very well; they would often send a would-be meditator who was struggling with the program up to the garden to take time out, to relax, or to do some planting, digging, chopping, burning, or other simple task that needed doing. In recent decades, grassroots garden projects have blossomed all over the world as social prescriptions for those who are sad, unwell, lonely, in prison, in marginalized communities, and in recovery from trauma and addiction. What is it that is so powerfully restorative about working and spending time in a garden?

Aligning with the patterns of nature — ever-changing yet curiously consistent — has brought a steadying influence to my own mind. When I feel impatient at my own progress, disappointed that I've run out of creative ideas or I'm just generally giving myself a hard time for being "unproductive," turning to the garden can provide me with a lot of wisdom. Spring will come again, and a fallow period of winter is inevitable and necessary. In February, growth is torturously slow; in June, "when weeds, in wheels, shoot long and lovely and lush,"[1] it is almost unstoppable. The garden shows me that things unfold in their own time and that when I interfere, worry, or prod around too much, I just get in the way. It tells me to slow down and accept my own natural pace in a culture where it's all too easy to pressure myself to go faster, harder, and do more.

"Like a suspension in time, the protected space of the garden allows our inner world and the outer world to co-exist free from the pressures of everyday life. Gardens, in this sense, offer us an in-between space which can be a meeting place between our innermost, dream-infused selves and the real physical world."

SUE STUART SMITH

Grief, like so many of our human experiences, comes in cycles. Long ago, King Solomon wrote: "There is a time for everything, and a season for every activity under heaven: a time to be born and a time to die; a time to plant and a time to uproot." We can find comfort in reflecting on the rhythms of nature during periods of loss and sadness. The garden reminds me that everything has its season, helping me to weather, emotionally speaking, bouts of wintry bleakness, as well as prompting me to savour spells of sunshine.

The healing power of gardens has long been clear to writers and artists. Some of the most curative gardens in our culture flourish in the collective imagination. Regular visits to the secret garden transforms Hodgson Burnett's "sour" and "contrary" little Mary into a child who "had run in the wind until her blood had grown warm" and "had been healthily hungry for the first time in her life." When Philippa Pearce's Tom discovers an other-worldly "Midnight Garden" beyond the door that, by day, leads only to a poky yard where the trash bins are kept, his lonely quarantine cooped up with an aunt in a London flat takes on a magical dimension, bringing solace and delight both to him and the little girl he meets within.

Creative Invitation: A Healing Garden
Media: Gouache

Spend some time in a garden, maybe one that you know well. Contemplate the seasons and cycles of this sheltering space. What remains the same, what changes, and what falls away but then comes back again every year? When you look around this garden, do you find any metaphors to support your own healing and self-care? If there's something on your mind or weighing on your heart, invite the garden to offer you an answer. What is present that can bring a sense of safety, comfort, joy or wisdom to you today?

Move now a little more into your imagination. Without thinking about it too hard, begin to create a healing garden of your own, using any media (I have used gouache). Let your garden evolve: does it have trees, water, flower beds, fish, frogs, other wildlife, another human? Does it have meandering paths? A rose bower under which to sit? Choose elements from the garden you are currently sitting in that you would like to include, and make up others as they arise in your imagination while you paint.

I seem to have painted a neat and well-organized garden — this is something of a surprise as I tend to favor wilder spaces. Perhaps this is a balancing memo, sent from myself to myself. Do I need a little more order in my life, and a little more tidiness in my mind? Perhaps it is time to sort out my messy desk.

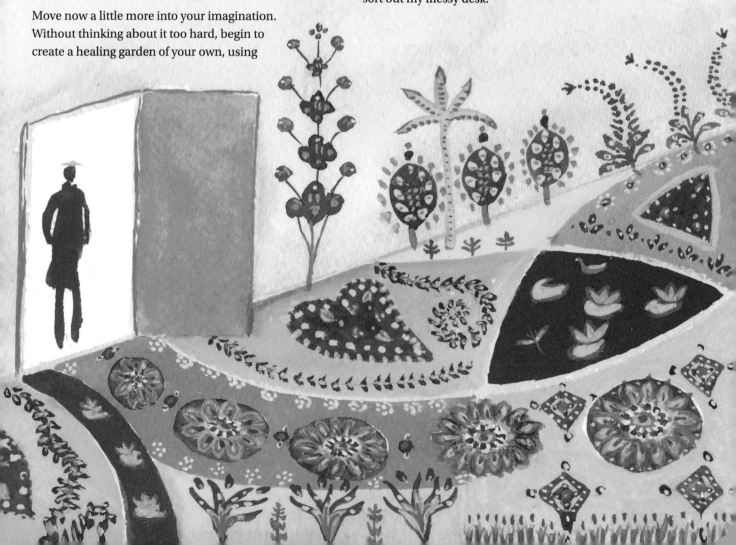

Join a litter pick and get creative with the litter (image by Jane Knight)

Day 2
Random Acts of Kind Wildness

Make a hedgehog doorway at the bottom of your fence

Back in the 1980s, journalist Anne Herbert suggested people should stop reporting on "random acts of violence" and start "practicing random acts of kindness and senseless acts of beauty." The catchphrase "random acts of kindness" caught on and a movement grew. "Positive acts always bring us inner strength," says the Dalai Lama. "With inner strength, we have less fear and more self-confidence, and it becomes much easier to extend our sense of caring to others without any barriers."[2] We might feel some despair that the small things we do individually make little difference to the troubles of the world, but the Dalai Lama encourages us to do them anyway, trusting that each small action will build our courage, and grow our confidence in the idea that we do make a meaningful contribution to the whole.

Practicing "loving-kindness" is key "not only to human development, but to planetary survival," he explains, and "a genuine change must first come from within the individual, then he or she can attempt to make significant contributions to humanity."

Small actions got us where we are now, argues Professor of Nature Connectedness, Miles Richardson, and small actions — as simple as caring about a butterfly — will turn the tide again:

"The political, scientific, and cultural environment led to an exploitation of natural resources that diminished habitats and polluted the atmosphere. Many of these changes occurred imperceptibly over time with each shovel of coal, each switch of the light and each tree felled. Small individual actions are both a product and shaper of culture. If a new culture can be created where a passing butterfly is noticed and enjoyed by the many, there will be a greater chance to limit climate chaos and the destruction of nature. Such nature-rich living would feel good and worthwhile, with people being more supportive of the wider changes needed for a sustainable future."[3]

Buddhist teacher Sharon Salzburg aspires to be the "ally of all beings everywhere."[4] Curiously, when I consider myself to be an ally and friend of all sentient beings — plants, rocks, rivers, trees, and animals (including human ones) — it actually takes some weight off my shoulders. Friendship is a joyful thing! I don't have to take on sole responsibility to solve all my friends' problems, nor burn myself out trying to save them, but I can enjoy caring for them in the ways I feel able to and bask in their reciprocal acts of care towards me.

Become a citizen scientist — participate in a butterfly or bug survey

Avoid slug pellets — make a pond for frogs instead, and encourage slow worms lizards by setting aside an area of your garden, letting the grass grow long and providing shelters

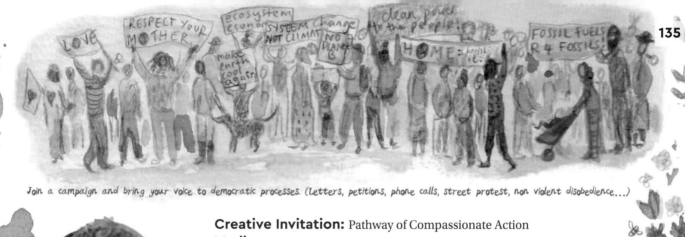

Join a campaign and bring your voice to democratic processes. (Letters, petitions, phone calls, street protest, non violent disobedience...)

Creative Invitation: Pathway of Compassionate Action
Media: Your choice

In the introduction to this book, I mentioned the "five pathways to Nature Connectedness" identified by researchers at the University of Derby. Today, let's take a stroll along the fifth path, the "Pathway of Compassion", which is about caring and taking action for nature. There are infinite ways you can actively express your care for this earth, and perhaps the best approach to choosing the right one for you is to see if it lifts your heart when you imagine doing it.

I have illustrated a range of suggestions on this page for you to consider. Choose one or come up with your own.[5] Make your action something you could start right now, today, even if that means it has to begin with a very tiny gesture, such as doing some research or gathering some resources. Joanna Macy recommends taking a modest step, but one that contains, for you, just a little bit of risk: make a small move beyond your mental and social comfort zone, so you do not remain stuck there.

Opposite page, top left: Image by Jane Knight.

Volunteer at a forest garden, learn permaculture, or get an allottment

Make a wildlife home (birdbox, bee hotel, toad house, slow worm shelter, hedgehog hangout, lizard lounge.)

Support an organic farm or food project, buy some local produce

Write a beautiful email or letter to your local representatives asking them to make your neighborhood more wildlife friendly and your roadsides pesticide free

"You don't need to do everything. Do what calls your heart; effective action comes from love. It is unstoppable, and it is enough."

JOANNA MACY

Plant wildflower seeds aound your area, - do a spot of Guerrilla gardening

Day 3
Wholeness with Guest Artist Netha Islam

Netha's soft pastel sketches, drawn on location, shimmer with subtle light. She evokes both a sense of spaciousness with her focus on distant horizons and an immediate, easy intimacy with the landscape where she sits. I find the effect soothing yet enlivening, gentle yet intense. Netha lived, breathed and — with her dog Daisy — roamed the rounded hills, the mists and mizzle, and the cool seas of Devon and Cornwall where she lived for much of her life. Perhaps it is because I love that part of the world too, but when I look at these sensitive sketches, I can almost smell the wildflowers, feel the soft grass under my body, sense a fresh breeze on my cheek and spot a buzzard circling silently overhead.

"Whole — all is connected," wrote Netha in her journal, "every movement we make, whether physical, emotional, mental or spiritual, has an impact on the 'whole' — the 'whole' of ourselves and the 'whole' of the universe. We are all interconnected — my actions impact you, yours impact me, whether we know each other or not, due to the collective field of energy — co-existence." Netha was interested in communicating her understanding of the interconnectedness of all things, and the relationship between humanity and the rest of nature: "No human action is isolated from its impact on the natural world," she noted, and when "we are disconnected from our awareness and experience of the 'whole' we feel a 'hole' which we try to fill with stuff, doing, trying, and striving. This affects the Whole — consumerism and materialistic goals produce pollution, waste, global warming and so on." For Netha, then, art was a spiritual practice, and she was interested in the place where one apparent boundary meets another: "Whole — all is interconnected One-ness — how sky meets land — land meets sky — how water meets the shore and the shore meets water. How humans relate to nature — how nature meets humans."

"Sitting in the daffodil field, watching the clouds drift by... Spring sunshine brings such beauty and solace."

NETHA ISLAM

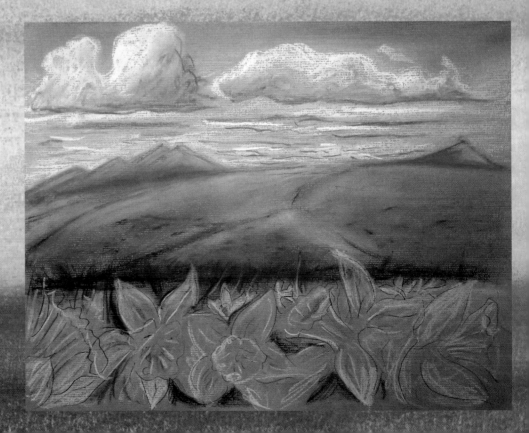

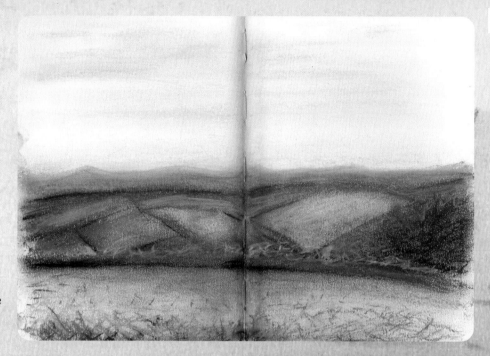

Creative Invitation:
Liminal Spaces
Media: Soft pastels

What aspects of Netha's practice resonate with you? Perhaps the softness of her pastel work, her sensitivity to color, her interest in "wholeness" and where one edge meets another, or the sense of space and perspective that is unrolled by finding a wide-open vista to draw.

Today, I suggest seeking out a "liminal" space, a place where one boundary meets another. Perhaps a perch high up on a hill or by the seashore where you can take a long view and ponder on perspective. How porous are the boundaries between one apparent thing and another? How does the sky meet the earth, or land meet water? Is the edge hard or soft?

You might like to work in soft pastels, as Netha has done. You can buy specialist pastel paper with a rough texture, which comes in a range of colors. However, Netha has worked very simply on ordinary white cartridge sketchbook paper. For a soft and subtle way of working that involves a lot of delicate smudging and blending, done fast and loose on location, sketchbook paper is a surprisingly good choice! Use your fingertips to gently blend colors together, and use the hard edge of your pastel stick for some lively mark-making to give definition to flowers and grasses in the foreground.

"Sketchbook time. Pastel color studies of misty skies and distant horizons. Letting go of needing to make a "good" or likeable sketch. Sketching and studying color purely for the joy of it. May the junky mind of judgement dissipate effortlessly when one chooses joy."

NETHA ISLAM

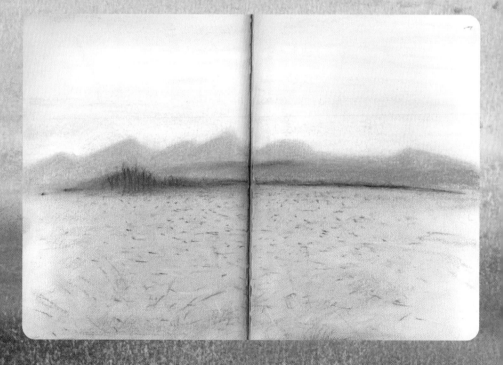

All artwork by Netha Islam, soft pastels on paper.

Day 4
The Infinitely Full Cosmic Sea

"I know nothing with any certainty, but the sight of the stars makes me dream," wrote Van Gogh, creator of *Starry Night* — that vision of swirling orbs in fathomless blues which is now one of the most beloved paintings in the history of western art. Gazing at the night sky from his bedroom window in 1889, the artist wondered whether other dimensions existed beyond our understanding: what if "life had yet another hemisphere, invisible it is true, but where one lands when one dies," he mused. Artists, poets, scientists and mystics, and probably all people everywhere throughout time, have looked up to the star-studded firmament and pondered on life, death, the universe, and everything.

The recent film *Infinite Potential* explores the life and work of theoretical physicist David Bohm. It begins with a memory shared by Bohm's former student, Dr Schrum:

"It was night and we were walking under the stars, a black sky. David looked up at the stars and said: 'Ordinarily, when we look to the sky and we look at the stars, we think of the stars as objects far out and that they have space in between them. But there is another way we can look at it. We can look at the vacuum, the emptiness, as a plenum, as infinitely full rather than infinitely empty, and that the objects are like little bubbles — little vacancies — in that vast sea.' So, he had me look at the night sky in a different way — as one living organism."[6]

Bohm saw space as a living, pulsing "cosmic sea." "Space is not empty," he said, "it is full, a plenum as opposed to a vacuum." To Bohm, the space around everything we consider to be objects "is the ground for the existence of everything, including ourselves. The universe is not separate from this cosmic sea of energy." Bohm's theory of reality, which he summed up as the "Implicate Order" echoes, in essence, what the mystics and sages have intuited for ages: everything that we see in our everyday world of space and time (what Bohm called the "explicate order") is in fact interconnected and not separate at a deeper level of reality.

What Bohm brought to the table was the science: the quantum phenomenon of non-locality shows us that particles seem to communicate instantaneously, flouting a central tenet of relativity that information cannot be transmitted faster than the speed of light. Contemplating this discovery led Bohm to explore the nature of consciousness, most famously through conversations with the Indian spiritual philosopher, Krishnamurti. "What particularly aroused my interest was his deep insight into the question of the observer and the observed," explained Bohm. This question had long been at the center of Bohm's own work as a theoretical physicist exploring the meaning of quantum theory. In this theory, he said, for the first time in the development of physics, "the notion that these two cannot be separated has been put forth as necessary for the understanding of the fundamental laws of matter in general." The Implicate Order is a radical and ultra-holistic cosmic view: everything is interconnected, and nothing is truly separate in the way it appears to us to be.

Bohm thought that creative intelligence originated in the depths of the Implicate Order and believed "the consciousness of mankind is one and not truly divisible." Each individual person, said Bohm, is an "intrinsic feature of the universe, which would be incomplete, in some fundamental sense" if that person did not exist. As individuals, our participation in the totality is essential, and as we develop in self-awareness we contribute to the phenomena of the "Implicate Order … getting to know itself better."[7]

Creative Invitation: A Starry Sea
Media: Watercolors and household products such as salt, liquid soap or oil

Tonight, go and gaze at the stars. Does the night sky make you dream like Van Gogh? Contemplate the ideas of David Bohm — could you, like Bohm's student, experiment with new ways of looking? Can you see the sky as a living organism, as a cosmic sea, as "infinitely full"? How does seeing in this way impact you? Do you notice any emotional, physical or mental reverberations in your body and mind?

Take some watercolors or inks and make a *Starry Night* painting of your own. It can be a lot of fun to hand over most of the creative work to chance when playing with this theme. Gather up a teaspoonful of any or all of these household items you happen to have — washing up liquid/liquid soap, alcohol sanitizer, cooking oil, salt, and sterilizing fluid. Use fairly thick paper (e.g. watercolor paper) and tape it down on all four sides to prevent the paper curling up. Cover your paper in a deep, dark layer of night sky colors — blues, blacks, purples, greens, however the sky appears to you. Let them run and bleed into each other and make sure the color is rich and dark. Now work fast, before it has a chance to dry, and experiment with dropping and flicking tiny amounts of each household substance onto your painting. Watch how the colors react, shrinking or spreading, in response to these new substances. You may want to try diluting some of the liquid items with water to find out what strengths offer the most pleasing effects. As for the salt, scatter it onto your wet painting, then brush it off when everything has dried out later.

Many of us live in cities where light pollution has made it hard to see the stars; you may have to work partly from imagination or your memories of camping out on inky nights beyond the city limits. Then again, perhaps you can find beauty even in a murkier atmosphere, like Doris Lessing, who praised the "hazed wet brilliance of the purple London night sky." Nearly two centuries ago, Ralph Waldo Emerson commented that we would be struck with amazement if the night sky were not such an everyday occurrence: "If the stars should appear one night in a thousand years, how would men believe and adore... but every night come out these envoys of beauty." If he were alive today, perhaps he would be a supporter of darksky.org, an international campaign to reclaim our night skies for the benefit of people and wildlife.

Day 5
We Are Surrounded by Genius

What do the bronchi in your lungs, the flow of electrical currents, and the tributary systems of rivers have in common? The same mathematical law that also governs the pattern of neurons in your brain and the way branches grow on trees. In short, all these phenomena are "fractal," meaning they repeat at different scales, something which has also been detected, incidentally, in the artworks of Japanese printmaker Hokusai and American expressionist Jackson Pollock.[8]

The universe is filled with elegant fractal designs, from the micro to the macro, from the rings of Saturn to snowflakes and DNA. Richard Taylor, from the University of Oregon, researches "bioinspiration" in which artificial systems utilize nature's patterns. Taylor has found that when people look at fractals, brain waves associated with relaxation and the regulation of emotions arise. Architects and designers have also begun to enfold these forms into their work. I'm not totally sure how I feel about this — perhaps I need to see it to believe in it — but Austrian firm 13&9 in collaboration with Taylor have recently produced "Relaxing Floors": carpets that are decorated with anxiety-reducing fractal patterns to bring calming visuals to workplaces, airports and hospitals!

"Biomimicry" is the related practice of applying lessons from nature to invent healthier, more sustainable technologies.[9] Biomimicry advocate, Janine Benyus, believes that "the more our world functions like the natural world, the more likely we are to endure on this home that is ours, but not ours alone." We modern cultures have forgotten, she says, that "we are surrounded by genius" and can learn from nature how to live gracefully on this planet.

Biomimicry informs many areas of human life. Architect Mick Pearce was inspired by the design of a termite mound for his office buildings in Zimbabwe and Australia, which require 90 percent less energy to heat or cool than traditional buildings.[10] In farming, permaculture is a set of design principles that follow the flow of natural ecosystems and embrace biodiversity. In infrastructure, researchers look to patterns such as leaf veins to find energy-efficient ways to distribute resources across cities. Bring on the "Biomimicry Revolution" based "not on what we can extract from Nature," calls Benyus, "but on what we can learn from her."

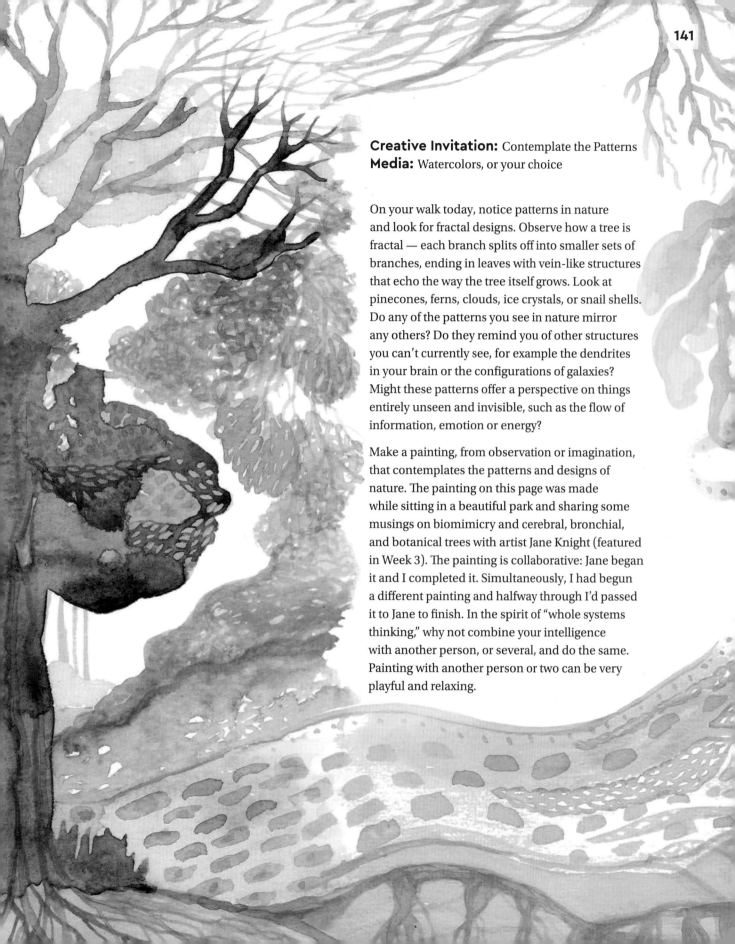

Creative Invitation: Contemplate the Patterns
Media: Watercolors, or your choice

On your walk today, notice patterns in nature and look for fractal designs. Observe how a tree is fractal — each branch splits off into smaller sets of branches, ending in leaves with vein-like structures that echo the way the tree itself grows. Look at pinecones, ferns, clouds, ice crystals, or snail shells. Do any of the patterns you see in nature mirror any others? Do they remind you of other structures you can't currently see, for example the dendrites in your brain or the configurations of galaxies? Might these patterns offer a perspective on things entirely unseen and invisible, such as the flow of information, emotion or energy?

Make a painting, from observation or imagination, that contemplates the patterns and designs of nature. The painting on this page was made while sitting in a beautiful park and sharing some musings on biomimicry and cerebral, bronchial, and botanical trees with artist Jane Knight (featured in Week 3). The painting is collaborative: Jane began it and I completed it. Simultaneously, I had begun a different painting and halfway through I'd passed it to Jane to finish. In the spirit of "whole systems thinking," why not combine your intelligence with another person, or several, and do the same. Painting with another person or two can be very playful and relaxing.

Day 6
A Wilderness Experiment

I was recently intrigued to learn that most land, left to its own devices, will eventually return to being woodland. Nature knows what to do. First comes the wind, and the berry-eating birds, to blow in and drop small seeds such as bramble and hawthorn. Then, along come the big birds, the squirrels and the mice, to perform Stakhanovite acts of tree planting, burying thousands of tree seeds such as acorns all over the ground in a frenzy of preparation for winter, and then naturally forgetting where they stored some of them. These forgotten stashes get the chance to grow into trees, and, right on cue as the saplings appear, thickets of hawthorn and brambly scrub spring up to form a protective ring around them, preventing an early death-by-nibbling from rabbits or deer — a defense far more effective than any human-made plastic tube.

In 1961, the custodians of an arable field decided to intentionally hand four hectares over to nature to see what happened. They thought it might be interesting to watch what happens to an area when no one interferes, wondering whether the land might become a forest, how long such a transformation would take, and which species would arrive. The experiment, at Monks Wood in Cambridgeshire, UK, became known as the Wilderness Experiment.[11] Sixty years later, the results are in: the Wilderness Experiment now resembles a rich, mature woodland teeming with trees, shrubs, fungi, invertebrates, and a diversity of birds including song thrushes, garden warblers, and nuthatches.

It seems that, if we could just step back and allow nature the freedom and space to get on with it, good things will happen. I wonder if we could apply a dose of "wilding" to our own creativity and our self-processes, including our health and our wellbeing. Claus Springborg, of the "Sensing Mind Institute," [12] guides people to access a range of positive inner resources, such as grounding, vitality, peace, compassion, and joy, through a process of relaxing the "self-critical parts of ourselves" that are over-helping by working hard to control our behavior. He comments, "I firmly believe that when people give up trying to control themselves, they will become more grounded, relaxed, and joyous. I do not know one person for whom this has not been true."

"The Wilderness has a special feel about it; no trees planted in straight lines, if a tree dies it is left where it falls... Many of the trees now exceed one meter in circumference. It is a lovely place and contains many species, but typically not the rarities associated with ancient woodland; this may take a few more centuries."

PROF. TIM SPARKS, GUARDIAN OF SOME OF THE LONG-TERM EXPERIMENTS AT MONKS WOOD

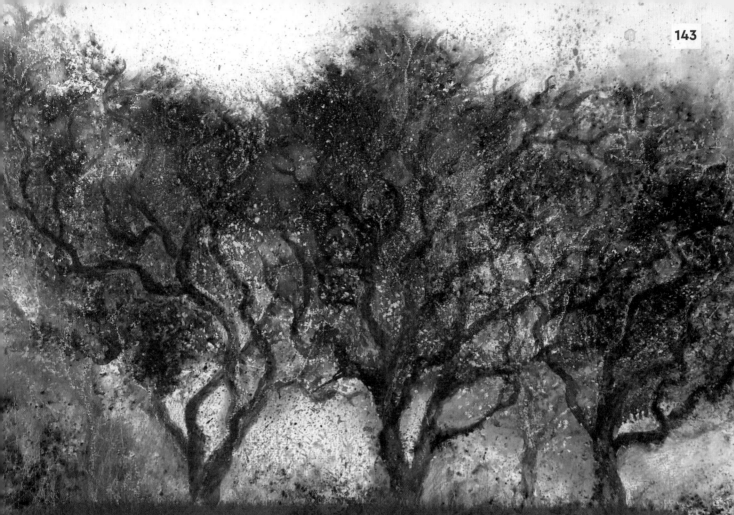

Resist techniques: Try drawing trees with a wax candle or oil pastels, then covering them up with ink or watercolor for a "resist" effect. You could also explore drawing with oil pastel over an already dry layer of ink or paint, then scratching some of it away with a cocktail stick (or something sharp) to reveal a bit of the paint beneath.

Creative Invitation: Trust Nature, Trust Your Process
Media: Anything you feel like!

We are not separate from nature — in fact, we *are* nature, however often we forget this. This tale of rewilding at Monks Wood, that occurred simply through a strategy of standing back and letting nature get on with it, leaves me wondering whether we could take the same approach of non-interference to our own creative process. What if you were to let random ideas blow in, then wait and see what takes seed? What if you allowed metaphorical plants, that you're not entirely sure you like, to bloom? Where are the thorny thickets of your mind, and might they be performing a function you cannot yet appreciate? Are there forgotten and discarded seeds about to sprout that you are not yet aware of? How

much can you stand back from trying to create certain results, or to help things along? What would a creative practice that is "wild" look like? Today, consider yourself to be an open space for ideas to drift into. Take a walk wherever you feel like going, and see what the forest, water or meadow invites you to do. Stay open-minded, trust your own inner process, and see what happens!

I have mixed my media in the drawings I've made today, using inks, gouache, oil pastel, wax, and colored pencils. I let things evolve, experimenting with building up layers using the different art materials. This is an exciting way to work — the oily pastels resist the inks, the colored pencils add interesting textures on top, and the gouache, being opaque, can be used to cover up areas and pick out emerging shapes.

Day 7

Re-Enchanting the World with Ritual with Guest Artist Isla McLeod

Isla McLeod is a modern-day medicine woman, "attending to the threshold between the visible and invisible realms, in service to the Earth community." Her work as a ritualist and healer is informed and inspired by her relationship with the natural world, and she's devoted to helping others remember what is sacred in their lives. She does this by creating rituals that reconnect people with a sense of meaning and belonging.

Isla is also a writer, and expresses herself beautifully in her own words:

"Rituals are essentially a vehicle for relatedness, performing a function for the fundamental human needs of connection with the sacred, purpose, and a sense of identity. To explore ritual is to remember the world as an alive, evolving communion of subjects with a common origin story and shared destiny.

My journey with ritual has given me the tools to cultivate these pathways of remembering, of knowing my bone-deep belonging to this Earth and my place in the Greater Web of Life that feeds and inspires me in every way. Ritual offers me a way to give back to all that sustains me and listen in to what the Earth is asking of me, so I can

live in sacred reciprocity with the wider Earth community as a conscious participant in Life's unfolding. In this way, I attune to the natural creativity inherent in all things and the Love at the source of it all, re-enchanting the world with wonder and potential."

Isla believes in making room for the Inner Artist, welcoming her "into ritual space and feeding her with beauty, inspiration and devotion." If you can give yourself the resources and freedom to create, she clarifies, you make space for "play, spontaneity and curiosity to naturally arise from the present moment."

All images by Isla McLeod.

"Creating offerings is a vital part of the ritual life, as a way of expressing your gratitude and making ripples of kindness outwards into the world to feed the wider Earth community. Whether reciting a poem to a tree, offering water infused with prayers back to a river, singing to the sky or scattering wildflower seeds on a patch of Earth, you can make offerings of Love and beauty in any way you feel inspired."

ISLA MCLEOD

Creative Invitation: Create an Offering of Beauty
Media: Flowers and foliage gathered by you

A mandala can be made as an offering for Gaia and the spirit of a place, or to honor a specific moment in time. The circular design represents wholeness, harmony, and unity. During the course of this book, you may have developed a connection with a specific place in nature that has provided support, refuge and healing for you: perhaps a stream, a tree or a corner of a park or garden.

Make a visit to this special place and set the intention to gather items for your mandala as you walk mindfully through the landscape towards it. Isla explains that "gathering the flowers and foliage for your mandala in an intentional way is an essential part of the ritual." It's important to "ask permission from the plant or place — however that comes naturally for you and take heed of the response. Practicing reciprocity by gifting something to the plant you harvest from — a song, birdseed, water — and being mindful to only pick what is abundant and nearing the end of its growth cycle will ensure you are in the right relationship with the plant spirits.

You can also look for items already left on the Earth you can collect."

In the place of your choosing, Isla suggests you kneel on the earth and bow your head to the ground where you will be creating your offering:

"Feel this connection and take a moment to express your intention to create a gift to express your gratitude.

Starting at the center, lay down an item as you share aloud something you are grateful for — about your journey, your life, the teachers who have guided you and the lessons you have learned. Continue adding items around this center point to create "a circle brimming with your praise, sharing your gratitude with each item you place, until you have created a beautiful feast for the Earth."

Finally, close the ritual space by sharing some words of praise, such as "I honor and give thanks to the Spirit of this Land, and all those that dwell here and share this Earth, our Home. Thank you for the beauty, abundance and inspiration you bring to my life. As I go forward, may I integrate all that I learn and stay connected and attentive to the living presence of the natural world, sharing my love and gratitude for this gift of life."

"Let the beauty of what you love be what you do."

RUMI

Endnote

So, we have come to the end of our journey together. Thank you for sharing your time and your creativity with me, and with all of our guest artists, throughout this course. I hope that it has been of support and interest to you, and brought you some joy.

By way of goodbye, I wish for you what I also wish for myself: may the roots of your relationship with this earth continue to deepen, may the seeds of your innate creativity flourish, and may your own true nature blossom.

Thank you

to everyone who has helped and supported me in so many direct and indirect ways to create this book. Thanks to my mother Ann for feeding me delicious meals and generally taking care of me when I turned up at her house for personal "Writer's Retreats"! Thanks to my readers Reza, Nic, Alexandra, Nick, Hugh, Flora (and Flora's mum!). Thanks to all those who contributed advice, images, ideas and more.

Thanks to everyone who generously allowed me to quote them and share their ideas, including David G. Lanoue and Michael R Burch for sharing their translations/interpretations of the insect poems of Issa and Basho respectively. Appreciation to Anna Quartly, for our many "artistic research" rambles in the woods. Last but not least, thanks so much to the team at Liminal 11 for helping to bring this book into being: Ella, Eleanor, Loveday, Rebecca, Kay and Darren.

About the Author

Emma is an arts educator and artist with a deep love for our natural world. She lives in the South West of England and has a heartfelt connection to the hills, seas, stones and trees that live there too.

Her fields of interest include nature connectedness, environmental arts therapy, forest bathing, ecology, eco-activism, yoga, meditation, relational mindfulness and creativity. She is the author of *Soul Color,* a ten-week watercolor course for mindfulness and creativity, also published by Liminal 11.

You can find out more about her books, comics, artworks and workshops at www.emmaburleigh.com

Artist Bios

Lindsay Alderton — Lindsay is currently walking across Britain on a Yew Tree Pilgrimage, and exploring ways of healing, reframing cancer narratives, and coming back into right relationship with nature. She writes about prayer, movement and the making of ritual objects at @knowingmeknowingyew on Instagram.

Emma Capper — Emma is an ANFT-certified nature and forest therapy guide, artist and workshop facilitator with over 25 years of experience delivering workshops in the expressive arts. In 2013, she founded "Creative Journeys in Nature", weaving her love of art and nature together to curate workshops and forest therapy walks to connect adults and children with their innate creativity and our natural world. www.creativejourneys.org.uk

Stewart Edmondson — Stewart is a plein air artist living on Dartmoor in Devon and he paints largely in wild places across South West Britain. He paints outdoors, on location, in all weather — painting quickly and dynamically and drawing inspiration from the light and energy of the place he is working in. He finds that the painting is an alchemy between him and the place — rain, wind and light will all often contribute to the mark-making and can have a major effect on the painting. He has a deep love of the natural world and spent his earlier working years taking groups of inner-city children out to explore wild places. www.stewartedmondson.com

Dr. Amy Goodwin — Amy is a traditional signwriter and lecturer, based in Falmouth, UK. Her work is heavily inspired by her upbringing traveling with steam fairgrounds in the West Country and she now works to commission predominantly in the fairground, circus and heritage industries. www.a-goodwin.com

Netha Islam — Netha worked in painting, drawing, photography, illustration, design, events organisation and styling. She was also a milliner, and the creator of the label "Gorgeous Hats". Recently, her focus moved to pastels and paintings, including her series on Burgh Island in Devon, UK. Netha loved to explore color and texture, using found objects such as feathers to paint with and capturing the changing landscape around her to remarkable effect. Sadly, Netha died of ovarian cancer in 2021. Her last series, "Chemo", will be featured in the third year show of the degree course she began at Plymouth College of Art (but did not get to complete) and is a testament to the power of color and her skill at wielding it. @artistnetha

Jane Knight — Jane is an artist and photographer with a love of the seashore, ocean, hedgerows, and moorland of South Devon. She's fascinated by the wild edges of landscapes, like the rich inter-tidal areas where seaweeds and rockpools emerge with the ebb and flow of the tides, and the Devon hedgerows, so abundant in beauty and diversity. @organicbotanic

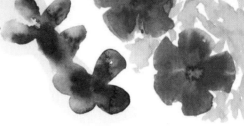

Mayumi Makabayashi — Mayumi is a flower mandala maker, a therapist (bodyworks and nutrition), and a "voice and vibration explorer." Her interest is exploring the ways to make peace with ourselves by looking at the seemingly opposed natures within us and within our communities through making art and learning about our body. @mayuminakabayashi

Isla McLeod — Isla is a ceremonialist, ritual designer, transformational healer and rite of passage guide. Inspired by nature, forged by longing, devoted to remembering. Lover of moss, mushrooms, trees, wild swimming and moonlight. www.islamacleod.com

Rima Staines — Rima is a lifelong multi-disciplinary artist, working predominantly as a painter, but also with sculpture, music, writing, drawing, printmaking, theater, puppetry, animation and book arts. She has published and exhibited work internationally. Her work has its roots in those invisible and oft-forgotten soul worlds that lie just behind or just inside this one. She dips her paintbrush into the wells of myth, folk arts, magic and story, human and more-than-human lifetimes and memories and works in a very intuitive and right-brained way. www. rimastaines.com

Lizzie Stevens — Lizzie finds voice through her alter ego, Eliza Freespirit, a small, often joyful, figure originally lovingly revealed through one strip of plasticine. Eliza is now formed the same size and in clay. She remains unfired, thus introducing the ephemeral to her outdoor installations, an invitation to symbolize the effects of climate change. Lizzie also works with and from citrus fruit, especially the peel. www.lizziestevens.co.uk

Hugh Warwick — Hugh is an author and ecologist with a particular passion for hedgehogs. @hedgehoghugh

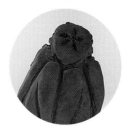

Jackie Yeomans — Jackie is an earth artist. Her predominant terrain is Soil & Seed embodied to explore issues of relationship between humankind and the natural world, motivated by environmental health and mental health. For the last 15 years, she has worked solely with foraged soils, clays, raw earth pigments and seeds, to craft 3D and installation pieces. www. jackieyeomans.com

Bibliography and Recommended Reading

Your Guide to Forest Bathing by M. Amos Clifford

Dawn Light by Diane Ackerman

Active Hope by Joanna R. Macy & Chris Johnstone

Environmental Arts Therapy and the Tree of Life by Ian Siddons Heginworth

Sometimes a Wild God by Tom Hirons

The Garden Jungle: Or Gardening to Save the Planet by Dave Goulson

The Earth Has a Soul: The Nature Writings of C.G. Jung edited by Meredith Sabini

Linescapes, The Beauty in the Beast, and A Prickly Affair by Hugh Warwick

The Well Gardened Mind by Sue Stuart-Smith

Pro-Voice: How to Keep Listening When the World Wants a Fight by Aspen Baker

Animal Talk, When Animals Speak, and Animals in Spirit by Penelope Smith

Anam Cara by John O'Donohue

Becoming Animal by David Abram

Dream Animals by James Hillman and Margot McLean

Braiding Sweetgrass by Robin Wall Kimmerer

The Nature Fix by Florence Williams

Creativity Through Nature by Ann Blockley

Online Inspirations

Nature Stewardship at johnmuirlaws.com * ecodharma at ecodharma.com * The Biomimicry Institute at biomimicry.org * Pat McCabe at patmccabe.net * Miles Richardson at findingnature.org.uk * The Pari Center at paricenter.com * Sensing Mind Institute at sensingmind.com * More Than Weeds at morethanweeds.co.uk * Green Bronx Machine at greenbronxmachine.org * Whitefield permaculture at patrickwhitefield.co.uk * David G. Lanoue at haikuguy.com * Bethany Sewell at www.bethanysewell.com

Resources on Creativity

You might also like to look at any books, talks and resources by the following artists and writers who have all influenced my work and approach: Pat B. Allen, Lynda Barry, Julia Cameron, Elizabeth Gilbert, Michele Cassou, Susy Keely, and Agata Krajewska at Theatre of Awakening

Works Cited and Other Notes

Introduction:

1. As outlined by the Nature Connectedness Research Group at the University of Derby, UK.

2. Martin, Leanne et al. 'Nature contact, nature connectedness and associations with health, wellbeing and pro-environmental behaviours.' *Journal of Environmental Psychology*. 2020.

3. The pathway of beauty and the arts, as discussed by Miles Richardson — aka the University of Derby's rather wonderfully entitled "Professor of Nature Connectedness" — has been more effective at connecting children to nature than various other educational approaches. See Prof. Richardson's blog findingnature.org.uk, or this study that he refers to: Bruni, C. M. et al. 'Getting to know nature: evaluating the effects of the Get to Know Program on children's connectedness with nature.' *Environmental Education Research*. 2015.

4. Prof. Miles Richardson from the University of Derby comments in his research blog at findingnature.org.uk, "the connection we form with nature does not depend on how much time we spend in the countryside. It is about a close attachment to nature, which benefits our mental wellbeing." For details, see the study by Richardson, M. et al. 'Moments, not minutes: The nature-wellbeing relationship.' *International Journal of Wellbeing*. 2021.

Week 1:

1. Coyne R. 'Nature vs. Smartphones.' *ACM Interactions Magazine*. 2014 https://interactions.acm.org/archive/view/september-october-2014/nature-vs.-smartphones

2 Gould van Praag, C. et al. 'Mind-wandering and alterations to default mode network connectivity when listening to naturalistic versus artificial sounds.' *Sci Rep 7*. 2017.

3. See the work of acoustic ecologist Gordon Hempton at www.soundtracker.com

4. Schreckenberg D, et al. 'The associations between noise sensitivity, reported physical and mental health, perceived environmental quality, and noise annoyance.' *Noise Health*. 2010.

5.University of Sussex. 'It's true: The sound of nature helps us relax.' ScienceDaily. 30 March 2017. www.sciencedaily.com/releases/2017/03/170330132354.htm

6. Richardson M. 'Nature connectedness and noticing nature: Key components of a good life.' February 27, 2020 www.findingnature.org.uk/2020/02/27/basic-components-of-a-good-life/

7. Yeager A. 'Smells of Nature Lower Physiological Stress.' *The Scientist*. Jan 2, 2020, referencing research from Marcus Hedblom at the Swedish University of Agricultural Sciences.

8. Franco, Lara S et al. 'A Review of the Benefits of Nature Experiences: More Than Meets the Eye.' *International journal of environmental research and public health* vol. 14. 2017.

9. Smells have a powerful effect on both our physical health and emotional wellbeing, thanks to the immediacy of the brain-nose pathway. Worryingly, most of us city-dwellers are breathing polluted air and inhaling particulate matter from sources such as diesel directly into our brains. Science and nature writer, Florence Williams, explains in her book, *The Nature Fix* (HighBridge, 2017), how small molecules travel straight up the nose into the gray matter. She connects this unobstructed nose-brain link to a range of air pollution related illnesses including dementia in humans and strange brain lesions found in smog-choked Mexican dogs. Fortunately, there are several great solutions to this problem, and a very important one is welcoming more nature into our cities. Not only do trees and soil emit odors proven to reduce stress and lower blood pressure, they also absorb vast quantities of airborne pollutants. Perhaps we can look to green-roofed, wild-walled, lushly-corridored Singapore for inspiration: government policy demands that builders must always make room for more nature than their new constructions will destroy, uplifting the health of everyone through this conscious greening of the city.

10. Ackerman, Joshua M et al. 'Incidental haptic sensations influence social judgments and decisions.' *Science*. 25 June 2010.

11. Keltner, D. 'Hands On Research: The Science of Touch, Dacher Keltner explains how compassion is literally at our fingertips.' Greater Good Science Center. 2010.

12. de Craen A J M et al. 'Effect of colour of drugs: systematic review of perceived effect of drugs and of their effectiveness.' *BMJ*. 1996.

Week 2:

1. For a much more detailed explanation of the "wet in wet" technique and how to use watercolour in general, you could refer to my previous book Soul Color, and you'll find a few free demo videos from me online via my website: www.emmaburleigh.com

2. You might like to watch Kate Raworth's TED talk on Doughnut Economics, look up Charles Eisenstein on "Sacred Economics" or listen to Giles Hutchins and Laura Storm talk about "Regenerative Leadership" to build "life-affirming businesses."

3. Marja J. Roslund et al. 'Biodiversity intervention enhances immune regulation and health-associated commensal microbiota among daycare children.' *Science Advances* vol 6, issue 42. 2020.

4. Thanks to childsplayabc.wordpress.com for the introduction to soil creatures. This is a great blog full of creative ideas. For more on just how amazing fungi are, watch the documentary *Fantastic Fungi* (Moving Art, 2019), or look up the work of Merlin Sheldrake or Paul Stamets.

Week 3:

1.Jiang, Shu-Ye et al. 'Negative air ions and their effects on human health and air quality improvement.' *International Journal of Molecular Sciences* vol. 19. 2018.

Week 4:

1. Nall R. 'What are the benefits of sunlight?' *Healthline*. 2019. https://www.healthline.com/health/depression/benefits-sunlight

2. You can read the poem, or listen to Tom Hirons reading it aloud, at Tom's website: www.tomhirons.com

Week 5:

1. Poulsen DV et al. 'Everything just seems much more right in nature: How veterans with post-traumatic stress disorder experience nature-based activities in a forest therapy garden.' *Health Psychol Open*. 2016.

2. Bloomer, Carolyn M. 'Principles of visual perception.' Van Nostrand Reinhold Company. 1990.

3. Ikei, Harumi et al. 'Physiological effects of touching wood.' *International Journal of Environmental Research and Public Health* vol. 14. 2017.

4. Monbiot, G. 'The gift we should give to the living world? Time, and lots of it.' *The Guardian*. 8 Aug 2021. https://www.theguardian.com/commentisfree/2021/aug/08/living-world-time-saplings-oak-slow-ecology-habitats

5. Visit John Muir Laws at www.johnmuirlaws.com for a cornucopia of great nature journaling ideas and resources.

6. Muri N. and Gobel N. 'See faces in the clouds? It might be a sign of your creativity.' *Psyche*. 15 July 2020. www.psyche.co/ideas/see-faces-in-the-clouds-it-might-be-a-sign-of-your-creativity

Week 6:

1. More Than Weeds has inspired or been inspired by similar initiatives in countries around the world — see www.morethanweeds.co.uk/in-other-countries for information covering the USA, Canada, and Europe.

2. Wong, James. 'Why the dandelion blows away some plant collectors.' *The Guardian*. 16 May 2021. https://www.theguardian.com/lifeandstyle/2021/may/16/the-dandelion-blows-away-collector

3. Evatt, Rachel and Geoff, and Nock, Sandra. As quoted in 'Weed thriller: garden of weeds takes home gold at Royal Horticultural Society show.' The Telegraph. 25 July 2021. https://www.telegraph.co.uk/news/2021/07/25/weed-thriller-garden-weeds-takes-home-gold-royal-horticultural. Visit sunartfields.com to learn more about Evatt and Nock's "nature-led farm."

4. Visit Matthew at www.treetoppermaculture.org

5. Find out more at www.greenbronxmachine.org/projects/food-for-others

6. Dave Goulson, Professor of Biology at the University of Sussex, casts light on this surprising fact in his book *The Garden Jungle*: *Or Gardening to Save the Planet*. You can also visit his research at www.sussex.ac.uk/lifesci/goulsonlab. To briefly summarise his explanation, plenty of diverse crops can be crammed into an allotment or garden. Pests will have a tough time finding their preferred plants amidst the riot of greenery and will also need to evade the many natural predators that flourish in this kind of environment (such as frogs and ladybirds).

7. Learn more at www.incredibleedible.org.uk

8. Visit www.greenbronxmachine.org and also Stephen Ritz at www.stephenritz.com

9. Quotes about Green Bronx Machine printed with the kind permission of the speaker, Stephen Ritz.

10. Learn more at www.aspenbaker.com or read *Pro-Voice: How to Keep Listening When the World Wants a Fight* (Berrett-Koehler Publishers, 2015) by Aspen Baker.

Week 7:

1. See Thomas Berry's book, *The Dream of the Earth* (Counterpoint Press, 2015.)

2. Research from Brighton and Reading universities, led by Scott D. and Baker P. 2017.

3. See Bethany's work, including urban fox photography, at www.bethanysewell.com

4. Find a wealth of information at The Natural History Museum. www.nhm.ac.uk/discover/british-wildlife.html

5. Lovell R et al. 'A systematic review of the health and well-being benefits of biodiverse environments.' *Journal of Toxicol Environ Health, Part B.* 2014.

6. There are about 1.7 million recorded species of animals, plants, and fungi, but it's estimated that anything from 7 million to 100 million more are still out there. Tragically, many species are being lost before we even become aware of them or the role they play in the circle of life. Right now, biodiversity is in freefall due to human behaviors including forest felling and pollution. You probably don't need me to tell you how much this matters, or that loss of biodiversity is a disaster for us all on a par with climate change. (For more on this, see the WWF's Living Planet Report 2020, 'Bending the curve of biodiversity loss.') Of course, the two issues are interwoven: extreme weather wipes out habitats. Giving nature the space and protection it needs is the crucial solution. Getting involved in lobbying politicians, supporting campaigns, even engaging in protests and non-violent direct action are ways to help. We can also do small, practical, healing things to nurture biodiversity on our own home patch of turf. We explored a few ideas in Week 6, and another simple one is to create "green travel corridors" — it is not just the loss of habitat, but the loss of large, unfragmented stretches of green space that is the issue for many local animals. An example is in your own garden: if there is a wall or fence with concrete footings all around then creatures cannot get in or out — so make some holes at the base of your fence to give safe through-passage to hedgehogs and other small creatures. Why not let your grass grow long and sow some wildflowers to provide food and shelter when they pass by, too?

7. Thanks for the enlightening information provided by Becca Rodomsky-Bish, 1 August 2018, wwww.content.yardmap.org

8. Quote from the poem 'Insects' by John Clare.

9. Laufer, B. 'Insect-musicians and cricket champions of China.' *Anthropology* no. 22. Chicago: Field Museum of Natural History. 1927.

10. Davidowitz, G. Professor in the departments of Entomology, Ecology, and Evolutionary Biology. Quote printed with permission from the speaker.

11. Information from the Smithsonian Institution at www.si.edu/spotlight/buginfo

12. Toshitaka N. Suzuki et al. 'Bent posture improves the protective value of bird dropping masquerading by caterpillars.' *Animal Behaviour* vol 105. 2015

13. From the Smithsonian Institution www.si.edu/spotlight/buginfo

14. Quotes from Penelope Smith with her kind permission. Find out more about Smith's work at www.animaltalk.net

15. Comment made by James Hillman in an interview entitled 'James Hillman on animals: a correspondence' with John Stockwell at www.digitalcommons.calpoly.ed. I also sourced ideas from Dream Animals by Hillman and McLean.

Week 8:

1. From the poem 'Spring' by Gerald Manley Hopkins

2. Dalai Lama XIV. *The Compassionate Life.* Wisdom Publications. 2001.

3. From Prof. Miles Richardson's blog at findingnature.org.uk

4. Salzburg, S. 'Becoming the ally of all beings.' *Lion's Roar Magazine.* 13 October 2020. https://www.lionsroar.com/becoming-the-ally-of-all-beings/

5. For more ideas you could visit randomactsofkindness.org or look at the Wildlife Trust's Random Acts of Wildness campaign.

6. Quoted with the kind permission of the speaker, Dr. David Schrum.

7. You might like to visit The Pari Center to explore the ideas of David Bohm at www.paricenter.com

8. Observed by Richard Taylor, academic expert in chaos theory, fractals, and the relationship between art and science at the University of Oregon.

9. To learn more, visit The Biomimicry Institute at www.biomimicry.org

10. McKeag T. 'How termites inspired Mick Pearce's green buildings.' *Green Biz.* 2 September 2009. https://www.greenbiz.com/article/how-termites-inspired-mick-pearces-green-buildings

11. Broughton R.K et al. 'Long-term woodland restoration on lowland farmland through passive rewilding.' *PLoS ONE.* 2021.

12. Quoted with permission from Claus Springborg at the Sensing Mind Institute www.sensingmind.com

Credits and Acknowledgments

Quote by Lynda Barry with permission from the author.

Quotes by Joanna Macy used with permission from the author.

Quotes by the Dalai Lama with permission from Wisdom Publications.

Quote by George Monbiot, printed in The Guardian, August 8th 2021, https://www.theguardian.com/commentisfree/2021/aug/08/living-world-time-saplings-oak-slow-ecology-habitats, used with permission from the author.

Quote by Ian Siddons Heginworth from *The Tree of Life, Spirit's Rest 2009*, used with permission from the author.

Quote by M. Amos Clifford from *Your Guide to Forest Bathing*, Conari Press, 2018, used with permission from the author.

Quote by John Muir Laws used with permission from the author.

Quote by Janine Benyus used with permission from the author.

Quotes by Penelope Smith used with permission from the author.

Quote by Dave Goulson from *The Garden Jungle* , Jonathan Cape, 2019, used with permission from the author.

Quote by Diane Ackerman from *Dawn Light* , W. W. Norton & Company, 2010, used with permission from the author.

Quote by Tom Hirons from *Sometimes a Wild God*, published by Hedgespoken Press, 2015, used with permission from the author.

Quote by Dr. David Schrum used with permission from the speaker.

Quote by Aspen Baker used with permission from Berrett-Koehler Publishers.

Quote by Claus Springborg used with permission from the speaker.

Quote by Bethany Sewell used with permission from the author.

Quote by Sue Stuart-Smith from *The Well Gardened Mind* used with permission from the author.

Quote by Stephen Ritz used with permission from the speaker.

Quote by Patricia McCabe used with permission from the speaker.

Quote by ecodharma used with permission from the center.

Quote by Agata Krajewska used with permission from the author.

Quotes by Prof. Miles Richardson used with permission from the author.

Quote by Prof. Tim Sparks used with permission from the speaker.

Quote by Prof. Dacher Keltner used with permission from the speaker.

Quote by Caroline Aitken used with permission from the author.

Image Credits

Seed Protector Photo 1, Seed Protector Photo 2, Seed Protector Photo 3, and *Raika Apple Seed Sketch*, page 38, by Jackie Yeomans. www.jackieyeomans.com

Bright Storm and *With All of This*, pages 52–53, by Stewart Edmonson. www.stewartedmondson.com

Sea 1, Sea 2, Sea 3, pages 56–57 and *Catch of the Day*, page 134, by Jane Knight. www.karunadesign.com

Boat, page 58, by Flora Bain.

Eliza 1, Eliza 2 and Eliza 3, pages 72–73, by Lizzie Stevens. www.lizziestevens.co.uk

Panagia, page 77, by Rima Staines. www.rimastaines.com

Lindsay Photo 1, Lindsay Photo 2, Lindsay Photo 3, Lindsay Photo 4, Lindsay Photo 5, pages 92–93, by Lindsay Alderton. www.instagram.com/ knowingmeknowingyew

Mandala 1, Mandala 2, Mandala 3, pages 98–99, by Mayumi Nakabayashi. www.instagram.com/mayuminakabayashi

Canal Boat Roses, 2, page 109 by Dr. Amy Goodwin. www.a-goodwin.com

Fighting Robins, Swan and Gull, pages 124–125 by Hugh Warwick www.instagram.com/hedgehoghugh

Pastel Landscape 1, Pastel Landscape 2, Pastel Landscape 3, Pastel Landscape 4, pages 136–137 by Netha Islam. www.instagram.com/artistnetha_

Isla 1, Isla 2, Isla 3, pages 144–145, by Isla MacLeod. www.islamacleod.com

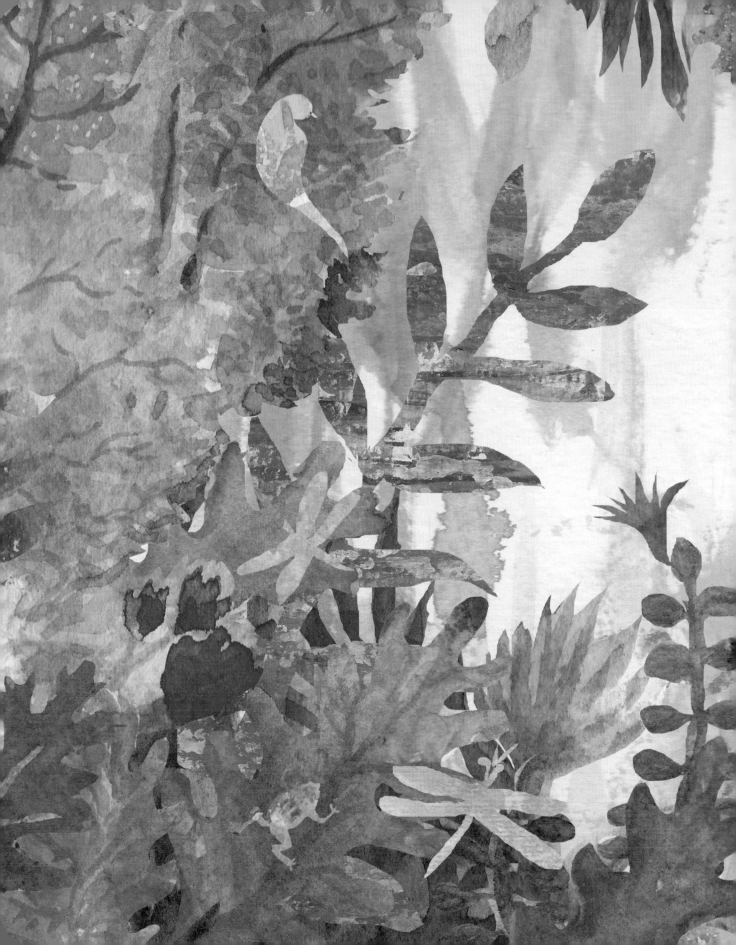

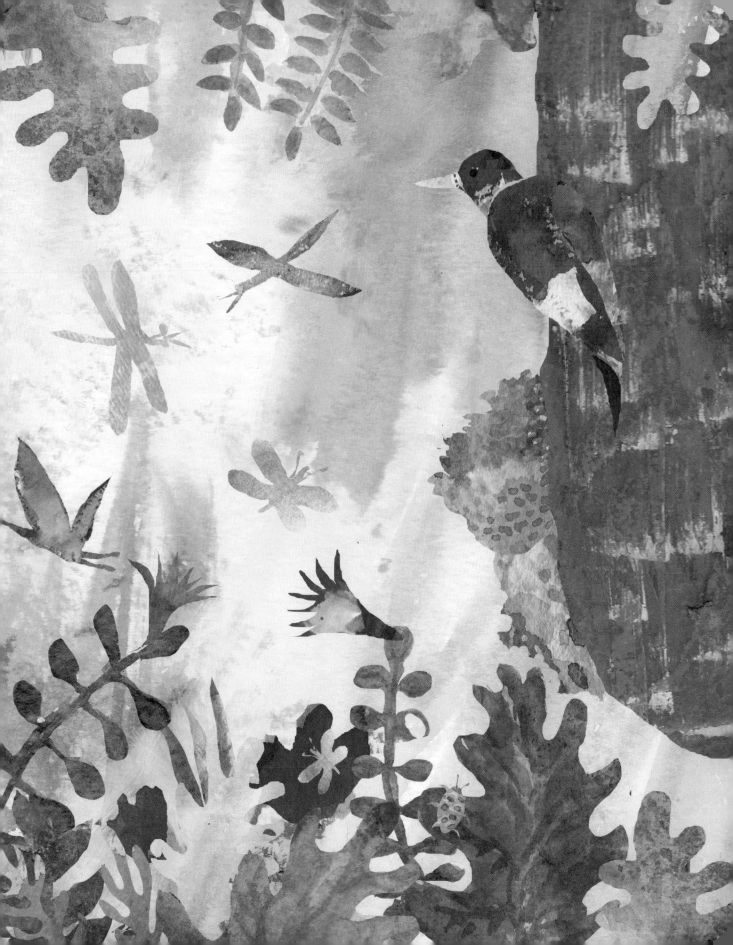

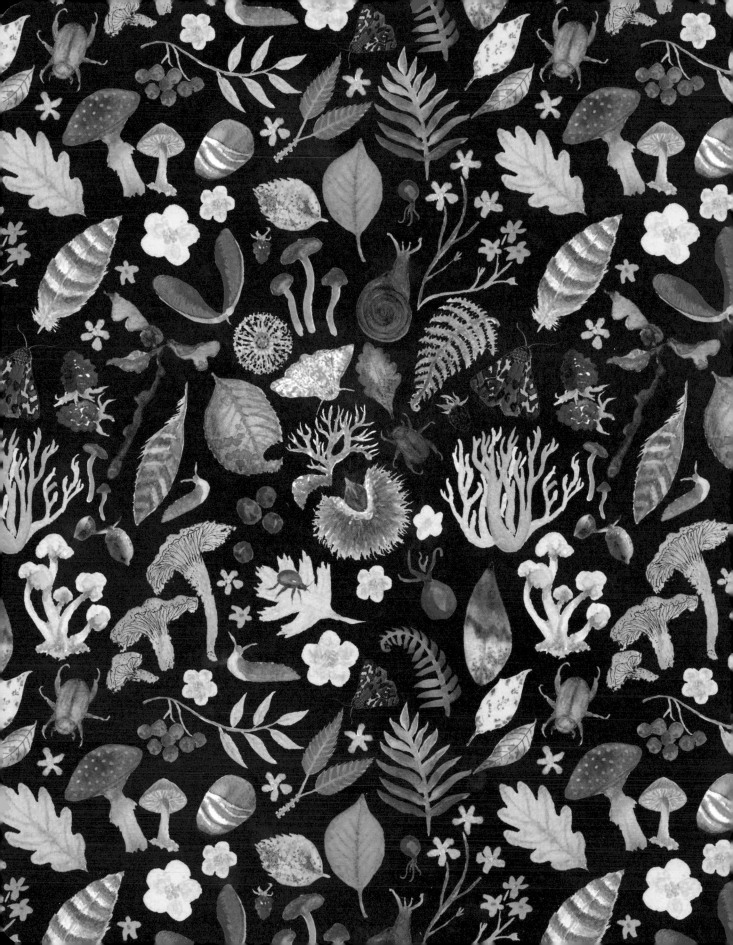